PSYCHEDELIC DECADENCE
SEX DRUGS LOW-ART IN SIXTIES & SEVENTIES BRITAIN

by
MARTIN JONES

CRITICAL VISION
an imprint of **HEADPRESS**

A Critical Vision Book
Published in 2001
by Headpress

Critical Vision
PO Box 26
Manchester
M26 1PQ
Great Britain
fax: +44 (0)161 796 1935
email: info.headpress@telinco.co.uk
www.headpress.com/

Psychedelic Decadence
Sex Drugs Low-Art in Sixties & Seventies Britain
Text copyright © Martin Jones
This volume copyright © 2001 Headpress
Layout & design: Walt Meaties & David Kerekes
Psychedelic Decadence model: Janice, photograped by Marie-Luce Giordani
Inside front cover: Christopher Neame in Dracula A.D.1972
All illustrations copyright © respective owners
Drawings on pages 134 & 146 copyright © Dogger
Drawings on pages 164, 165 & 166 copyright © Rik Rawling
World Rights Reserved

No part of this book may be reproduced or utilised in any form, by any means, including electronic, mechanical and photocopying, or in any information storage or retrieval system, without prior permission in writing from the publishers.

British Library Cataloguing in Publication Data
A catalogue record for this book is available from the British Library.

ISBN 1 900486 14 8

The author & publisher of *Psychedelic Decadence* encourage correspondence; ideas, comments and suggestions on the contents of this book are welcome.

Contents

Introduction iv

Death is not the End
Reeves and Ogilvy Merge in The Sorcerers 7

Penthouse Perfection
Roxy Music's Plastic Dracula 19

Thousand Yard Stare
The Eyes of Peter Cook 27

A Couple of Bad Trips
Dracula A.D.1972 vs. Performance 33

The Man in the White Suit
Conformity, Suburbia, JG Ballard 45

Meaty, Beaty, Big and Bouncy
Ingrid Pitt's Breasts 57

The Birds
Confess or Die, Timothy Lea! 61

Six Shillings to Happiness
Entertainment for Men 81

Real Class!
British Bikers Develop Psychomania 97

Filthy Towers
Basil Fawlty and S.E.X. 109

Vessel of Pleasure
Ruffling Emma Peel's Feathers 121

A Menace in Pigtails?
Earlyscarybowie 127

Party Girl Who is Painted
Horror Film Gigs (A Continuing Saga?) 137

Cracked Actor
Mike Raven's Bad Timing 145

"Aieeeee!"
Memories of 2000AD 149

The Generations of Britain
An Imaginary Orgy 163

> ... the thing about a record is that it's a record: if you don't wanna listen to it right now, don't listen. Listen in thirty years... In a sense, you put a record on and there it is. There's that moment they captured.
>
> —Tom Waits

Introduction THE ABOVE quote could be applied to almost any cultural artefact. I was born in 1970, smack in the middle of the period covered by this book, and so too late to experience at first hand most of the subjects under discussion. Because of this, *Psychedelic Decadence* is full of moments captured and dragged into the present. They may only be a small selection, but I'm still wandering around, half-lost, half-amazed — there's just too much to enjoy, for wildly varying reasons (an idea of psych-heaven can be found in the **Six Shillings to Happiness** chapter).

After completing this book, three things became apparent: (*1*) British horror films set in the 1960s and 70s — whatever their levels of competence — are naturally *odd*; (*2*) a shadow hangs over *Psychedelic Decadence* and in it lurks the music of The Stooges, the novels of JG Ballard, and the cooler than cool disco-haunting killer of *Scream and Scream Again*, as played by Michael Gothard; and (*3*) if I hadn't already decided to limit the book's content to British culture, I might have broadened the scope further afield, if only to ask a question like: Why wasn't Charles Manson influenced solely by the guitar riff on The Beatles' 'Happiness Is A Warm Gun'? Oh well, maybe next time...

Until then — dig the writing, kids!

Acknowledgements

MY THANKS go to David Kerekes, who has helped guide this book from its beginnings as a few vague, excitable ideas into the volume you now hold. Thanks also to the following people for artwork, suggestions, inspiration, assistance, or just because they want their name in print: Mel Holmes, Rik Rawling, Mark and Rachel Brook, Dogger, Tania Dessolin, Jez Holmes, Eva Marie Scheper, Roger Maynard, and 'mad' Ian Marshall.

Two books have been used as factual backbones for the chapters on Emma Peel and Peter Cook, but are not mentioned in the main text; they are: *The Avengers Dossier* (Virgin, 1998) by Paul Cornell, Martin Day & Keith Topping, and *Peter Cook: A Biography* (Sceptre, 1998) by Harry Thompson. My thanks to the authors of both.

Finally, gratitude must go to the anonymous BBC1 television continuity announcer who, whilst introducing the horror film *Incense for the Damned* late one night, unwittingly provided me with the title for this book.

Dedication

For my parents, Jenny and Joe.

Death is not the End

Reeves and Ogilvy Merge in *The Sorcerers*

> MARCUS: I've invented a machine that allows the user to experience the sensations felt by others.
> MIKE: Bully for you, mate.
> —*The Sorcerers*

A REAL attitude problem. That's what Mike Roscoe has. He's one individual in the most rapidly-evolving species of the 1960s: the self-assured youth. He's also self-centred, good-looking and — most importantly — bored. Mike wanders unenthusiastically through the London he inhabits without purpose until he takes a detour into the main plot of the film he is part of. Controlled and manipulated towards fatal ends in *The Sorcerers*, Mike is perhaps unconscious of the fact that someone outside the frame of the picture is pulling his strings as well…

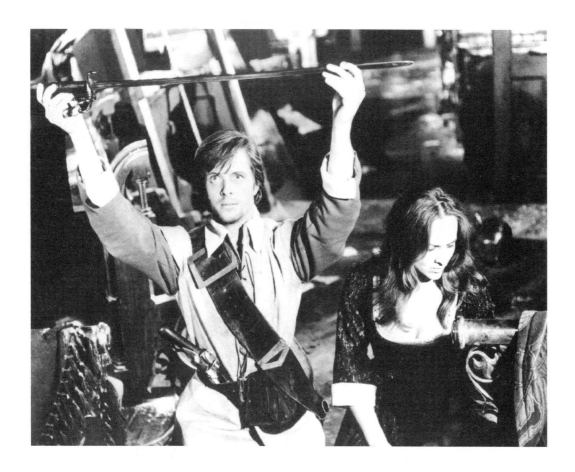

Ian Ogilvy in *Witchfinder General*.

1. *The She-Beast* (1965), *The Sorcerers* (1967) and *Matthew Hopkins: Witchfinder General* (1968).

2. In *Targets* Karloff plays a horror star well aware of his sell-by date, who plans to retire after the drive-in premier of his latest film; Tim O'Kelly is your all-American teen who seems to have strayed off the set of *Happy Days*, until he blows away his family and numerous car drivers. Reality and fantasy meet at the climax. One day, everyone's final moments will be marked by a motion picture simultaneously celebrating and exploiting their lives.

Take another individual, in many ways similar to Mike: talented, obsessive, controlled, locked-down, single-minded and most definitely dead. Even those with a passing interest in British horror cinema will know that Michael Reeves, director of *The Sorcerers*, took the suicide option in 1969 at the age of twenty-five (appropriately enough, drugs were the chosen method: a dose of unhip barbiturates). Reeves has genre immortality thanks to the lasting epitaph of his three completed films,[1] but he chose his exit in February of the final year of that psychedelic decade, slipping away from the party without many people noticing. Boris Karloff — star of *The Sorcerers* — died the same month of the same year. It's curious that Universal's original monster and horror's newest blood should depart simultaneously. Bypassing his involvement in a few cheap Mexican exploitation flicks, Karloff ended a long career with knowing nods to the weight of his past, through *The Sorcerers* and *Targets* (1968),[2] exquisite full-stops both. Michael Reeves had a whole lifetime of creation ahead of him, right? Maybe. Because he died young, there is the constant echoing whine of "he never had the chance to realise his full potential". But did anyone point out such a career move to the young Michael Winner?

Psychedelic Decadence

Like Mike Roscoe, Reeves was a full-on product of his generation and at the same time a rejecter of it. He might have advanced to making even greater films, but we can be glad that there was never a chance in his life to fuck it all up. As career plans go, slipping through the final curtain before thirty tends to add points towards immortality in the mausoleum of the dead young artist; greatness only achieved through retrospection and the advance of time. Human brains crank flat out with misty, pleasant simulations of post-death scenarios: everyone wants to be remembered, everyone wants to eavesdrop from beyond the veil and see the crying crowds at the funeral, hear the specially chosen music being played and the secret declarations of loss from those you least expect. Call it a lone strobe in the dark, but it's highly unlikely that Reeves is aware of all that has been written about him, of all the plaudits that have been heaped on his films. Let's not go off the tracks now with heavy afterlife discussion, but, for the years beyond 1969, Michael Reeves' death has not been the end.

TRENDS — the invention of ambitious coat-tail riders. There have been trends for regurgitated summers of love, and trends for viewing the entire 1970s as kitsch and, y'know, fun (and so allowing numerous sad bastards to splash about in the shallows of their own personalities). Those of us born after a certain period of time view years in which we did not exist as a series of trends. So many gaze back at the swingin' sixties through Lennon sunglasses, shaking their heads with retrospective wisdom and wondering how could people *not* enjoy it; how could someone choose to end their life at the tail-end of such a *liberated* decade? But 1969 is many things to many people, and not all of

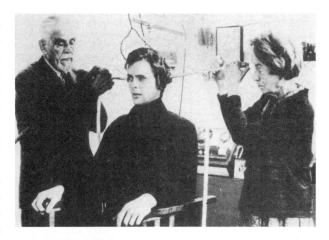

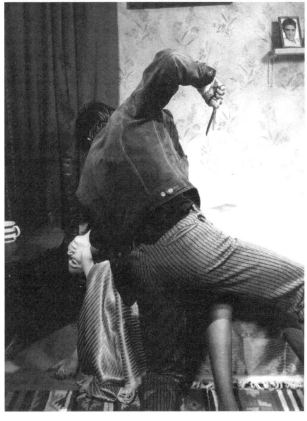

Top & Above: Under the mind-guidance of Boris Karloff and Catherine Lacey, Ogilvy goes thrill-killing in *The Sorcerers*.

Death is not the End

them are sweet: the Manson family, the knife-wielding Angels of Altamont, any gloriously evil Stooges song. Add Michael Reeves to that. By givin' it up in the same year he is a minor footnote on the roll-call of bummers. The nasty taste left by retrospection is that bad times stain more than good, and so all the fucking miserable trips personified by people, events, songs are horse tablets to psychedelic freedom, and only aid it in coming round on a puke-covered kitchen floor with its parents returning home soon.

Unable to decide his own posthumous fate, Michael Reeves stalks that highly romanticised place of the dead young artist, and admission there ain't for everyone. Timing is vital. Reeves was lucky in that the summer of love was not for him; his mental facilities seemed closed off, the complete opposite of the mind-expansion flooding the atmosphere. Can you fight depression with acid? How many cocktails does it take at the local nite-spot to dispel those negative feelings?

Depressed? At such a colourful time? It's hard to erase the image of some poor soul coughing up a lung as he sits by his last candle, desperately trying to create (think: Beardsley, Lautréamont *et al*), so keep in mind the diseased and deceased artists of the nineteenth-century; romanticised beyond redemption they may be, but they're a kind of comparison here: live fast, die young, and leave behind a good portfolio. Maybe Reeves would have done better in Paris in the 1890s. The 1960s seem a strange place for someone like him to exist in. A very strange place…

IF THERE'S detachment — even disgust — from Reeves for the time he lived in, it shows also in Ian Ogilvy's Mike Roscoe. *The Sorcerers* is crow-barred from a series of films permeating the late-sixties/early-seventies that attempted to weld the attributes of horror onto some kind of youth scene: B-movie plots illuminated by a flashing disco ball. Watch one, squint your eyes, and you can almost see the ghostly outline of the producers (wearing suits, naturally) on

Ogilvy turns the bloody tables on Price, the Witchfinder General.

the screen, fingers crossed and hoping all the ingredients have been mixed right. Fat chance. *The Sorcerers* is distinctive in that it takes on these demands with a straight mind and a straighter face, and the face is Reeves'. No working your way up the ladder here: Reeves cadged a job off the American director Don Siegel when he was still in his teens, then his advanced training ground was the schizo territory of the Italian film industry. He returned to England at a time when top dog Hammer was scratching its liver-spotted head in despair over what to offer the kids next. Young Michael Reeves takes on the old order; the battles within the film are the same.

Ageing mesmerist Marcus Monserrat and his wife Estelle (Boris Karloff and Catherine Lacey) have invented a hypnotic device that will allow them to experience the lives of others vicariously. But first they need a guinea-pig. Enter Mike Roscoe, a handsome, bored Kool Kat. After the kaleidoscopic experiment is completed, Mike begins to suffer blackouts which place him under the control of the Monserrats. Marcus sees this as having scientific value, but Estelle soon gets a taste for these new experiences and urges Mike onto more extreme acts. Eventually unable to take any more of his wife's desires, Marcus forces Mike to crash a car he is driving, and the couple share the sensation — along with their young plaything — of burning to death.

The Sorcerers oozes Reeves' attitude. It is a huge statement on the barriers between the ages. Here the old are humble, thrifty and apologetic and the young extravagant, carefree and trivial. The look Mike casts over Marcus when they first meet screams "DODDERY OLD CUNT!" In this world the post-war

generation don't give a toss how many limbs you lost in battle, you are nothing but an out-of-touch embarrassment that should be locked away. Not that all contempt is heaped on the aged; Mike Roscoe is plainly bored by everything. The liberation promised by the decade already appears to be getting on his nerves. He could be searching for a way out of the scene he is part of. The kicker is that Marcus and Estelle Monserrat are relying on someone like Mike (and all that they think he represents) to escape the way of life they have fallen into. A fresh mind and body is their exit from a wasted, lonely existence, and Mike is their reluctant guide to the mythical World of the Young.

And this world, with its coffee-bars and night-clubs, is the battle arena for the real kick-off in *The Sorcerers*. It's an uneven punch-up between Marcus and the merged Estelle/Mike. She may begin the film dutifully cooking dinner for her husband, but Estelle ends it encouraging violence onto the beautiful young things of London, like a drooling spectator at a cockfight. In the dual control of Mike, she is the more possessive half that pushes him towards theft and murder. Marcus can moan all he wants, but only an act of self-destruction will stop her (as with the Monserrats, Reeves burned out rather than faded away, although the anonymity of their demise is something he doesn't share). Estelle is fixin' to die on those timeless pleasures of the kids: sex and violence.

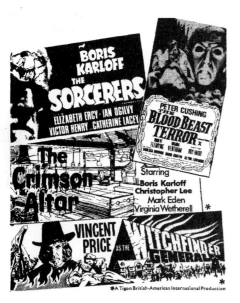

After the initial success of their experiment, Marcus tries to anchor the new sensations in scientific waters. But for Estelle, this fresh burst of life is an escape from their current situation in a way they had not originally planned. Through Mike she becomes young again, but only in a way the older generation look upon teenagers, believing their lives to be orgies of amorality. Parts of Estelle's life are obviously unfulfilled, and so she urges Mike on to more and more brutal acts. Estelle is an impostor passing through a time she understands little of, and, because she misunderstands it (see: any other bloodthirsty, ignorant, powercrazy fool) she must destroy it; she is a psychic dictator of 1967, a pioneer of the Mansonite future of LSD-control. Except here the tools of command are from a different age: laboratory equipment dragged from Karloff's black-and-white past, created — like acid — in labs, but not yet tested on humans.

Estelle's homicidal desires are initiated by a teasing glimpse of a world she has no place in. There is a suggestion of sadistic glee in this from Reeves, dangling the old bitch over the pit of delights, pulling her up by the ankles when she gets too excited. Mike may be bored by the life he leads — he has friends, relative freedom, a girlfriend — but to Estelle, most likely born in the previous century to live frugally through two World Wars, there is a touch of

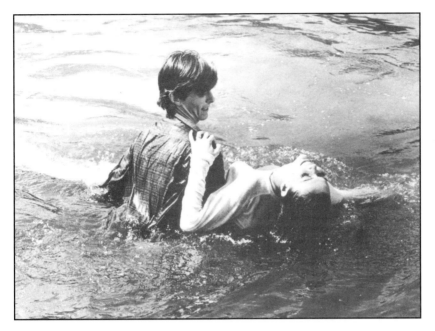

Ogilvy in-deep in *The She-Beast*, Reeves' not particularly good feature film debut.

the forbidden about such a life. The murders eventually carried out by the possessed Mike are the climax of Estelle's excitement, as she takes his generation's power to fuck freely one step further. Sex moves on to violence.

The first murder is of a female friend of Mike's. It occurs in her flat (already a symbol of autonomy that Estelle has never known). The second is of a female night-club singer, who is fooled by Mike's offer of professional help. By this point, Marcus has been reduced to a moaning old git banished to a corner, watching Estelle transcend her ordinary surroundings to walk at the edge of what she believes to be the pastimes of the young. Everything has reached full circle, and after the total exhaustion of life there is only death to look forward to. The Monserrats' lives terminate in seclusion and anonymity, burnt by glimpses of a world that was forbidden to them: the swingin' sixties. They keepa knocking but they can't come in.

BEFORE returning to Reeves, let's glare in wonder at the actress who played Mike's first murder victim: Susan George. When I think of her the name of a film, *The Violation of the Bitch*, taunts my brain like a dirty neon sign. Susan George and that lurid title were made to be together. She appears to have spent her entire acting life getting her kit off and being thoroughly abused by whoever could get it up first, although I have a permanent fixed image of her career existing only in the early 1970s. Her *shape* alone belongs in such a time: contemplate the tanned skin, wide child eyes and long, straight blonde hair and it's only a short step to the glorious days of spangly-knickered porn mag starlets in tropical beach shots (or cavorting on brown bedspreads), women

Death is not the End 13

Psychedelic Decadence

with an abundance of pubic hair and an aversion to bikini lines; days when, past their sell-by date, such magazines would assume the shape of corrugated iron.

The image of Susan George as professional victim stems, of course, from *Straw Dogs* (1971), but I've always considered her game for anything. Catch her name in the credits of a film and there's a good chance of finding nudity or degradation within its reels. Involving her. She seemed to take sexual freedom to a questionable edge, stopping short of hard-core bushwhacking. The day I realised that her innocence was limited entirely to her looks arrived when, as an ignorant child, I was taken down to the local video shop (membership only £10! Full range of films, VHS and Beta!) to pass some time off school. Once there I was overcome by the gullibility experienced by many and chose a title packaged as the distant cousin of a Big Film (*Star Wars* or *Mad Max*, f'instance). This time it was one of the many rip-offs of *Jaws* — *Tintorera* (1977). Fooled by ad-lines on the sleeve ('the crazed shark attacks the hunter furiously — in a scene that is among the most appalling ever filmed') I watched it dumbly, confused as to why there was so much dubbed talking and so little shark attacking. Vague memories remain, however, of a (semi-?) naked Miss George tempting two well-oiled skin-divers into bed, though I can't remember if this developed into a pig-on-a-spit, bookend-style situation. I'm sure she'd like to consign such trash to history. However, shit sticks pretty easily... was there *nothing* this woman wouldn't do?

In *The Sorcerers*, George is stabbed to death with a pair of scissors, but no such dignified exit awaits her in *Straw Dogs*. Here she falls prey to some rugged yokel violation, seventies style. Returning with her American husband to the Cornish village where she grew up, Amy Sumner (George) appears to have once occupied the position currently held by young minx Sally Thomsett, that of village bike. Soon enough, the pencil-dicked hubby is cuckolded and Amy at first resists, then welcomes, the meaty probings of her rural ex-boyfriend. This isn't enough, though, so his mate — eager to have a poke at the hay himself — indulges in sloppy seconds. Yeah, great to work with Sam Peckinpah and Dustin Hoffman, I'm sure, but this rough riding set the ball rolling for a long line of directors all shouting "My film next, Susan! Bring your wet-wipes!"

Bizarrely, meditating on George's career curve brings to mind thoughts of the gang-rape of Tralala in Hubert Selby Jr's novel *Last Exit to Brooklyn*. The violation of the bitch, indeed...

Susan George (previous page) and husband Dustin Hoffman (below) in *Straw Dogs*.

Death is not the End

TO THE outsider Michael Reeves' life could, at the very least, be called enigmatic; and like all enigmas, the slightest details receive intense attention. Photographic evidence of the man himself veers to the thin side, but what there is shows an intense young man with short dark hair and a face that betrays a good education and sleepless nights; his clothes are rooted in his own generation: jeans, polo-neck beneath shirt and velvet jacket. The attire of an artist, the image of a Film Director.

The photo is of Reeves and Vincent Price on the set of *Matthew Hopkins: Witchfinder General*. Apparently, Price didn't think much of the young director. Tough shit, Vincent. As the well-known quote goes: you made eighty-seven films, Reeves made two good ones.[3] Controlled, locked-down, *single-minded*... someone deep in the realms of his creation, knowing exactly what he wants. Imagine a flower-child of the age approaching Reeves on location, drawling "loosen up a little" or "chill out, mate". He would have had them thrown off the set. The impression given is that Reeves never ventured onto the dancefloor of that local nite-spot to let his hair down, but stayed in the shadows, watching and planning. The most striking aspect of Reeves' appearance is how physically similar he was to his favourite actor.

RADA-trained Ian Ogilvy was the leading man in all three of Reeves' films, and a close friend and contemporary.[4] Director or actor under control of the Monserrats? Mike Roscoe or Mike Reeves (MR/MR) challenging Karloff in *The Sorcerers* for a place in horror film history? Here's Mike Roscoe: short dark hair and a face that reeks of a good education, suede jacket, polo-neck and modish two-tone pinstripe slacks. Self-assured and cavalier in attitude (when his girlfriend criticises his eating habits, Mike replies "my mouth, my prerogative"), Roscoe is Reeves' more upfront doppelgänger, breezing through a world he finds uncomfortable. The director is controlling Estelle controlling Mike — the hip hipster-killer — slashing through the beautiful people at his creator's bidding. Reeves uses them both to demonstrate his indifference to London 1967.

Mike Roscoe meets his end through uncontrollable forces: the Monserrats. Michael Reeves met his through something just as unpredictable: depression. In projecting Ogilvy into his films (particularly *The Sorcerers*), Reeves etched a lasting image of himself onto the screen, then made sure death sealed his work in a box of immortality. The transformation worked. Whenever I see Ogilvy on television, in *Ripping Yarns*,[5] say, or Hollywood detritus such as *Death Becomes Her*, I see Reeves as well, passing from one strange time to another...

SPECULATION is a worthless waste of thought; it can trail off into infinity. Had he lived, Reeves might have gone on to make films equal to those he left behind,[6] but, considering that within a few years the British horror film industry was in retreat from the puke being spat in its direction by *The Exorcist*,

3. This line is most commonly found in Kim Newman's *Nightmare Movies: A Critical History of the Horror Film, 1968–88* (Bloomsbury, 1988, p.14), although I have no idea from where it originates. Great quote, though.

4. Ogilvy is still probably best known as the star of the 1970s revival of *The Saint*.

5. In one of the best episodes, 'Tomkinson's Schooldays', Ogilvy played a superior school bully to Michael Palin's downtrodden protagonist.

6. Various interviews give passing mentions to future projects. His next was to have been *The Oblong Box*; the critic Ernest Harris, in *Shock Xpress* (Vol 2, No 4) mentions a script titled *Razor*. The writer Chris Wicking (interviewed in *SX* Vol 2, No 5) makes a reference to HG Wells' *When the Sleeper Wakes*. The speculation spirals like water down a plughole.

he may well (like many contemporaries) have gone off into the television business instead. No-one will ever know. There does, however, seem to be a general genre consensus that two films post-Reeves add unconsciously to his chronology: *Scream and Scream Again* (1969) and *Blood on Satan's Claw* (1970). Strange that they stem from the period immediately following Reeves' death, as if his rejection of Britain's cosy horrors rallied the individualistic imagination in others, if only for a short time.

Scream and Scream Again is the old and new welded together: mad scientist plot and conspiracy theory, along with limb-snapping set-pieces and an odd, complex structure that finds the veteran actors of the time — Price, Lee, Cushing — looking confused and cheque-hungry. *Blood on Satan's Claw* has the young of seventeenth-century rural England falling under the devilish spell of pubescent coquette Linda Hayden, until adult authority blows out the party. These films pick up themes of Reeves' — the descent into violence, youth vs age/authority — but act more as horror comforters, giving those unable to accept the finality of his death something relevant to suck on. Marvellous movies both, but ones that belong to different directors and writers. All we're left with is what is and what can never be.

And what is are three films, a short-lived enigma, and a successful merging. Michael Reeves: you sorcerer, misfit. Like hyperventilating adults desperate to continue their bloodline through children and grandchildren, you took cool precautions for continuation of your particular line; through your films and Ian Ogilvy, celluloid ambassadors to a more understanding time.

Ogilvy (left) and Reeves (right), as portrayed in the *Witchfinder General* pressbook.

Next page: Starting as she means to go on — Linda Hayden in Alastair Reid's *Baby Love* (1969).

Death is not the End 17

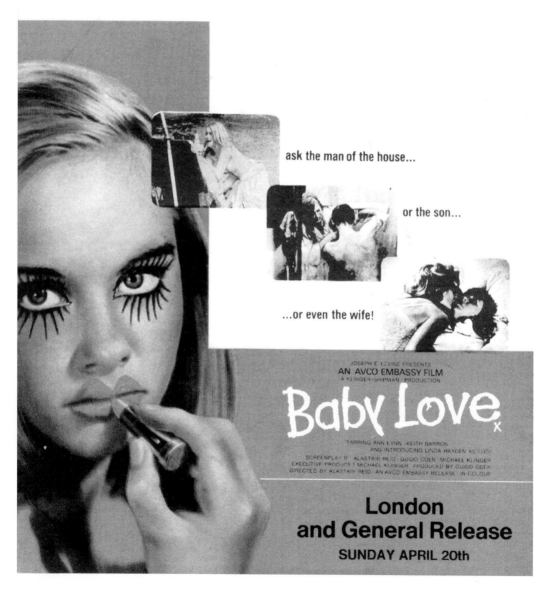

Penthouse Perfection

Roxy Music's Plastic Dracula

Is this a recording session or a cocktail party?
—From the sleeve notes of *Roxy Music*

She hears / she talks / see what I mean?
—'Re-make/Re-model'

HISTORY leaves plenty of corpses scattered about, so it's easy for the curious to examine the symptoms of the dead, learn from their mistakes, and adapt. The 1960s eased into the 1970s so sweetly that the previous decade's concerns and fun-fun-fun trips were soon forgotten, wrapped-up and disposed of in shiny material and glorious plastic materialism. I think of the early seventies and imagine (for that's all I can do) a time dominated — strangely enough — by alcohol and useless gadgets: Watneys Red Barrel, Double Diamond, party sixes, air-pump corkscrews.

What the period between 1972–1973 was really like is no concern of mine; I want it to stay the way I imagine it was, like the sealed-off living room of a suburban house. With a bar in the corner. This is a time of cocktails and cocks, where the dutiful wife considers an affair with her husband's brother who, under the light of a disco glitter ball looks *just* like Jason King; a quick fuck on the new green sofa, safe in the knowledge that it still has the clear covers on it. But let's not dirty this creation with droplets of kitsch. Kitsch: the undignified autopsy of any specified time. We laugh now because the ice container was shaped like a pineapple; because who seriously had cocktail stirrers lying handy around the house? Because surely wife-swapping wasn't as simple and easy as, well, swapping wives? It was *so* kitsch, right? Well, no. It was so normal. Day-to-day life. But normality is the furthest out sometimes, the most fragile, the state of existence most likely to crack first.

Picture the hi-fi in this room, next to the chrome and glass coffee table, thrust into a corner. A stack of LPs by it, mostly Glam Rock stuff. Like most labels for musical movements, 'Glam Rock' doesn't fare too well under detailed inspection. A couple of important singers/bands rise above it: David Bowie, obviously, and Roxy Music. There are superficial similarities, but beyond this, the two go their separate ways. Bowie: perverse extremes celebrated in sex, intoxication and pop songs; Roxy Music: hell-bent on sticking around at the suburban drinks party to see what happens once the guests get drunk. If Roxy equals glam, it's glam to the value of a cracked Babycham glass, with all the impact of a post-sixties swinging breakdown.

THE CORE of Roxy Music were Bryan Ferry's lyrics, expressed through lounge-lizard vocals, and Brian Eno's electronic experimentation, hermetically sealed off from the rest of the band.[1] Circa 1972, Bryan Ferry had a strange relationship with living-room materialism, fighting the urge to accept, realising the plastic instability of such a domestic life; wanting to suck some good out of it, but relishing the bitter aftertaste more. In every dream home: a heartache. Ferry was masterful in chronicling the contents of these palaces, full of vinyl coverings and automaton women, faceless husbands and nothing deviating from the norm. Channelling obsession through music, Ferry speculated on the security of these planned lives. Such lifestyles have become intensified to the present day.

Alarms, gates, codes, signs. Home is the castle, my private time is my own. For every job security and audio-visual equipment and a decent holiday a year and weekends away and "who is that? No-one usually calls at this hour?" there is the nagging feeling, held deep in reserve beyond the advance diary of the mind, that all this perfection will be tarnished, that everything earned will be altered or destroyed; that someone will — one way or another — take a free ride on your hard work. As it is now, so it was then. The material world of the 1970s becomes Edgar Allan Poe's *Masque of the Red Death* for the twentieth-century, a bubble of plastic protection. Similarly, the hairy-pussied protesting students of the sixties become the aproned hostesses of the seventies, running out of olives as hubby plies the boss with more drink in order to ask for a pay rise.

When you're documenting a lifestyle, you're bound to be tempted by some of its attractions. Ferry may be repulsed by plastic elephant-shaped ice-cubes, but he enjoys hanging around to watch the hostess drop them into glasses. Women are the centre of his white-walled world, and he waits for them to crack up, to graduate from Babycham to gin. The perfect female to Ferry is a near-robot; the fact that her skin is like vinyl, that her emotions are masked by alcohol, does not seem to concern him too much.

The signs are there on the covers of the first two Roxy Music albums: *Roxy Music* (1972) and *For Your Pleasure* (1973) (let's be bold here, there are hair, clothes and make-up credits on each). The woman stretched across the gatefold sleeve of the debut LP is pure pale blue and pink, her swimsuit and hair dragged from the 1950s into the 1970s. She has pink finger and toe nails and ankle-strapped silver heels, a (naturally) pink rose lies between her left thumb and forefinger. Her teeth are clenched. She is Ferry's 'Ladytron':

> I'll use you / and I'll abuse you /
> then I'll lose you / still you won't suspect me

For Your Pleasure goes up a class: in the black foreground of a city night sky a pouting blonde poses in a strapless black (rubber? Lycra?) dress. Her stilettos lift her a good six inches off the ground. A long-gloved hand holds the leash of a panther, eyes and fangs gleaming. Turn to the back cover and her chauffeur waits by the polished limo, smiling. It's Ferry of course, working his way up the social scale, ready to drive her to the next party, then slip into his white jacket and mingle:

> So if life is your table / and fate is the wheel /
> then let the chips fall where they may

The cover-girls Ferry leaves stranded on Roxy's LPs are heavily made-up perfections, sculptured far away from his songs. They exist only to decorate

1. The full line-up of the band at the time was Bryan Ferry (vocals & piano), Andrew Mackay (Oboe & Saxophone), Brian Eno (synths & tapes), Paul Thompson (drums) and Phil Manzanera (guitar).

records, to line the wire racks in some perfect penthouse. Every other woman in Ferry's lyrics is on the verge of disintegration: "hopeless cases with fake alibis." He's smart to such celluloid pictures of living, but doesn't seem so sure as to what the best remedy is. In 'The Bob (Medley)' the singing is stretched almost to the point of collapse — "you were so pure / not for this world / so gentle and light" — and the heavy atmosphere only fades when Eno brings in taped noises of war. Is Ferry celebrating his cover-girls' lives, glad that they are not touched by the pill-popping stress of a housework lifestyle? He himself seems undecided. Crash the manorhouse party and chase a certain model or resign himself to the domestic world he so badly wants to document? In *Roxy Music*'s most downbeat song, 'If There Is Something', the tone shifts almost two minutes in, although the monotonous, reliable drumbeat remains the same. What begins deceptive mock-country descends into pleas aided by Eno's wailing machines, with Ferry at first declaring:

I would do anything for you / I would climb mountains /
I would swim all the oceans blue

But then switching to:

I would put roses round our door / sit in the garden /
growing potatoes by the score

Never has the cultivation of vegetables sounded so desperate. The origins and preparations of household foods are a thousand miles from the exclusive estates in Ferry's mind, an alien concept. He's only interested in the finished product. The last minutes of 'If There Is Something' play out with a sense of loss, overlapped by a spooky, effective refrain ("when we were young"). Again Ferry is undecided: the struggle with domesticity or the in-crowd high-life? Dish-washing automaton or cocktail-clasping siren? Maybe there are no easy options, as the melancholy 'Sea Breezes' states:

We've been running round in our present state /
hoping help will come from above
But even angels there make the same mistakes /
in love / in love / in love

It's deep within the grooves of *For Your Pleasure* that Bryan Ferry makes his decision, steps over the threshold and hands his jacket in at the front desk, leaving outside — like the guests in Poe's story — the realities of a fragile world.

But let's not forget his assistant, Brian Eno. Eno: electronic Renfield to Bryan Ferry's plastic Dracula; Eno: soon to leave the band after *For Your*

Bryan Ferry (main picture) and (from top to bottom) Brian Eno, Phil Manzanera, Andrew Mackay as they appear on the first Roxy Music album (photography: Karl Stoecker).

Pleasure because of the usual 'creative differences'; read: Ferry about to accept his cocktail lifestyle, Eno wanting to continue with noise experimentation. Social/anti-social. The precarious mix of high-life and musical innovation continued to embrace Roxy Music for a while after Eno's departure, but sometimes you have no control over what you're doing, no realisation as to how you're getting it right. (Before that, though, there is claustrophobic confession — "before I die I write this letter" — in 'Strictly Confidential', relieved post-orgasmic breathing at the end of 'The Bogus Man', and the portentous executioner's drum-roll that opens 'For Your Pleasure'.)

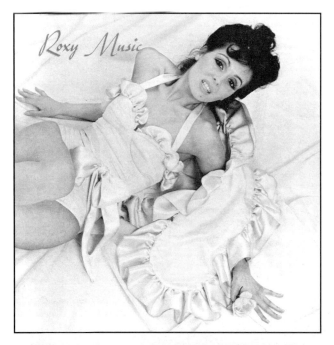

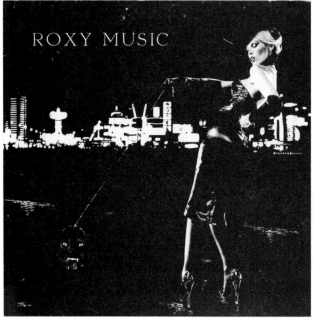

Sleeves to Roxy Music's first two albums.

The culmination and release of Ferry's pent-up domestic cravings emerges in the whirlpool-like 'In Every Dream Home A Heartache'. Here, Ferry admits to his own desires, though still acknowledges the instability of this penthouse perfection. The description of his gleaming living arrangements soon pales beneath love for the mail-order, plain-wrapper inflatable sex-doll that floats in his new pool. Why didn't Ferry become more unhinged after this? 'In Every Dream Home A Heartache' drills into the brain like the aural equivalent of JK Huysmans' novel *Against Nature*: the affluent gent playing house with his own obsessions; though in the song Ferry sometimes tries to convince himself that these material gains are necessary ("all of its comforts / seem so essential"). But it's the necessity of a sick man.

Over a sterile, funeral-pace musical backing, Ferry tentatively confesses his needs and comments on the remoteness of his neighbours' own lives:

Penthouse perfection / but what goes on? / What to do there? / Better pray there

And you see vividly a thousand housewife breakdowns amid material gains: midday cocktails and mechanical sex, wipe-off aprons and remote-control garage doors. No wonder Ferry retreats further into his solitary love affair with an immobile, synthetic orifice. No arguments, no resistance, no mess. The climax of desire nothing more than semen crawling out of a plastic vulva. But at the same time no response, no retaliation, no surprise. Little wonder that before the song finds

release in an explosive guitar riff, Ferry questions his role in this domestic paradise:

> Inflatable doll / lover ungrateful /
> I blew up your body / but you blew my mind

One final confession before he embraces the rock star lifestyle. The battle is won with the end of the LP (and the departure of Eno), and the listener is left with no doubt as to which side Ferry has absconded to. Towards the close of the title track of *For Your Pleasure*, Ferry — the plastic Dracula — has let his crooning subside into reverberating helicopter blades: they hypnotise the listener as a final command is issued beneath the music: "don't... ask... why."

FREE to pursue his own way, Bryan Ferry embraced it totally: the mansions, the French lifestyle, tennis with Rod Stewart. The domestic paranoia left far behind, all he could do was document — without guilt — the glitzy world he was reborn into, through solo work[2] and occasional Roxy Music reformation. His future form is mapped out in 'Editions Of You':

> Well I'm here looking through an old picture frame /
> just waiting for the perfect view
> I hope something special will step into my life /
> another fine edition of you

So Ferry became comfortable in the folds of the exclusive party, with no desire to observe tormented housewives or survey plastic furniture or declare love for lonely sex-dolls. Although there may have been a hint that everything had not lived up to expectations. On 'The In-crowd' (from his solo LP *Another Time, Another Place*), Ferry sings the lyrics in the tone of a man desperate to convince his listeners that he has made the right decision, that he really *is* having a ball with his new friends...

Comparisons have already been made between Ferry's lyrics and the written word, but perhaps the most explicit kinship can be claimed by the novels of JG Ballard, particularly his documentation of cohabitive social implosion, *High-Rise*. Before their animalistic division into corridor-roaming hunters, you can imagine the residents of Ballard's seemingly perfect tower block listening to Roxy Music LPs on their expensive hi-fis, unaware of how very close to their own collapsing psyches Ferry was.

2. The promotional video for 'Let's Stick Together' is a fine example of Ferry's more clear-cut way of life: outfitted like the kind of creature who habitually haunts expensive night-clubs, he sways to the brazen music, as an absurdly long-legged Jerry Hall caterwauls around his white-jacketed form. Vindication, if any were needed.

Penthouse Perfection

PETER COOKS UP A TREAT FOR US

Comedian PETER COOK is at present working upon the new film "Bedazzled" in which he co-stars with Dudley Moore, Raquel Welch and a great supporting cast. The dry humour and dead pan of PETER COOK is rapidly winning for him the place in the hearts of millions of fans who loved that other dead-pan comic Buster Keaton.

29 JUN 1967

Thousand Yard Stare

The Eyes of Peter Cook

IF THE only thing we can be certain of in life is death, then something to look forward to once dead is a messy autopsy of our living years. This may well include a number of undignified mutterings saying what a waste that life was, or had become. Such retrospective judgement was meted out to Peter Cook when he died in 1995, aged fifty-seven. To many, Cook was a comic genius who went off the boil sometime in the early 1970s, his reputation resting on the twin towers of *Beyond The Fringe* and *Not Only… But Also*.

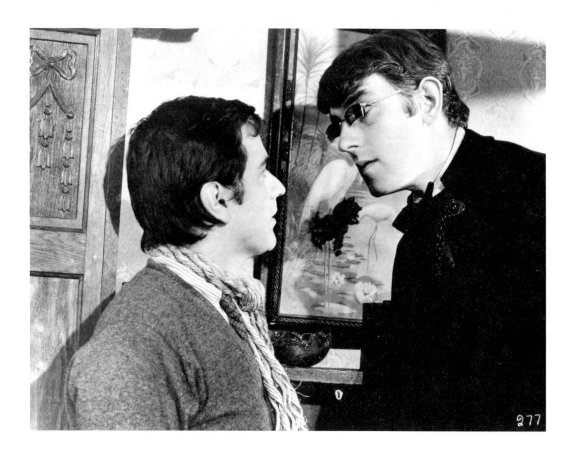

Dud and Pete converse on *Bedazzled*.

These sturdy vessels of satire were to sustain him the rest of his life as he descended into drink, drugs and flab. But what a strange word 'descend' is, when used in the context of addictive substances. To hear people moan "his descent into alcoholism was quite saddening" is to see an image of knowing faces standing round a gigantic beer keg, shaking their heads as the intended victim splashes about below. It denies a bigger picture (the bigger picture being to take a life as a whole). Peter Cook had a famously low boredom threshold, and his later years — although sometimes bare of creation — seem as marvellously eccentric as his initial successes (where he reigned as a sort of Wilde of the sixties: young, handsome, tirelessly witty) were glamorous. Beyond occasional abstinence, Cook continued drinking and taking drugs (Peter Cook on ecstasy!), settled into a comfy pear-shape, watched a lot of TV, attended a number of orgies, read a lot of newspapers and picked up a few oddball friends along the way. Throughout this strange progress, there were occasional glimpses of the 'old' Peter Cook — such as his barnstorming take-over of Clive Anderson's chat show in 1993 — to keep punters and critics happy. As his soundbite-frenzied football manager character from that show remarked: "I can look myself in the mirror in the morning and say, 'There is a man.'"

And what a man, because as well as having a razor-sharp talent for comedy, Cook also had another less obvious weapon at his command: the most intense pair of eyes this side of Marty Feldman. They seemed to be under a control separate from the rest of him, glancing off in slightly different directions, as if he were not satisfied with just one viewpoint of the world. Cook utilised them well to fire barrage after barrage at Dudley Moore in *Not Only... But Also*. Okay, like so many others, I'm harking back to that 'Golden Age' of 1964–67, but Dudley was an integral part of Cook's thousand yard stare, a sniggering dartboard for his ruthless weapons. In their Pete and Dud incarnation, Cook's eyes — dark, blue and endlessly knowing — became the killing stroke in so many one-sided battles. And there was never a fair fight. Not that the audience didn't mind Cook's merciless destruction of Moore: for all intents and purposes the audience *was* Dud, cracking up helplessly under the strain of such a surreal inquisition.

Given the relationship between the two, it's strange that their most famous film together, *Bedazzled* (1967) — although littered with clever comic moments — finds Cook on the loosing end, character-wise. The first thing you'd look for when casting the Devil is a mean set of peepers. The film is *Faust* given a Carnaby Street makeover. Insignificant chef Stanley Moon (Moore) gets up to the usual shenanigans with the Devil, George Spiggott (Cook), in order to win the affections of Margaret Spencer (Elenor Bron), a beautiful young waitress. Stanley Moon *is* Dudley Moore, but a bit more pathetic and with none of the real-life "birds swarm over me like flies on shit" attitude. As the Devil, Cook is witty, charming and always on top of the situation, much as he was in real life at the time. But something is missing. Maybe it's the fact that Cook — like Kenneth Williams — was much less of a comic actor and more of a loose cannon at his best when unrestrained by a script. Cheerful though Spiggott may be, his evil, his low-down immorality, fails to sparkle due to the disinterest in his eyes. Celluloid seems to have wiped them of life. The one moment of inspired deviance comes in the section where Stanley has his wish fulfilled to become a pop star singing in front of screaming, adoring girls, only to have Spiggott undermine him (as he has done throughout the film) by coming on next as Drimble Wedge and the Vegetations, a sort of prophetic precursor to The Velvet Underground. Static, monotonous and uninterested in the hoards at his feet, he sings the equally complimentary 'Bedazzled', complete with a pay-off line worthy of The Stooges: "you fill me with inertia". But again, the one thing marring Spiggott's nihilistic act — ten years before the Sex Pistols — is the fact that his eyes are playing along with the bored pop star role, and not drinking in the admiration before him. *Bedazzled* is flawed but entertaining. Cook could have been perfect for such a diabolic role, but perhaps it needed more of a conventional actor to drag out the darkness behind those pupils. At the critical and commercial height of his powers, Cook created a far more interesting master and servant scenario away from

the cinema screen, with only a script ripe for detours and a squirming victim placed in front of him.

In the more innocuous pairing of Pete and Dud, flat-capped and macintoshed unwitting suburban philosophers with a surreal array of experiences to their names, Cook had a superiority lacking in *Bedazzled*, and appeared to take sadistic pleasure in reducing Moore to a giggling mess. The finest example of this occurs in their 'Art Gallery' sketch where Pete and Dud — equipped with packed lunches — eviscerate Vernon Ward (here Pete's eyes never stray from Dud), Rubens and da Vinci, before homing in for the kill on Cézanne's *Les*

Grandes Baigneuses. As they both nibble on sandwiches, Pete, head tilted, chin tucked into his right shoulder, eyes lasering beyond his victim, remarks:

> Five hundred thousand quid we paid for that. Those nude women came out of our pocket, Dud.

To which Dud adds:

> Works out about fifty thousand pounds a body, dunnit.

> PETE: Well, you could get the real nude ladies over there for that price.
> DUD: My Aunt Dolly would've done it for nothing.

Next, there is a killer pause from Pete, as if he's flipping at lightning speed through an itinerary of replies in his brain, before he almost offhandedly comes out with:

She does anything for nothing, doesn't she, your Aunt Dolly. Dirty old cow.

By this point Dud is choking on his sandwich, but Pete remains calm, hardly veering from his victim, almost pinning him to the ground with his stare. He nibbles the sandwich a bit more, pauses and flashes a sly glance back at Dud — a malicious look of total power — before finishing him off entirely:

You enjoying that sandwich?

And Dud *is* finished off. Years later Cook commented on how cruel he had been to Moore. But with eyes like that, how could you be anything else? In any other life he would have been an evil bastard. Here he was just a very, very funny bastard.

In a massive case of corporate lunacy, the BBC wiped most of the episodes of *Not Only... But Also*. 'The Art Gallery' survives, though. And the eyes. They survived the supposedly hedonistic sixties to plunge with Cook into wilder times, skewering chat-show hosts and bringing a touch of madness to numerous charity events. Then those dissenting voices cried out, like a Soho Greek chorus, that Peter Cook had never been able to follow on from his initial success. Look at Dudley, *he* went to Hollywood and became a movie star. That's success, right? But Cook achieved his own niche of fame, somewhere (as he once observed) between Dudley Moore and Charles Manson. Between laughter and a psychopathic stare. It's a unique spot hard, if you're not the man himself, to visualise.

SOMEWHERE IN YOUR HEAD THERE'S A WILD ELECTRIC DREAM

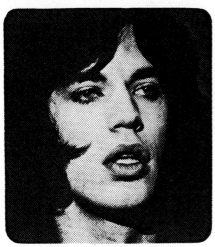
Mick

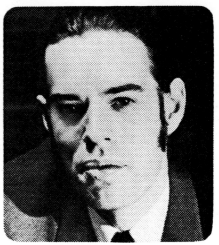
Jagger

Come see it in

PERFORMANCE
where underground meets underworld

Warner Bros. presents
Performance
A Goodtimes Enterprises Production
Starring
James Fox Mick Jagger
Anita Pallenberg
Michele Breton

Technicolor® Written by Donald Cammell Produced by Sanford Lieberson Directed by Donald Cammell and Nicolas Roeg
Hear Mick Jagger sing Memo to Turner in the original sound track album on Warner Bros. records and tapes.

 NO ONE UNDER 17 ADMITTED

Psychedelic Decadence

A Couple of Bad Trips

Dracula A.D.1972 vs. Performance

THE CELLULOID children of the psychedelic age could never win. Righteously hip in front of the cameras, by the time their performances reached an audience, they were as old and dated as the grown-ups they ridiculed. Desperate for themes identifiable to teenagers (though sometimes not realising that audiences have too much to identify with in real life anyway), producers would slip in any old trend and then watch helplessly as it rotted away during the time taken for the film to be released. Such things are beyond the control of the film-makers, turning them into grotesque parodies, unfit for serious approval. Only good for laughing at.

There's a superior kick to be had in calling a film dated; it's like laughing at the odd, quaint ways of ancestors. But would we really want to see something up there on the screen that could be related to totally? That would be like looking in the mirror every morning: same old face. You *know* what your fucking miserable life is like, for Christ's sake. So why get excited when the men in suits pop up and offer out another slice of generation representation as entertainment? Some punk watches *A Clockwork Orange* and thinks "I've never looked as cool as that"; a punch-hungry brawler watches it and thinks "I've never had a fight like that"; a Beethoven fan can't understand the interpretation of his music; and so it goes on: they are intimate with the subjects and yet at a distance, because everything has been filtered through other minds. What's contained in those four walls of the screen is separate from your life, from my life. No matter how hard it tries, film will always be removed from reality. Good thing, too. The sight of psychedelic decadence can be exciting and enticing, but that's all we're doing: watching. So let's get stoned and watch the freaks.

And look at the parade we've got here. Two far-out movies, voices of a generation, carriers of the flame of free-livin' youth: *Dracula A.D.1972* (1972, natch) and *Performance* (1970). One is continually crushed under that dead heavy word *Zeitgeist*; the other is ignored or ridiculed whenever the spirit is right. But look hard, and you'll find the real psychedelic moments in them, hermetically sealed in that strange world called cinema. Both have similarities, but you can bet your life the makers of each wouldn't admit to them. Guilt by exploitation? Too right...

"Dig the music, kids!"

Dracula A.D.1972 CHELSEA, London. Circa 1972. A gang of kids — wild for kicks — are bored of their usual way of life and on the lookout for something more happening. One of the newest members of the gang, Johnny, suggests some black magic. In a deserted church at night, they think it's a blast, up to the point where Johnny slits his wrist and things get a bit freaky. The gang split in panic, not knowing that Johnny has resurrected Count Dracula.

The Count vampirises Johnny, who sets out to trap Jessica Van Helsing, great-granddaughter of the famous professor. The police, aided by the current Professor VH, investigate a number of strange killings in the area, but eventually the Professor realises that Johnny is behind them, and battles triumphantly with the Count just as he is about to take Jessica as his bride.

In *Dracula A.D.1972*, Hammer films betray their unease at the idea of producing something more 'up to date' by setting the prologue of the film in 1872, where the original Van Helsing and Count Dracula flap about once more in a climactic battle; the only winner here is a mysterious figure who takes

possession of Dracula's ring (*not* Joe Dallesandro) and a vial of the disintegrated Count's ashes. Like an embarrassing relative that the family tries to ignore, the studio was already in a downward spiral, and the opening of this film looks the same as its predecessors, safe in cosy Hammerland. But before the producers can offer soothing words like "it's okay, come in… nothing unusual here" the titles and theme song (complete with horn section) burst in on the action: Planes! Motorways! London! A red bus! Never more blatantly have Hammer tried to kick out the jams. This is no place for stuffy Victorians. In this buzzing metropolitan hive live the gang, lead by cool Johnny Alucard. Whatever the rest of young London is doing, this bunch of Chelsea rejects get their kicks gatecrashing upper-class drinks parties where — strangely — indescribable bands such as Stoneground make their living. Beyond these self-proclaimed freaks, it's the formally-attired middle-aged guests who look more sinister. Extras from a Dennis Wheatley novel, they watch in silent terror as

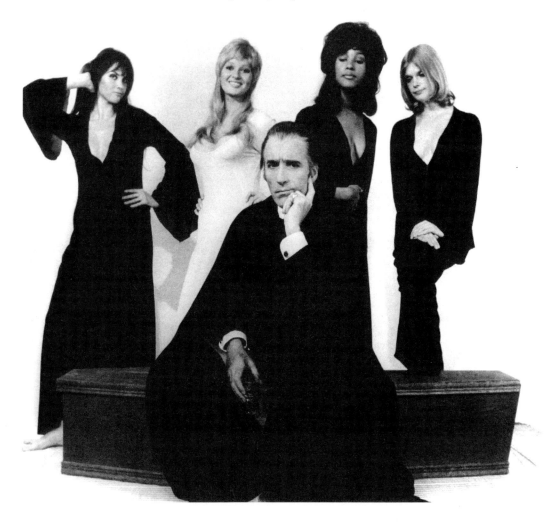

Fangs ain't what they used to be — Dracula ignores the Mini Girls: Christopher Lee and (left to right) Caroline Munro, Stephanie Beacham, Marsha Hunt, Janet Key. A publicity shot for *Dracula A.D. 1972*.

A Couple of Bad Trips

35

Laura (Caroline Munro) turns heads in *Dracula A.D.1972*, while Johnny (Christopher Neame) looks skew-whiff.

the gang play their delinquent acts: dancing on furniture, drinking, painting mirrors, getting off with the daughters of society. There's even a couple snogging under a table, though, true to the spirit of the time (free sex, as and when you want it), the girl acts bored and nibbles at an apple. Johnny (Christopher Neame), in his velvet suit, ruffled shirt and wide-brimmed hat, acts the dandy from a previous century, which he most definitely is. Looking very much like a chubby Sting, he's still infinitely cooler than the rest of his gang, which include wide-eyed, pig-tailed Jessica (Stephanie Beacham) and her boyfriend Rob (Philip Miller); prerequisite afro'd black chick Gaynor (Marsha Hunt); raven-haired Laura (Caroline Munro); and wanker in a monk's get-up, Joe (William Ellis). Self-confident in their strange kind of rebellion,

they smugly debate how long it'll take for the police to arrive, and disappear before the fuzz get a chance to smash their groovy heads in.

This gang communicate in a series of incomplete sentences peppered with words like 'gig', 'jazz' and 'kicks'. They consume soft drinks and coffee at the Cavern (their club), where the current topic is always what to do next, for kicks. Like Mike Roscoe in *The Sorcerers*, they seem to teeter constantly on the brink of boredom, and the only thought given to every suggestion is whether it sounds exciting enough. When Johnny suggests a spot of black magic, the replies are "Hey, but it sounds wild!", "Black mass and that sort of jazz", without a moment's thought for the implications of such an act. Bizarrely, although they are nowhere near the ages they are supposed to represent, these cinematic children act in a manner that *suggests* youth, if nothing else. They aren't just thirty-one-year-old delinquents in too-tight slacks (either that or they have grand powers of hypnotism). All, that is, except Joe, a man who acts like Robert Powell let off the cross; a man who is just dying to scream "I'm *really* weird!":

> But if we do get to summon up the big daddy with the horns and the tail, he brings his own liquor, his own bird and his own pot.

A quip for every occasion. Unfortunately, in this film, Satan neglects to bring his own disembowelling equipment, and Joe lives to be weird another day.

Although she looks the part, Jessica appears to be the one most distanced from the rest of the gang. She's the innocent, hanging out with the in-crowd, but sensible enough to know when to stop. She isn't too sure about the Black Mass, a definite sign that disaster is imminent. Maybe it's her heritage: her grandfather is Professor Van Helsing, which means Peter Cushing is around — cast out of his time again — with the knowledge and library and common sense to defeat whatever evil lays ahead. There are other things he knows, as well:

> It seems to me [*he tells Jessica*] that you delight in deriding anything that is not on your particular wave-length.

Eternally wise, Cushing sums up the attitude of the gang in one sentence. But who's going to listen to such a dusty old relic when there's *fun* to be had?

The Mass takes place in a soon-to-be demolished church, unhallowed ground. For Mass read: Hammer's concession to a psychedelic moment. All seven of the gang sit round a pentangle, hands linked, while Johnny — robed and in charge — starts the proceedings. With taped music and collective swaying and closed eyes, it's not so much a devilish rite as Satanic yoga. Johnny screams at them to dig the music: "let it *floooowww* into you." Apparently

turned on, Jessica and Rob kiss, which leads Johnny to lech: *"that's it*, now you've got it together!"

Unconsciously, Johnny desires the status of a rock star. He yells "I demand an audience with his Satanic Majesty!" and then, thinking ahead to the groupie quota, beckons Jessica towards the altar. Far too sensible, she refuses. But black-robed Laura has by this point got well into it; wildly orgasmic, she doesn't possess the stick that Jessica apparently has rammed up her arse...

"By the 6,000 terrors of Hell!" When Johnny gets his switchblade out, things turn serious. A blood-and-Dracula-ash-mix spills from a goblet onto Laura's pumping chest, the horn-led music starts up, the gang get out of there. Crying like a girl, Laura becomes the resurrected Count's (Christopher Lee) first victim. The gang's wishes for 'kicks' are purely cosmetic. They don't want to go that far. "The gig'll be a kick and all that jazz." Words, just words. All mouth and no (wide) trousers.

Now they have a far-out moment that will last them forever. Laura is dead but life goes on. Unable to tempt Jessica to an Albert Hall Jazz Spectacular, Johnny settles for Gaynor as the next victim (perpetually innocent, Jessica wears her mindset on her sleeve, through iron-on 'Have A Nice Day' patches and a peculiar Heidi outfit). Finding Laura's body, the police make reference to cult murders in the United States — presumably its very own Dracula, Charles Manson. But Charlie and Johnny are a million miles apart. The former masked his real intentions (drilling as many hippie holes as possible) with druggy philosophy, cheap sci-fi and pop music; despite looking the part, the best Johnny can do is a surname like Alucard. Just in case any idiot doesn't get it, Cushing — ever practical — writes out 'Dracula' and 'Alucard' and then links the names up (he later tells a detective what we have already seen, just to empathise the diabolic link).[1] Vampirised by the Count, Johnny picks off stoned Gaynor, a girl in a laundrette, and turns Jessica's boyfriend Rob into one of the new gang. He's offering new trips for old, all to the chords of a substandard 'Shaft' rip-off.

Like Mike Roscoe, and disco vampire Keith in *Scream and Scream Again*, Johnny has an older (unhip) controller behind him. But Christopher Lee's Count, no doubt tired from over a decade of arsing about in freezing castles, appears reluctant to actually go into Chelsea and chase the mini girls.[2] Comfortable with the arena he knows best, he lurks in the derelict church waiting for Johnny to *bring* him victims. An agoraphobic vampire, or just lazy? Typical of many raised in the provinces, there is a fear in him of big cities. Either that, or he's simply afraid of the put-downs that will inevitably come from meeting people like monky prick Joe ("blood-sucking freak, daddio!" Etc.).

This is Hammer's world, however, and so the enticing prospect of vampire Johnny sucking the life out of trendy London in a way never before seen disintegrates quicker than the man himself dying under the running water of his shower, screeching like a petulant child. Johnny is destroyed in his Bohemian

1. You haven't really lived until you've heard Peter Cushing pronounce the name "Johnny Alucard".

2. Cushing also shows signs of unease in Chelsea A.D.1972. Running through its streets at the climax of the film, he looks terrified by the modern world around him.

apartment by no-nonsense Van Helsing, who can now get on with the job he has come to accept in such films. The young, trendy bloodsuckers have no place in his Good vs Evil universe. Any attempts to steer the film away from Hammerland have failed.

Innocent equals virgin and, like so many before her, Jessica is the juicy prize to be fought over. By now we want skin. Abducted by Alucard and taken to Dracula's hiding place, Jessica is laid out on the church altar, dressed in a flowing, skin-tight white dress; its low-cut neckline her most rebellious act in the whole film. The protective movements of Van Helsing make her breasts ripple softly. No wonder Dracula gets a steaming hand when he gropes for them (he pretends he's reaching for the crucifix around her neck, but we know better). At the end, the party really is over for Jessica, with her boyfriend dead, and the realisation that trivial fun-seeking can result in life-threatening danger. Such acts show her the errors of living a carefree life, of indulging in decadent acts like Black Masses for kicks and all that sort of jazz. No doubt after this she reverts to the good girl she really is, retreating with her grandfather to the warm confines of libraries and afternoon tea, leaving far behind the gate-crashing, coffee bars and strange language of celluloid youth. But most of all disruptive rebels like Johnny Alucard and his dangerous intentions.

"I'm determined to fit in."

Performance

CHAS, an East-End gangster, lives a life of rough sex and casual violence until the firm he works for decide to lean on a bookie owned by an old friend, Joey Maddocks. After disobeying orders from his boss, Chas is attacked by Joey and a couple of cronies, which results in him shooting Joey dead.

Chas goes on the run and, through an overheard conversation, rents a room in a Notting Hill Gate residence owned by Turner, a rock star past his prime. Turner lives a reclusive lifestyle with two girls, Pherber and Lucy, and appears to have lost any talent he might once have had, but he realises that Chas is as much a performer as him. The four fall into a long session of drug-taking and sex, until Chas' firm catch up with him. Before he is taken away, Chas shoots Turner in the head and, as he is driven off, it is clear that these two performers have merged.

Performance is supposed to be a film of two halves, where opposing worlds of besuited gangsters and stoned rock stars clash. One's uptight, the other's loose. But it's clear from the beginning that all the real danger is stacked in Chas' world, and woe betide anyone foolish enough to muck about with it. This East End gangsterville is dominated by bodybuilding, stinging violence, sweaty homosexuality and blind hypocrisy, and for a while, Chas is reigning prince ("I am a *bullet*"). His sharp lifestyle is reflected in the narcissistic mirrors that pepper his precision-ordered flat. The first forty minutes of the film

comes on like *Get Carter* directed by a hot young director of the day, someone like Donald Cammell or Nicholas Roeg perhaps. To an audience of outsiders, Chas' life seems weird enough, but the film's directors want to make it weirder. For some reason, they don't see their gangsters as strange, feeling the need to pour on the hallucinogenics and shove Chas into an arena where hip young things can sneer "you're square".

Preoccupied — seduced even — by Turner's way of life, Cammell and Roeg don't recognise the strange London outside the walls of their rock star's castle. In this city gangsters read Jorge Luis Borges[3] while Chas' boss holds meetings in bed, with homo skin mags scattered about and a young plaything lurking in the bathroom. In this city the hidden depths are so vast that a simple statement such as "I'm not one of those" hints at a past that wants to be forgotten; it's a man's man's world where Chas can admire himself in a mirror whilst receiving a blow-job. There is order, but it's a violent one. And no-one paid to watch this fast-edit gangster show take up all of the running time; it's not a typical example of the era, is it? Where is the psychedelic trip, and when can we join in?

Things get pop-culture freaky approximately forty minutes into the film when Chas goes on the run. He crosses over the Thames into North London and a happening scene that

What a *Performance*! Top: Mick Jagger as Turner. Above: James Fox as Chas, becoming acquainted with Lucy (Michèle Breton).

has already happened. People are bored, new kicks are ready to be teased out by those equipped with the right psychological make-up: self-confidence, self-centredness, arrogance. When Chas (James Fox) is finally let in to Turner's (Mick Jagger) decaying mansion, he's closing the door on the outside world, his world, and letting himself in for unknown experiences. You'd think the way he's 'disguised' himself — suit and tied-up mac, hair dye taken from a tin of red paint — would leave his new landlords speechless and wary; but no, they're far too conscious of *not* appearing conscious. The only thing they're wary of is blowing their cool. In a telephone conversation to his outside con-

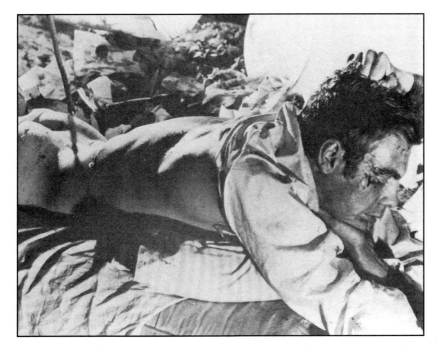

Chas, severely beaten in the early part of *Performance*.

nection, Chas paints an accurate picture of 81 Powers Square, Notting Hill Gate:

> What a freak show... it's a right pisshole. Long hair. Beatniks. Druggers. Free love...

In a burning-out decade, this collection of psychedelic moments has to stay cooped up. Turner, Pherber (Anita Pallenberg) and Lucy (Michèle Breton) run (or rather *shuffle*) wild in their own private universe, with its Eastern-style red boudoir, and bath, and bed, that invite free-for-alls. For the purposes of description, Turner *is* Mick Jagger, a long-haired stick insect in flowing robes,[4] lording it up over the European *ménage*: blonde, feminine Pherber, who sticks needles into her nice arse and is infuriatingly, enigmatically French; and androgynous Lucy, a flat-chested whiner from the same country who can't even fit two plugs together. Add to this the annoying urchin child of an unseen cleaning lady, and you wonder why Chas doesn't shoot them all within a few hours of arriving. Turner may make grand allusions to Chas' role in his playground, especially when they feed him a dose of mushrooms:

> I just wanna go in there, Chas. Y'see, the blood of this vegetable is boring a hole. This second hole is penetrating the whole of your face, the skull of your bone...

But really all this freaky threesome are doing is obtaining a superior high

3. Borges was co-director Cammell's favourite author, and a copy of one of his books works its way through a number of hands throughout the film.

4. Face to face, Chas makes a prophetic remark about Turner's appearance: "Comical little geezer. You'll look funny when you're fifty."

A Couple of Bad Trips 41

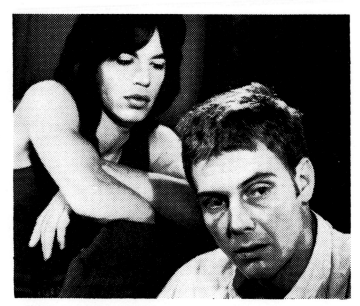

MICK JAGGER, playing a retired rock music star who shares his house with Anita Pallenberg and Michèle Breton, confronts murderer JAMES FOX in Warner Bros.' controversial drama, "Performance," which opens in Technicolor on.at the.Theatre.

through getting the straight stoned. Chas should have stuck to his original getaway plan and gone down to Devon. What decadence means in *Performance* is being trapped in an enclosed space with Turner, Pherber and Lucy, and having to suffer the consequences of their ramblings: the film should have been renamed *Purgatory*, as it's some kind of endurance test to sit through conversations such as this:

TURNER: A fly!
LUCY: A fly?
TURNER: In my eye. Why?
PHERBER: Because you are afraid of him.
TURNER: Yeeesss. Riiiggtt. Right

Hell is not just other people. Hell is other *stoned* people. Chas appears to be aware of this on his first meeting with Turner, who has already told him that he "wouldn't fit in here". To the background noise of 'Wake Up Nigger' by The Last Poets, Chas stumbles through a badly-constructed alibi: he's a juggler (perhaps the most far-out profession he thinks is closest to Rock Star), but when Turner goes off on a microphone-led History of Juggling rant, Chas looks less than impressed, and you can see his tolerance level dropping, as his eyes gleam with the delights of giving this free-love beatnik a good kicking. At

Psychedelic Decadence

this point the audience is right behind him. But we can switch off. Poor Chas is trapped until his fake passport arrives, sentenced to indefinite time in a departed hipster's basement room, while outside roam a bunch of mushroom pickers: outside, where Chas cannot venture…

Performance's psychedelia is pretty straightforward: grab someone non-scene, dose them up, and then watch the bad trip emerge while your own superiority kicks in. Up until this new experience, the way Chas liked his mushrooms was fried; now his mental defences are helpless against them ("we sat through your act, now you're gonna sit through ours"). He's manipulated, dressed up in gowns and made-up, has a wig put on, while — as were the preoccupations of rock stars of the time — Turner rambles on about Persian bandits and Hassan I Sabbah, the Old Man of the Mountain. What with being surrounded by lit candles and mosaic tables and Turner and Pherber, no wonder little cracks begin to appear in Chas' hallucinations, reversions to his gangster persona through flashes of stares and sadistic grins, warnings to his hosts not to push him too far.

Their world may be alien territory to Chas ("… he's weird. And you're weird. You're kinky"), but there's nothing dangerous about Turner. The only weapons he has are chemical highs and too much hip experience in too few years. Chas carries a gun, he is a bullet, and it's only a matter of time until he uses *his* experience on Turner, and shoots him through the skull. The fatal journey ends with shattering glass and a picture of Borges.[5] The reclusive pop star's lost his creative demon, so it's up to another performer to put him out of his misery. Turner only stalks the dark edges when he sings, and he only sings when he invades Chas' addled mind, giving us a touch of why he was once so popular.

Bewigged and bloused up, Chas wanders into a 'recording studio' with a mirrored ceiling, guarded by four giant white speakers; Turner's there, and Lucy, snaking along to the mongrel blues/rock music, the beginnings of 'Memo From Turner'.[6] Chas shakes to the vibrations, but somehow it's like watching your (homicidal) uncle dance: as in, I'll do this for a minute then be accepted. In the end the noise wins and freaks Chas out. It's either that or being taunted with a fluo-

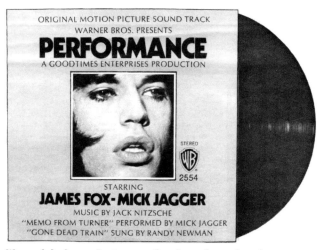

Warner's independent promotional men have already started a massive campaign with radio, record stores, reviewers, advertising media. Performance is the strongest soundtrack since Woodstock.

5. Donald Cammell — one of those breed of artists whose lives are just as, if not more, interesting than their art — killed himself in much the same way in 1996. For more enlightenment seek out Chris Rodley and Kevin Macdonald's documentary *Donald Cammell: The Ultimate Performance* (1998).

6. Which itself sounds uncannily like the first moments of 'Don't Sit Down', a too-short 1969 David Bowie composition.

A Couple of Bad Trips 43

rescent tube by Turner. When 'Memo From Turner' kicks in proper — literally inside Chas' head — he's back on familiar ground (his boss's office: bullets and muscle mags scattered on a desk), albeit with a gangstered-up Turner calling the shots now. Besuited again, Chas watches unimpressed as Turner sings and his ex-colleagues get naked and flowing to the music, like overweight rock festival babies. Turner has achieved the aim of the with-it hipster: to suck the stiffness out of the suits, to obliterate the uptight, the straight. This is fantasy music video land. In Chas' reality, he would have killed Turner in an instant for allowing him to pull so many guards down.

That happens, of course, along with the apparent merging of Chas and Turner, two characters different yet with similar agendas. Before that, however, Chas has to suffer the consequences of his bad trip. It's not enough to wake up in bed with Turner (or does he? Split-second frames play now-you-see-them, now-you-don't games). Or is it Lucy? Which is worse? Spat out the mangler, the result is a passport photo produced under the influence: make-up, itchy-looking wig and smoking jacket, a beatnik for the next ten years. Chas' gangster friends are giving him an easier exit, better to die than have to maintain such an image every time he travels abroad. Confused? In the end it's an innocuous forged note left for Lucy that ties it all up: 'Gone to Persia' is all that it says — my God! He really has turned into Jagger…

DRACULA A.D.1972 vs *Performance*. Who wins in the psychedelic stakes? The latter would like you to think that it was the more credible, the more realistic, whilst dismissing the former as bandwagon-jumping, naïve and exploitative: a bunch of suits pretending to know the kids and their wicked, wicked ways. But compared to the living, breathing irritants of *Dracula*, Jagger and his merry gang come across as old hags already, bloated on their druggy knowledge and experience. What would happen if Johnny Alucard and Co. tried to crash Turner's party? Who would call the police then? Both these trips are as bad as each other. You wouldn't want to be stuck in Powers Square any more than you'd hang around for the climax of Johnny's black magic ritual (despite the presence of chicks like Jessica and Laura). And yet both films could be screened for outsiders to the capital, to enhance their impressions of London: *Dracula* as in-flight movie, welcoming the rest of the world to a city still draped in Victoriana but trying to party its way out of it; *Performance* as moral warning to the rest of England — this is what happens when you fuck about with X, Y and Z. In the end they are a perfect double-bill to warn against the dangers of unknown forces, be it Count Dracula or Mick Jagger prancing in a leotard.

The Man in the White Suit

Conformity
Suburbia
JG Ballard

> … the 1960s had effortlessly turned the tables on reality. The media landscape had sealed a technicolour umbrella around the planet, and then redefined reality as itself.
> —*The Kindness of Women*

WHAT makes a rebel? Unfortunately, face-values still rule ninety-nine per cent of the time, but sometimes the conventional is the key to hidden depths. The great shame is that judgement occurs in the blink of an eye, and more often than not it is the beholder's loss. Those in the know can see outward and inward appearances merging into one glorious whole. Take the late (and greatly missed) William Seward Burroughs: 'formal as an undertaker in his natty suit'.[1] Burroughs' smart attire (practical smart rather than say, Tom Wolfe dandy smart) did little to mark him out as a face in the crowd…

intentional, as Burroughs always wanted to be 'el hombre invisible'. If to the general populace he was a laconic southern gent, to his admirers Burroughs was the private detective to the Interzone, the aged — and ageless — 1950s dick filing reports back to his clients: the readers. Burroughs' sober appearance made this possible, triggering image association that stuck to him like a Siamese twin: heroin, insects, teenage boys and Tangiers. Now take JG Ballard: cars, technological breakdown, clinical sex and Shepperton, a town on the Thames some fifteen miles west of London. Like Burroughs, Ballard's novels and short stories conjure up a renegade writer living his life of words, a sane voice amongst the mad documenting the disintegration of the twentieth-century. But again, appearances can be deceptive. Both outwardly conventional, where the two differ is that Burroughs' books were his life, and his life was in his books. Ballard has always maintained separate tracks for his writing and private lives, although this conjures up more association: the writer and single-parent raising children amongst the middle-income professionals, casting a surrealist eye over his surroundings...

In the 1960s, Ballard was such a figure, with the looks of an architect or doctor, but with an imaginative life that would make most physicians choke on their cocktails. Where better to begin observing him than in that metamorphosising decade. We can view his life as interesting as his work, a story that travels in tandem, and makes for a fascinating, honest and ingenious read in *Empire of the Sun* (1984) and, especially, *The Kindness of Women* (1991).[2] Here is a man deep in the cultural unravellings of that decade, near enough to London to witness the art, music, drug and sexual explosions but at such a removed distance as to cast an outsider's eye over it all (Ballard has famously said that he watched the entire 1960s on television). Happily restricted by family, an enthusiastic suburbanite,[3] Ballard still emerges as one of the weirdest figures of that particular 'revolution': a courteous and energetically interested man, whose one debt to intoxication is early morning whiskey-and-sodas.[4] In *The Kindness of Women* the fictionalised Jim Ballard is constantly berated by friends for not attaining some element of hipness; but again, like Burroughs, his readers know better. His image in the mid-sixties is of a renegade maths teacher with hidden, darker depths.

The classic *image* of Ballard utilises the duality of separate personalities: the family man, and then the writer, creating his science fiction worlds — and later mind-fucks such as *The Atrocity Exhibition* and *Crash* — while the kids are at school. Although in many ways the two men were very different, Ballard and Burroughs both shared a link through the sudden death of a spouse. Burroughs chose to write his way out of the black hole, pursued by what he called the 'ugly spirit'. Though he might deny it, Ballard's fiction around the time of his own personal loss suggests that time moves forward and stops for nothing: *The Crystal World* (1966) is a colourful hymn to the unstoppable forces of change, and a key book in the Way Forward. One of Ballard's group

1. JG Ballard's description of Burroughs sighted at an open-air festival, from *The Kindness of Women*.

2. "'It's based on my life, but it's my life seen through the mirror of the fiction prompted by that life — if that makes any sense.'" Ballard interviewed by David Pringle in *SFX* 9, February 1996.

3. Martin Amis: 'A friend of my father's, he would show up fairly often — affable, excitable, and noisy.' From *Visiting Mrs Nabokov and Other Excursions* (Jonathan Cape, 1993).

4. Ballard's brush with the mandatory hallucinogenic experience came with a single LSD 'experiment'. It is detailed in Chapter 10 of *The Kindness of Women* ('The Kingdom of Light'), and serves as the basis for his Messianic 1979 novel *The Unlimited Dream Company*.

5. Republished as *The Venus Hunters* in 1980.

6. "It's not the evil potion in a dusty bell-jar that frightens us now, it's the contents of the hypodermic syringe, and the needle that may not be too clean. The props have changed." Ballard interviewed by David Pringle in *Fear*, February 1990.

of literal disaster novels, where the title explains everything (*The Drowned World*, *The Wind from Nowhere*), it reads like Joseph Conrad on acid, highly appropriate given the chemical adventurers around at the time. Like other works (such as the short story 'Storm-bird, Storm-dreamer', from *The Disaster Area*) it is concerned not so much with the event as with acts *after* the event: the examination of character psychology under the strain of freak changes. As a part of West Africa is slowly and irreversibly crystallised, and time condenses like ice, Ballard's protagonist Sanders reaches the state of mind most favoured by his creator: the acceptance of change, and the ability to live on knowing that what has gone before will never return. Within this landscape, with its bejewelled crocodiles and helicopters, there is a sense of Ballard writing the way forward for his own life.

Until the 1970s, the way forward was primarily short fiction, with five collections between 1966–1973. At the time, Ballard was recognised almost exclusively as a writer of short stories, one of the science fiction new wave (such as Michael Moorcock and Brian Aldiss) who drew attention to the dead-end naval explorations of 'serious' literature. With a headful of the classics, these adventurous writers chose a path away from the rocketship pulp that HG Wells had unwittingly unleashed. But strangely, what could be considered Ballard's 'straight' science-fiction writing (if we can categorise straight sci-fi as involving other-world situations and technologically-enhanced futures) is his most unmoving work; it feels like a writer treading water, and halfway through any given short story you long for another tale of the breakdown of a film editor, or some other urban psychosis writ large. This is not to say that Ballard's science fiction is sub-standard to his other writings, some stray towards prediction that was the genre's forte ('The Concentration City', for instance, dates from 1957 and pre-empts by twenty-five years or so the themes — the dreams of flight from a suffocating metropolis — of Terry Gilliam's *Brazil*), but the stories that remain in the mind are those that veer off the New Wave track, into territory previously uncharted: Edgar Allan Poe armed only with the map to inner space ('Now: Zero' and 'Track 12' — both from *The Overloaded Man*[5] — suggest slivers of Poe or Lovecraft, short bursts of psychological horror quite separate from most of the other stories.[6])

Ballard himself was — naturally — one step removed from the literary group he was part of, due to an accident of birth (he was born in Shanghai in 1930, and did not enter England until 1946, by which time he had experienced three years in a Japanese prison camp) and a unique writer's influence: the surrealist painters (Dalí, Ernst, Magritte). Both combine to make a peculiar

outsider's view. A regular writer of non-fiction for *New Worlds*,[7] we can see what influenced and bled into his writing through articles he produced at the time: Salvador Dalí, *Mein Kampf*, sexual instruction manuals, Ralph Nader, and the necessity of the car;[8] such subjects had — mainly — no critical respectability at the time, but they were obviously fuel to Ballard's imagination, crucial documents of the twentieth-century. Hence a story such as 'The Day of Forever' (from the 1967 collection of the same name) has characters wandering through a blend of Dalí's most famous painting, *The Persistence of Memory* and Jean Cocteau's 1950 film *Orphée*: fused sand and sinister figures, ethereal refugees from a Poe story.[9] Unlike Burroughs, Ballard's imagination was not sewn into his appearance and actions, and you had to dig deeper to find the ideas that form his stories. Perhaps his bourgeoisie appearance guides him in utilising high-income professionals as his characters: psychiatrists, doctors and media producers are particular favourites, and Ballard delights in informing us that these peoples lives are just inches from collapsing. It's these situations that are most returned to. Maybe Ballard's disappointment upon returning to an 'empire' that was smaller than the country he had grown up in enhanced some kind of sadistic glee in destroying these affluent, comfortable lives. That it was not an urban terrorist achieving this but a father of three operating from a semi-detached headquarters makes it all the more enticing; a very unique way of taking a chain-saw to a literary tea-party...

Apocalypse IF *THE Crystal World* mapped the way forward for Ballard, then *The Atrocity Exhibition* (1970), was the starting point, the base, for the bleak works that populated the next decade: harsh visions of an England ruled by sharp concrete angles and disaffected minds. This is the nearest Ballard has come to the style of Burroughs and, like that author's own *Exterminator!*, *The Atrocity Exhibition* is a collection of short stories masquerading as a novel. And vice versa. It is a breeding ground for subsequent works, most significantly an embryo for *Crash*, amongst others. The solar deserts and lost buildings of the author's past fuse with real people and events. The seventeen chapters offer classic Ballard titles ('The University of Death'. 'The Summer Cannibals') or bold statements ('Plan for the Assassination of Jacqueline Kennedy',

'Why I Want to Fuck Ronald Reagan'), and then separate into paragraphs with their own headings. The effect is not unlike flicking through TV channels at high speed, blips of multiple worlds, slices of Burroughsian cut-ups:

> Optimum child-mutilation film. Using assembly kits of atrocity photographs, groups of housewives, students and psychotic patients selected the optimum child-torture victim. Rape and napalm burns remained constant preoccupations, and a wound profile of maximum arousal was constructed.

And throughout the book, like Burroughs, there is a sense of Ballard writing his way out of his imagination, expanding further into the mind, so that even a genre such as science fiction can place no constraints on him. All human deviance is here, a re-mapping of the twentieth-century's most violent acts.

To offer a coherent synopsis would be useless, and to be honest, *The Atrocity Exhibition* is possibly Ballard's most impenetrable work, a book to admire rather than devour; an important work rather than his most enjoyable. Ever the enthusiastic participant in controversy, Ballard's chapters offer provocative challenges to the moral majority, direct attacks that the author has no intention of playing down. The 'Why I Want To Fuck Ronald Reagan' chapter was published as a booklet by Brighton-based Unicorn Bookshop in 1968, and was included in items seized in a police raid and subsequent trial:

> Preparing me, the defence lawyer asked me why I believed [the booklet] was not obscene, to which I had to reply that of course it was obscene, and intended to be so.[10]

Ballard's honesty is uniquely disarming. *The Atrocity Exhibition* is just that: the car-crash for rubberneckers, the unforgettable event never to be repeated. However, its value was doubled some twenty years after its first publication when North American publishers RE/Search brought out an edition of the book with comprehensive annotations by the author himself. Intended primarily as guides for the reader, these notes could make a book in

7. Which Michael Moorcock edited between 1964 and 1971.

8. These subjects (most of which were published in *New Worlds*) can be found — along with many others — in *A User's Guide to the Millennium* (1996), a selection of Ballard's non-fiction.

9. Ballard has cited Cocteau's film as an influence on his 1973 short story collection *Vermilion Sands*.

10. Annotation from the 1993 Flamingo edition.

themselves: they throw up a whole host of influences, anecdotes and ideas ('During the Apollo flights I half-hoped that one of the spacecraft would return with an extra crew-man on board, wholly accepted by the others, who would shield him from a prying world') that could be the basis of ten further novels. They also serve to show that, throughout his career, Ballard has always been an engaging interviewee,[11] prone to outbursts of ideas thrown away in the print that other authors would treasure and copyright. Read in its updated form, *The Atrocity Exhibition* is the perfect example of Ballard's two separate worlds of imagination and reality colliding.

Vaughan died yesterday in his last car-crash

SCEPTICS who scoff at Ballard's claims that *Crash* (1973) is the ultimate marriage of sex and technology should look no further than the author's own experiments in that area. In 1969 Ballard — ever willing to move in avant-garde circles that less adventurous authors would avoid — staged an exhibition of wreaked cars in a London gallery. The opening night descended into drunken chaos, and subsequent visitors reacted aggressively to these specifically chosen metal coffins. These events convinced Ballard that he had witnessed cracks in the collective psyche.

Crash is the rubbernecker syndrome taken to extremes, its participants being all the more honest for confronting directly a form of death that is literally seconds away for thousands of people each day. But the book needs the right kind of guide, and here Ballard introduces his most enduring character-type, a sort of Pied Piper of psychopathology. In *Crash*, it is Vaughan: the 'hoodlum scientist'. He makes his debut amongst the many images of *The Atrocity Exhibition*, a ghostly presence in a leather flying jacket; Vaughan is a dangerous beacon for the professional people of Ballard's novels. The template for his type can be found in earlier stories[12] (such as 'The Encounter' from *The Overloaded Man*) and continues into later novels. But where Ballard can cast his professionals as renegades — as with the psychiatrists/psychologists of the stories 'The Man on the 99th Floor' and 'The Insane Ones' (both from *The Day of Forever*), where patients become pawns and psychiatry assumes a role similar to backstreet abortion clinics — characters such as Vaughan are driven by obsessions that make sense only to themselves. He draws James and Catherine Ballard into his world in *Crash*, but his scars and zoom-lens photos and endless prowls of London's airport car parks are mere accessories to a main goal: here it is to die in a car crash with Elizabeth Taylor. Like a psychopathic libertine Vaughan weaves through the characters' lives in the novel, but Ballard never uses quirks of character or useless accessories to make Vaughan enticing; effective symbols they may be, but the flying jacket and stained jeans hang limply on his frame. Vaughan's dangerously seductive nature stems from his other-worldliness, his single-minded pursuit of the goal. Such a personality is heightened when let loose amongst the TV producers and advertising executives of Ballard's novels, lives built on nothing more

11. Two of the most comprehensive Ballard interviews can be found in Vale and Juno's *RE/Search 8/9: JG Ballard* (RE/Search Publications, 1984) and Will Self's collection of interviews and essays, *Junk Mail* (Bloomsbury, 1995).

12. Strangely, the first chapter of *Crash* reads like a self-contained short story.

The Man in the White Suit

than material gain. Vaughan is there to remind them that their hi-fi systems and modish mini-bars are no protection from the breakdown of society, and would cease to be useful once such an event occurs.[13] Vaughan is the maniac on the suburban doorstep who won't go away, the staring individual on the street, the man who only sees you when he needs to use you.

> Soon after three o'clock on the afternoon of April 22nd 1973, a 35-year-old architect named Robert Maitland was driving down the high-speed exit lane of the Westway interchange in central London.

If *Crash* introduced anything new to Ballard's style then it was a sense of emotional sparsity, a detached view of the world. This is the twin of the state of mind introduced in *The Crystal World*, a scaled-down emotional response to those earlier disasters. If the characters in those novels came to embrace the catastrophic changes around them, the participants of the technological nightmares that were Ballard's novels in the 1970s never flinch when faced with smaller-scale atrocities...

An underlying fear in modern life is that routine — that almost unconscious undertaking of events — will be rudely interrupted. In Ballard's novels routine is a precarious tightrope, and the message is: "take nothing for granted". Robert Maitland's routine is drastically interrupted in *Concrete Island* (1974). The drive home from his London office is halted irreversibly when a tyre blows and he crashes off the road and down an embankment. The large, triangular stretch of waste ground — severed on all three sides by slices of motorway or high fences — becomes Maitland's prison and then his home. This is the classic Ballard arc of change: initial anger at such a situation subsides into abandonment, then grudging acceptance, then renewed vigour hiding the unchangeable acceptance of fate, where the grandest of plans are put off until tomorrow. But, like Crusoe, Maitland finds that he is not alone, and has intruded on someone else's habitat. The island's other inhabitants are Jane Sheppard — a vagrant prostitute — and Proctor, a mute ex-circus acrobat. Every further exploration of the island by Maitland uncovers another discovery: about himself, about the other residents; for all his attempts to escape, Maitland realises that he does not *want* to leave. At the close of the book, when he is left alone, Maitland is finally in absolute power over his island:

> Already he felt no real need to leave the island, and this alone confirmed that he had established his dominion over it.

Removed from the anonymity of a city to a more feral environment, Maitland is king of all he sees. We know that this man has found his true home on that stretch of waste ground, and will stay there until he dies, a wild

13. 'Options multiply around us, and we live in an almost infantile world where any demand, any possibility, whether for life-styles, travel, sexual roles and identities, can be satisfied instantly.' From the new introduction of the 1995 Vintage edition of *Crash*.

14. Coincidence or not, but halfway through a first reading of *The Final Programme* I was reminded of author David Britton's own malevolent creation, Lord Horror.

figure existing only in passing drivers' peripheral vision.

Concrete Island's bizarre landscape hides simple messages: those abandoned on the island have been abandoned by society, the vehicles drive by so fast as to ignore them, or pretend to; but while Robert Maitland, Jane Sheppard and Proctor live on their microcosmic world, hundreds of other Robert Maitlands pass by on the roads above, unaware that their displacement from society is — here at least — literally feet away. If *Crash* is characters running mad in their own precarious society, then *Concrete Island* — and *High-Rise* after it — is the unstoppable collapse, the beginning of personal descent; moral: don't ignore those who have been forced out, because one day it could be you.

An allegorical warning, but Ballard also colours it with a certain amount of enticement for such life-changing events. Maitland is a London businessman who is now master of his own island, and who amongst the ant-like hordes has not dreamt of "getting away from it all", free from income tax and job pressure and other trials of modern society? People plan their vacations with meticulous detail in order to do what? Relax. Spend two weeks on a beach doing nothing, answerable to no-one. The desert island is the Xanadu of the twentieth-century, a clean haven for the white-collar worker. The commuters search to places abroad to find their slices of paradise, but the island waiting for Maitland has been within sight every day of his working life.

IF BALLARD'S novels take the spine of society as their starting point before running wild, then he seems to be even more displaced in the 1960s when compared to someone such as his friend and contemporary, Michael Moorcock. This writer's 'Jerry Cornelius' quartet (or 'tetralogy' as it is better known) — *The Final Programme*, *A Cure for Cancer*, *The English Assassin* and *The Condition of Muzak* — have no firm anchor in reality; a set, yet each self-contained, they defy any limits placed on the imagination. Compared to Ballard, Moorcock dived headfirst into the cultural stream: long hair, beard and mandatory Hawkwind collaborations his accessories (when it comes to music Ballard has admitted to having a "tin ear"). A massively prolific author of science fiction and fantasy novels, Moorcock's tetralogy mirrors the time they were written in. In Jerry Cornelius — assassin, soldier, musician, fashion guru, party-giver, traveller and sexually ambiguous (anti-)hero[14] — is the perfect guide to the boom industry that was the 1960s. *The Final Programme* (1968) is perhaps the most conventional of the set, concerned as it is with Cornelius' battles/allegiances with the mysterious Miss Brunner and the creation of the 'all-purpose human being': an adventure that begins in Cambodia,

travels through France, London and Sweden, and ends with the lemming-like deaths of masses of followers recruited at a lengthy party in Ladbroke Grove. Conventional in the sense that the chapters are numbered 1, 2, 3. After that, the subsequent books go wild with non-conventional narratives, illustrations, page-short chapters and — most memorable of all — headings taken from myriad publications, from *Guns and Ammo* to *The Observer*. By the time of *The Condition of Muzak* (1977) you are left in no doubt as to what Moorcock has achieved: the opening of the floodgates of the mind. We believe all of what his anti-hero undertakes as we would him simply crossing a road. Cornelius' adventures make you believe that anything in writing is possible, that there are no rules of play, that telling a good, three-act story is not necessarily as important as snapping at the heels of your imagination. It's an unstoppable thing: I have only read the quartet, but by all accounts Moorcock lets Cornelius loose in at least another nine novels,[15] as well as featuring him in pre-tetralogy short stories. This character's presence everywhere echoes words spoken to him by his sister/lover Catherine: "omniscient old Jerry".

Later, as he sat on his balcony eating the dog, Dr Robert Laing reflected on the unusual events that had taken place within this huge apartment building during the previous three months.

Like Moorcock, one of Ballard's greatest weapons is a free mind: free to investigate everything, unrestricted by any moral constraints. In his fiction there is never a moment's hesitation to explore a new area, no matter how dark (and you could argue that once the mind starts stalling for reasons — however small — before leaping in to these places you may as well give up writing). Ballard knows that his characters must come home at some point, and *High-Rise* (1975) is the perfect environment for them to live in. You can imagine James and Catherine Ballard watching the motorway from one of the building's precipice-like balconies, or Robert Maitland driving faster than usual in order to return to his studio apartment and fix

15. *The Complete Book of Science Fiction and Fantasy Lists* (Granada, 1983), edited by Maxim Jakubowski and Malcolm Edwards, lists at least twelve other authors who have used Cornelius in their own stories, poems and comic strips, including Michael Butterworth and Brian Aldiss.

himself a drink. This apartment block is high-tech and self-contained, and all of Ballard's professionals are here, stacked one on top of the other for forty floors:

> The high-rise was a huge machine designed to serve, not the collective body of tenants, but the individual resident in isolation. Its staff of air-conditioning conduits, elevators, garbage-disposal chutes and electrical switching systems provided a never-failing supply of care and attention that a century earlier would have needed an army of tireless servants.

But where other writers would have induced a breakdown aided by rogue technology, the downfall of Ballard's high-rise lies solely with its tenants, a rough mix that includes the renegade Dr Laing (who, with his 'fondness for pre-lunch cocktails, his nude sunbathing on the balcony, and his generally raffish air' is quite possibly modelled on Ballard), the ape-like television producer Richard Wilder, the block's architect Anthony Royal and numerous other high-income types who show that, as well as being the bleakest book in the 'technological breakdown' trilogy, *High-Rise* is run through with sardonic humour; particularly when involving Steele, an orthodontic surgeon, and particularly Laing's fascination with Dr Steele's hair:

> His slim face topped by a centre parting — always an indication to Laing of some odd character strain — pressed ever closer...

And:

> Although he [Steele] was in his late twenties, his manner was already securely middle-aged. Laing found himself fascinated by his immaculate centre parting, almost an orifice.

Ballard relishes these societies within society. The personal disasters of *Crash* and *Concrete Island* are here multiplied a thousandfold, sparked off by absurd, pointless vendettas that are the staple diet of neighbourly living. It is gradually made clear that the high-rise is really a combination of three tiers of tenants: lower, middle and upper class. All within turn their backs on society to roam their concrete nests; cut off from 'routine', their only concerns the

gathering of food and repelling rival gangs, the forty stories become a separate world, a broken-down satellite planet. And in a world without rules, activities that are thought of as taboo in normal society — cannibalism, incest — become the norm. Even the good-humoured Dr Laing ('Within half an hour almost all the women were drunk, a yardstick Laing had long used to measure the success of a party') succumbs to the lure of savagery and decides that he will never leave the high-rise; the demands and desires for a new dishwasher soon become nothing compared to capturing an elevator shaft ...

WITH his characters marooned on urban islands or hidden within high corridors, Ballard shows us that the material aspects of modern life — everything from selecting a coffee filter to dusting the window ledge — are not the skills that will be needed once the precarious shell is broken. Ballard, Maitland and Laing, at first wrapped up in their own professional and personal blankets soon realise, like Sanders in *The Crystal World*, that their lives up to the point of 'disaster' have been a mere rehearsal for what their real achievements should be: death by car crash, the ruling of an island, the hunting of food for the womenfolk. They embrace the change, knowing that it is an unstoppable force; adapt or die has become the evolutionary necessity of the twentieth-century.

And in the end, you remember that the author of these warnings has not been a crazy-eyed Manson figure broadcasting from his tent in the desert, rugged in his own appearance so as to denote his distance from those he rallies against, but a Shepperton father in his early forties, a figure of outwardly bourgeois appearance: the man in the white suit. Returning briefly to *The Kindness of Women* (chapter 9: 'Craze People'), Jim and the children, accompanied by their dervish, child-like friend Sally Mumford, attend a rock festival so that Ballard may undertake a reading to the crowds. Understandably nervous of his presence amongst so much radical chic, so many hostile concept artists ('intense young women... with the intimidating stares of gangsters' molls'), in reality Ballard stands out as the individual:

> Lykiard informed them that I would read a text celebrating the perverse sexuality of President Kennedy's widow, and there was a momentary flicker of interest behind the heavy shades, soon replaced by a stony hostility. Class assumptions and exclusivities survived strongly amid the rock amplifiers and Warholiana.

More radical than the psychedelic crowd around him, Ballard seems to thrive on enthusiasm and honesty, emotions that others — like the fictionalised artists above — feel too cool, too aloof, to display. Look beyond the image! And, to revel in a cliché — albeit an appropriate one for this subject — don't judge a book by it's cover!

Meaty, Beaty, Big and Bouncy

Ingrid Pitt's Breasts

WEIRD shit, one and two. One: advocates of vampirism may well have orgasms over blood and big teeth, but for the rest of the warm-blooded populace, such things are merely tools accompanying the main attraction, namely pale bodies in sexy costumes. Considerably more exciting than getting a mouthful of metallic liquid. Two: the vampiric lifestyle is romantic. Now, there's 'romantic' and there's 'boring'; sit through dull feasts such as *Vampyros Lesbos* — where undead sex-kittens are damned to stalk their dismal arenas accompanied by a soundtrack best described as 'Je T'aime' with an aneurysm — and be persuaded otherwise.

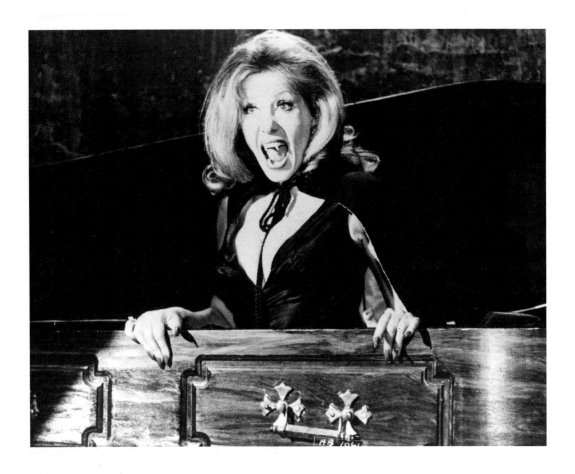

Ingrid Pitt in 'The Haunted Screen' segment of *The House That Dripped Blood* (1970), an Amicus omnibus affair.

The mechanics and purposes of vampiric seduction come a distant second to seeing predatory females with their kit off. It's here that Ingrid Pitt is an exotic advertisement for her kind: an entire body that is a mapped path of lust, wisely distracting the viewer from her acting. Wandering eyes congregate at Ingrid Pitt's breasts, those spherical twins of delight, perfectly poised in a variety of bodices to allow easy access to false-moustachioed actors. Nineteen-seventy was a good year for suitors. In *Countess Dracula* (1970), Ingrid bewitches men and drains women; *The Vampire Lovers* (1970) has victims of both sexes trapped like furry playthings in the headlights ('the headlights' being a dumb euphemism). How could anyone resist?

Ingrid Pitt is a woman out of time. Pre-twentieth-century is no place for her voluptuous form to exist in. As you travel the long journey down the geometry of her curves, you realise that dark castles and sucking the daughters of the rich are habits forced upon her by her surroundings; in the timespan of the world outside Hammer's hermetic studio, Ingrid should be running naked through a grassy field, laughing in Polish, a chain of daisies around her neck, her round breasts bouncing happily. Or perhaps dressed in white leather with

a sports car to match, big 'Jackie O' sunglasses balanced on that compass of a nose, pulling over to pick up a straight-haired, wide-flared hippie girl. How hip would that be?

In *Countess Dracula*, no such freedom awaits Ingrid. She is transported to a world that is not darkest Europe but the circular universe of a home counties film studio. Somewhere outside the papier-mâché boundaries stalk the Ingrid-alikes, in their cars and fields. The prematurely-aged Countess discovers that the blood of snivelling servant girls (and emaciated slaves, and gypsies: virgins all... *gypsies*?) rejuvenates her skin, transforming her into the Ingrid we know: blonde, beautiful, bouncy. When Nigel Green sees her new image for the first time, he kneels and makes the sign of the cross. That's how good the transformation is. Ingrid leaps chest-first into her new roll. No wonder her young lover sucks at a breast (a fleshy dome of delight) with all the enthusiasm of an eager moon explorer. Lucky Sandor Eles would recoil in horror if faced with the Countess's real mammaries, a pair of flaccid fried eggs from the darkest depths of Castle Bathory.

Once again out of place, Ingrid would be better suited to some kind of sex comedy. She is caught naked, unawares, in *Countess Dracula*, but it really needs the attention of a Robin Askwith to mutate it into, say, *Confessions of a Naked Bloodbather*. Green and Eles are unfortunate enough to blunder onto her health regime as she bathes in the red stuff. The camera modestly films from above her pubes as she leans back to scrub a thigh with a large comedy sponge. Those blood-stained breasts stand alert (their medium-sized nipples erect), secured to a reliable rib-cage, acting their hearts out. Off-screen and in the viewers imagination, Sandor Eles gulps and imagines the red trail crawling between them is really his jizz...

Caught in a perfect pose mid-wash, Ingrid could just as well have been emerging from some clear pool on some flowery summer day, her lover watching from the comfort of a Volkswagen perched on the slope above; instead, she has to suffer the scorn of Eles, a man who unfortunately sees further than the superi-

A collection of snaps taken during the making of *The Vampire Lovers* — a film with a title that is really rather stranger than you think.

Meaty, Beaty, Big and Bouncy 59

ority of her tits and curves, and will not turn a blind eye to the methods she uses to keep them. Crazy fucking fool.

The Vampire Lovers (1970) is *Playboy* brought to life. Or rather, vampire wank fodder that flicks Vaseline in your eyes. What better situation is there to establish than dropping swingin' Ingrid Pitt into an eighteenth-century family hotbed? She has slipped down from another century to liven the stiffs up, using her body as a free-love tool with which to gain pleasure. Unsurprisingly, few decline the invitation. It's a full-stop kind of film, combining those two Ingrid qualities: sex and vampirism; pushing them full tilt so that they never, ever have to be utilised again.

Ingrid is having fun here. Scourge of the dusty Hammer elders (Peter Cushing and Douglas Wilmer), she picks off a succession of lovers with the ease of pinching out erect nipples. Mostly women, they fall under the spell of her breasts and undefined sexuality, while the mature male contingent (older and wiser, obviously) can only stand back and fume like cartoon villains. It isn't the bloodsucking that's sexy, it's the implied fucking; the hetero dream of young girls (with emphasis on that drawn-out final 's') developing lusty feelings for the same sex. And who better to be attracted to than Ingrid, with her well-equipped body?

Waiting for the virgin blood to kick in, an aged Pitt in *Countess Dracula*.

The most serious relationship (if you can call it that) to emerge in *The Vampire Lovers* is between Ingrid and Madeleine Smith. Doe-eyed and timid, Smith rivals Ingrid in the chest stakes, so it's a beautiful pairing of pairs. Naked, Ingrid seduces Madeleine on her bed; on top, her breasts push into her latest victim, offering her no options except the softcore one ahead. Like the Ingrid-alike skipping through the fields, the pair indulge in gravity-defying japes by running topless around a bedroom, Ingrid's tits especially firm in anticipation of the delights to come. A pair of secretive teenagers in a closed-off world, it can only be a matter of time until the parents find out and put a stop to it all. But here Ingrid's punishment isn't a grounding or a cut in pocket-money, it's death. Wilmer and Cushing stake her through the heart and then decapitate her. Who really killed the permissive sixties? Ingrid has her head cut off at the climax of *The Vampire Lovers* because the elders — wise but deprived of sex — fear where the strange sensations emitted by their hard-ons will lead them. Best to put a stop to such nonsense: Peter Cushing with a boner? Don't even *think* about it!

The Birds

Confess or Die, Timothy Lea!

> Beneath her long skirt Sam wears — absolutely nothing! The discovery fills me with a certain disquiet because it does not seem quite nice really. I may be old-fashioned but I do expect birds to wear a pair of knicks! I mean, it's more refined, isn't it?
>
> —*Confessions of a Film Extra*, Timothy Lea

INSANITY! Even without diving too far into the pit of British sex comedies, you feel as if it will never end, and your marbles will be lost well before you reach the bottom. One or two are about the limit, and I don't want to go any further. The deeper you go, the murkier the jokes and sexual escapades, with an adventure or admission for every occasion (not to mention title: *I Like Birds, I'm Not Feeling Myself Tonight*). And there's scarce reward for sitting through these movies: it's not as if the audience is offered some hot action after the expositional tedium (as is the case with your standard hardcore fare).

The Brit sex comedy is a celluloid prick-teaser. It says "yes", and then changes its mind and says "no".

It seems that if you were a manual labourer in a 1970s sex comedy (or engaged in any other employment that brought you into contact with the general public) you had every possible chance of getting your end away with birds of all denominations. They were all just waiting for you to deliver that milk/letter/tarmac driveway. All it took was a pair of flared denims and the ability to lever right arm over left fist and you were in there, son. Curious travellers, eager to venture into this seemingly endless parade of British T&A should go armed with the right guidebook,[1] the rest of us wimps can take a comforting step backwards and be lumped with the *Confessions* series. Welcome to the Unadventurous Adventures of a Puritanical Titillation Seeker...

Like all British things cinematic which deal with the softcore pursuit of hot pussy, the *Confessions* films stand in the shadow of the twenty-eight *Carry On* titles, which carry as big a weight off-screen as on. At their best the series threw up classics of Anglo farce, xenophobia and smut (*Carry On Abroad*, 1972); and strangely, these elements also make up the worst films (*Carry On Emmanuelle*, 1978, being just about as low as you can go), but with all the life sucked out of them. What puts this lot above the rest is the cast of main characters, most prominently Sid James, Kenneth Williams, Hattie Jacques and Charles Hawtrey (with an able group of supporting actors and notable guests, i.e. Fenella Fielding in *Carry On Screaming*). These actors will forever be associated with these films, their faces and actions eternally the characters on-screen. But where some kind of Mephisophelean pact had been made with the *Carry On* stars (fame at a price), the two protagonists of the *Confessions* films — Robin Askwith and Anthony Booth — would be lucky to get an appointment. They are permanently on hold in Lucifer's waiting room. Lucky thing, too. The reputations of some of the *Carry On* cast became larger than life. James: voracious humper; Williams: sexually tormented could-have-been; Hawtrey: not of this earth. Since the publication of *The Kenneth Williams Diaries* in 1993, the nasal one's co-performers have had numerous new angles added to their characters (albeit through the author's barbed pen). Williams displays his own dislike of the films that be-

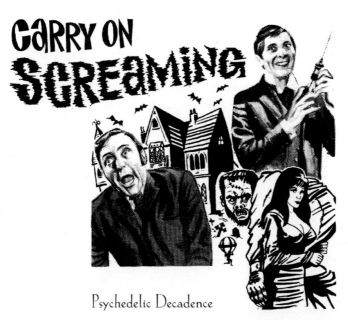

Psychedelic Decadence

came his living, but which stole away many of the opportunities that might have arisen from his earlier theatrical direction. This is typical of the comments:

> This is v. odd, the way that 'Carry Ons' are just starting to get mentioned: why are they suddenly fashionable? They're even trying to justify the bad scripts now! and talk about the classlessness of them. What hogwash! You can only call a mess a mess.[2]

Williams' downfall was that everyone loved him for what he presumed was only one facet of his character, and that he loathed himself for constantly playing up to it. (The diaries reveal him to be extremely well read, if a little snobbish: the entry for January 2, 1966, has him dismissing William Burroughs with the flick of a sentence.) This characterisation of himself was inescapable, and, up until the emergence of his writings, was what the public presumed him to be like twenty-four hours a day. Some of the *Carry On* team's private escapades would fit well into a film, a very British sitcom of perversity and eccentricity. Like all good bodies of correspondence, Williams' writings — as well as revealing much about himself — give often too-short glimpses of the lives of others, leaving the reader keen to dig out more depravity, real or exaggerated.[3] What would children make of dandy, bird-chasing Charles Hawtrey if they had read this extract from a 1970 Williams letter, relating a press launch for *Carry On Henry*:

> They asked Charlie Hawtrey to put his arm around Barbara Windsor and kiss her for a photograph and he cried 'No thank you — find me a gentleman instead!' and reeled off to another part of the room. The photographer looked utterly bewildered and asked me 'Is he for real?'[4]

In the few times he appears on the page, Hawtrey is very larger than fucking life, a walking, talking approximation of the *Carry On* world. Retired in Deal, Kent, Williams relates visiting him:

> As we walked along the front, fishermen eyed us warily. Charlie was in orange trousers, blue shirt and silk scarf at the neck. He was carrying his umbrella as a parasol... the rest of us were trying to look anonymous. 'Hallo lads!' he kept calling out to men painting their boats. 'They all adore me here,' he told us, 'brings a bit of glamour into their dull lives.' They smiled back uneasily, and certainly some returned his salutations, but I didn't get the impression of universal adoration.[5]

This is what such a pact does to you, turns you into a monster Day-Glo caricature of yourself, a living exaggeration of what appears on the cinema screen. What a price to pay. But the result is a collection of brilliant comedy

1. David McGillivray's *Doing Rude Things: The History Of The British Sex Film, 1957–1981*, Sun Tavern Fields, 1992. The biographical notes in this chapter come mostly from McGillivray's book.

2. Entry for August 9, 1964.

3. A rather disturbing example of this is an incident related to Williams by Sid James, regarding the singer Matt Monroe waking one night to find Tony Hancock attempting to give him a blowjob (entry for April 24, 1972).

4. *The Kenneth Williams Letters*, edited by Russell Davies, HarperCollins, 1995. Letter dated October 15, 1970.

5. Letter dated September 9, 1987.

grotesques. Williams may have hated 'lowering' himself to such a level, but that nasal whine of superiority is the key to legendary status, cutting through the fat of lesser British celluloid sauce. Where are Robin Askwith and Anthony Booth now? One took the series to the global stage, the other is the current British Prime Minister's father-in-law…

CHARISMA isn't the name of the game here. The four films — *Confessions of a Window Cleaner* (1974), *Confessions of a Pop Performer* (1975), *Confessions of a Driving Instructor* (1976) and *Confessions from a Holiday Camp* (1977) — have precise instructions: to follow the amorous young Brit in his pursuit of birds, notching up the dry-humping as it happens. Timothy Lea (Askwith), a missing link in flared denim, is constantly under sexual and career guidance from his brother-in-law, Sidney Noggett (Booth). Rutting antics occur relating to the chosen profession. That's all the plots in a nutshell.

> All these high-rise flats springing up like fast-growing mushrooms from a cowpat. Only the boozers left like fish heads to remind you of the rest of the body that has been gobbled up. Go in some of those pubs and they have to have the lights on all the time because there are so many blooming great buildings leaning on them, shutting out the light.

What would-be chronicler of London's bleak streets wrote this? Some bright spark with a good education and a desire to 'speak the language' of the working-classes? No, it's Timothy Lea, the pseudonym of the infinitely less-famous Christopher Wood. Like many British jack-the-lads, Timothy's adventures began in literature, with a series of first-person novels that, judging by the above example (from *Confessions of a Film Extra*[6]) could claim to be far superior to the films. True to some kind of Dickensian boy-makes-good theme, the book even begins with chapter summaries, outlining the hero's exploits. The Lea family of Clapham, London, live in a state of dilapidation and urban renovation unique to the 1970s. But don't kid yourself that social comment is the main theme of the book; as with the films it's euphemised — and very often interrupted — sex that is the main selling point: drop Timothy into a new job or place and let him drill away till his little toes curl. Not difficult, as there's usually scarce competition, all other males present being uptight growlers or screaming fruits ('I reckon the last bird Dominic fancied was probably his mum'). It's a pity that Lea's exploits in low-budget exploitation and porn films — as told in *Confessions of a Film Extra* — didn't make it to the screen, as Wood throws up some perceptive observations of the British film industry, the most blatant being the portrayal of Ken Loser, the film's director, who is not a million miles away from our own home-grown nutty auteur Ken Russell:

> He is wearing a shaggy sheepskin coat that drags along the floor behind him,

[6]. Sphere, 1973.

and from the niff that sprints across the room you would reckon the sheep was still in there with him. He has matted shoulder length hair... a wooden cross round his neck and open-toed sandals... In his hand is a riding crop which he twirls impatiently.

Just in case the reader doesn't get it yet, Wood makes the comparison explicitly clear in Loser's opening declaration:

'I see this thing as totally nihilistic... I want everything — the orgies, the rapes, the desecration, the infanticide, the underwater lesbianism, to bring every man, woman and child in the audience face to face with the fundamental question.'

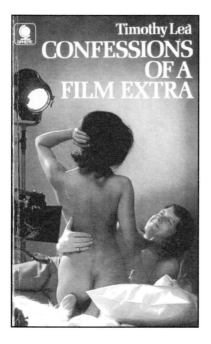

Asking what the fundamental question actually *is*, of course, is entirely out of the question. *Confessions from Loudun*, anyone? Loser is (re-)making *Oliver Twist* (plus the ubiquitous hardcore version), with a little financial help from Sidney; Timothy is getting to know the ins and outs (ahem) of the film industry, and the whole thing climaxes with the disastrous Cyprus shoot of a 'Horror Western' called *Revenge of the Monster from the OK Corral* which has me thinking uneasily of *Incense for the Damned*, another Mediterranean-based turkey. The book comes out better off than three of the films, though as I haven't read any of the other source novels, I'm in no position to speculate as to how good they are; however, two more of Wood's books remain unfilmed: *Travelling Salesman* (yes!) and *Hotel*. Couldn't Channel 4 do something about this?

BUT THERE'S only so far that you can imagine a pair of tits, and I'm not talking about the characterisations of Timothy Lea and Sidney Noggett. Welcome to the cinematic *Confessions* world, a Theme Park that thrusts a hand up your blouse and goes "whroowwggh!" Christopher Wood's screenplays jettison the slivers of social comment for an all-out knockabout nookie-fest. Watching each film, it's handy to have a bed-post nearby with which to notch up the conquests. This London is the land of opportunity, where it takes two seconds to set up the next money-making scheme and even less to bed a bird; where there is always a shed hanging around implausibly, waiting for a liaison like a nookie Tardis; where there is no 'g' in the word 'darling'; where character actors wish they didn't have so much character and where once nubile (and never nubile) actresses pray for the accidental loss of every single negative now they've grown up...

Incense for the Damned, a Mediterranean-based turkey.

And through this world travels 'simple, unaffected'[7] Timothy, unsullied by human hands and, at the beginning of *Confessions of a Window Cleaner*, female genitals. Robin Askwith (Arse-quiff, what kind of name is that?) seems to have made a substantial living playing the same character in every film I've seen him in, right up to *Britannia Hospital* (1982). The template is here: eternally happy and astounded at his luck, from some angles his features look strangely like those of a reconstructed burns victim, topped off with a Luke Skywalker haircut; even his various theme songs are upbeat: they might just as well declare "what a *lucky* boy you are, Timothy!" His Christian name is no accident either, as the queues of women can use it to register annoyance ("Timothy!"), or attraction ("oh, Timmy!"). Verily, this man could not even lift the shitty stick it would take to beat them all off.

In *Window Cleaner*, Timothy cycles through busy streets with not a care in the world: a happy-go-lucky youth with a monkey smile and voyeuristic tendencies. There is a theme song, 'This is your life, Timmy Lea' ("always getting into crazy situations/having trouble with romantical relations") and Askwith's narration. But he's not the agile humper we know him as yet. Sid's business (slogan: 'we rub it better for you') is being built on a foundation of smashing birds and satisfied customers. It takes a set-up — initiated by Sid — with a squeaky-voiced redhead stripper to warm Tim up (even if that does end with Tim shooting his bolt by humping the girl's suspender; though any doubts

7. 'Is simple, unaffected Timothy Lea too nice for the hard world of film making?' states the back-cover blurb of *Film Extra*.

that he may be 'kinky' soon disappear from his non-stick brain), and a soapy session on a kitchen floor to really start the ball running. From then on it's a downhill struggle as the little head seizes power. *Window Cleaner* is by far the most coherent of the series; a few good jokes crop up in others, but you've got to sit through a Hell of a lot of unfunny business to get to them. Here, the story is belted out dead quick: Tim gets laid, Tim *likes* getting laid, Tim falls for girl but is puzzled as to why she won't do it on a first date, answer: she must be the one for him, they arrange to get married, Tim misses ceremony, Sid — naturally — steps in, Tim catches them at it, oh well — no hard feelings, eh?

Enough of plot, what about the birds? The first film is the template, a scorecard of sexploits. These girls are diversions for Lea as he pursues chubby-chinned copper Linda Hayden, although his social etiquette extends only to trying to stick a hand up her skirt in the cinema. The boy has better luck with his first ride proper, Mrs Jacqui Brown (sex comedy regular Sue Longhurst), a customer and "bit of a nympho" according to Sid, who has previously test-driven a number of Tim's lays. Talk about sloppy seconds. Blonde, curvy and

A pair of tits: Timothy Lea (Robin Askwith, left) being offered sexual and career guidance by brother-in-law, Sidney Noggett (Tony Booth). A scene from *Confessions of a Pop Performer*.

The Birds 67

into her thirties, it's only a matter of time before Tim is distracted from cleaning the windows (inside! Since when did this practice begin?). This is the archetypal clothes-shedding scene, the one where someone says: "oh, isn't it warm in here. Aren't you *hot*?" Mrs Brown is a loose-bloused bored housewife whose husband is 'away';[8] Tim knocks over a tub of (industrial-strength) washing-up liquid and neglects to turn the sink tap off; an oversized lather is worked up as the pair get naked in the suds. The film speeds up to empathise what fun shagging is. Tim leaves the house with 'Hallelujah' blaring and equates sexual prowess with learning to ride a bike. He has just ridden a bike: women like Mrs Brown and chubby brunette Brenda (Olivia Munday) are available in that easy-as-falling-off-one category. Not everyone is such easy putty in Tim's hands, and you soon realise that the *Confessions* films contain more interruptus than Mary Whitehouse at a suburban orgy. Strangest of the lot is Carole Prendergast (Katya Wyeth), a biology teacher. We know this because she wears her blonde hair up, sports glasses, is a bit gangly and talks posh. Like every other woman in these films she's looking to a member of the working classes to give her a good seeing to. Enter Tim, spewing out lines from old films before diving in. Miss Prendergast is a bit odd, dressed in a kind of house dress and speaking in the third person about herself and her sexual needs. There's something not quite right with the lady, and it goes beyond shyness. Not that Tim sees any of this, as he's now jack of all fucks, and that includes getting his big gob round

8. Remember that in this cinematic England half the male population are continuously abroad, leaving rich pickings for Lea and co.

9. *Confessions of a Film Extra*.

10. Matheson fares better in *Crucible of Terror* (1971) playing Marcia, an alluring bisexual hippie chick.

68 Psychedelic Decadence

hair pie, until the pair of them are interrupted, obviously.

Stranger still is Tim's encounter with another of Sid's customers, Mrs Villiers (*Dracula*'s Melissa Stribling). This could have been the film's most interesting sex scene but, freaked out by the circumstances, Tim flees before anything can happen. No sense of adventure. Mrs Villiers is a middle-aged lady of the manor, a hygiene nut with a cleanliness fetish. Tim first encounters her when she interrupts (it's happening everywhere!) a little innocent yoga session between him and a skinny European housekeeper. When Sid drags him back to apologise, Mrs Villiers has Tim change a lightbulb in the coal-cellar, a simple task made difficult when she begins to run her hands over his "fit, young body". Two seconds later he's lost his balance and has fallen onto the coal pile, taking her skirt with him; Mrs Villiers remains stern and insists that he take a bath ("you're just a dirty little boy") but Tim is having none of it and escapes before the woman can pin him down. Pity he didn't hang around to see what she really wanted of him; he probably would have had to curl up a turd on her face or something.

The face of British sex in the seventies. Askwith in *Confessions of a Window Cleaner*.

Simple and unaffected, Timothy Lea cannot get his (big) head around sexual concepts that don't involve banging away at hot pussy. If he knew what it meant, he'd describe himself as a libertine, but one with a very narrow outlook: gay men ('... the phone is answered in an accent that makes Kenneth Williams sound like Richard Roundtree'[9]) just mean more birds for Sid and him, and the films come on all Queen Victoria when lesbians are encountered. In *Window Cleaner*, Tim encounters a depressed dyke called Elvie (Judy Matheson[10]), unaware that the 'Ronnie' she is sobbing over is in fact a woman. No matter, for when Elvie suggests they get in the sack in order to make the returning Ronnie jealous, all Tim can see is a naked brunette and a fold-out bed (de-

The Birds

spite the fact that she's repulsed by him). Sure enough, Ronnie is the archetypal seventies lezza: short hair, suit and a beret. These kinds of women are immune to Tim's charms, his simian grin is no passport onto their Sapphic island...

For all the women that he bangs, Tim is still as straight-laced as the next honest, decent citizen. Any deviation from dry humping has his brow transform into a ploughed field. If you only knew the man through second-hand stories you'd think him a depraved fuck with the morals of a Nazi, but really all he's out for is a bit of fun, with the sex being strangely equitable and barely a blow-job in sight. Rather than take lusty, decadent delight in his conquests, Tim sees what he does as a service, with plenty of clients queuing up.

Confessions of a Window Cleaner is the only film in the series to have a decent plot insomuch as will Tim leave behind his wild ways and settle down to married life and kids with Elizabeth Radlett (Hayden)? The answer in the end is obviously no — even Sid steams in there with the jilted bride — but it's amazing what lengths people will go to in order to get someone into the sack. Tim persists even when Elizabeth tells him that daddy is a high-ranking copper (he spits his beer out); after all, his speciality is surreptitious undressing: whatever the main focus is in the room, Tim's eyes are always elsewhere. As soon as he suggests that they get married, however, Elizabeth has her clothes off faster than a possessed nun. Hayden was no stranger to full-frontals,[11]

11. Linda Hayden and *Confessions*' executive producer Michael Klinger get a mention in *Doing Rude Things*: 'Baby Love [1968] introduced Klinger's protégée Linda Hayden, who was to appear, to her decreasing advantage, in other Klinger productions.' Hayden also had the dubious honour of being involved in a relationship with Askwith for some time.

Psychedelic Decadence

although she could have had a word with wardrobe over her choice of underwear: granny tights over knickers and her pointy little tits clamped in a disgustingly-coloured see-through bra. Thank god that, naked, she's a picture to the eye, and a definite runner in the Susan George award for the most amount of screen time given to pubic hair.

In the end, with Elizabeth out of the picture, Tim has cast aside any thoughts of fidelity, and is ready to steam onto the next conquest; and so subsequent films jettison story for a series of encounters with a variety of women. Not that this is a bad thing, of course…

In fact, it's the diversity of female forms that keep you going through each film. It can't be anything else. Askwith's charms are as limited as a crab; Booth comes across as slightly creepy; only Bill Maynard, as Tim's dad, injects a level of droll humour that the films don't deserve (when mum finds frilly undies in Tim's cleaning bucket and asks what they are, dad replies: "Well from memory I'd say they were a pair of knickers"). The levels that Timothy Lea's creators go to convince us of his lovableness are overwhelming: by the time *Confessions of a Pop Performer* kicks in there is some subliminal voice screaming "DON'T YOU JUST LOVE HIM?!" echoed in the title song 'Confessions Of Timmy Lea' (which is 'Jimmy Mack' rehashed, sung by Three's A Crowd. And in these films they definitely are). They want us to embrace Tim as a sweet, accident-prone rogue, forever making Sid shake his head in despair; but really he's just Frank Spencer with a burning libido.

Pop Performer tries to grasp that slice of youth market that film-makers find constantly slipping through their fingers by having Sid Noggett manage an up-and-coming band. It's a mark of how out-of-touch Sid is (and how clueless Tim is) that he thinks he can hear the band playing in the back room of a

Opportunity knockers for Peter Jones (top) and Bob Todd (above) in *Confessions of a Pop Performer.*

Iggy and the Stooges? No, Timothy Lea and Kipper — raging full on. Confessions of a Pop Performer.

pub when all it is is a record of 'Rock Around The Clock'. If I was the band I wouldn't trust Sid. In this film Booth looks plastered in make-up, a pantomime dame half-way through transformation: thick black eyebrows, a slit mouth and spray-on sandy hair make him double-take material, the sort of freak you'd run a mile from. The band don't seem to care, though; like pigs in a trough they muddle through their lives and music: godawful Dr Feelgood/Blockheads-style numbers with the slightest of bootboy pretensions. A five-piece, they live in a psychedelic van on council estate waste ground (The Clash would have killed for street-cred like that!). Lots of naked girls are packed inside; there is a Gary Glitter poster pinned up; the van exterior is painted with clouds and lips and other worthless images. One band member looks like David Koresh. The unfortunate singer/pianist has an albino afro and sports a T-shirt with the word 'Superstar' on it. They call themselves Bloater, but Sid doesn't think that sounds classy enough and changes the name to Kipper. He should have gone one step further and called them Tosser.

But of course this plot is peripheral, as Tim's sex life is once again up and down more times than his arse-cheeks. His two best successes here are a Mrs Bramwell and a girl working in a record shop. Mrs Bramwell (Brit TV star Jill Gasgoine) has already had her cogs oiled by Sid — in the first minutes of the film where Tim 'drops in' after being pursued by another inflamed husband — but Tim is sent in to work further wonders as her husband is a music promoter. Mrs Bramwell is another posh, bored housewife with a body innocent to sex comedies and a re-usable pink nightie: Gasgoine comes across as a

suburban Joan Collins; throughout the film she appears to be the vital link in the rounds of circular humping, with the same hairdo sported in the subsequent years of TV work. By this point, the audience may be numb to the lame jokes, but Tim's innocence has now reached the edge of unbearable irritation and he begs to be put down. The eye begins to wander, to assess the next woman in line, and drifts away from the so-called focus of the films. Hoping to get Kipper to the top of the hit parade, the family Lea launch an assault on record shops, buying up as many copies of the single 'Kipper' ("mean as Jack the Ripper") as they can. Tim never gets round to this as the girl working in the shop he enters is a bit of a looker: suede miniskirt, tight blouse, impish beauty and flashing knickers. There are Bad Company and Roxy Music (advertising the *Country Life* album) posters on the walls. This is the best bout of nookie in the film: the pair roll about on the floor amongst records and tapes, their clothes dropping off with unnerving ease as stray hands attack the music equipment, blasting out a bewildering array of song snippets (one of which is Spike Milligan's 'Ning Nang Nong'. Sue, Spike, sue!). But again, there is a failure in Tim to stay centred, to get on with the job in hand. He rolls about as if afraid to commit himself to one particular sexual act. All the birds in the *Confessions* films go for the full frontals with gusto, but you soon begin to wonder if Timothy Lea's genitals really exist (is that what he wants to confess?), as there is never one sighting of his tackle in all his exploits; although we are assured that he carries a veiny French stick in his tight denims. The Sellotape effect, or just cold weather? Even the raunchiest of his fucks are nothing your granny couldn't watch; his record shop roll-in-the-hay comes nowhere near the LP cover squashed beneath squirming arses: Queen's *Sheer Heart Attack*.

Askwith (to the right of the elevated Leonard Rossiter) plays a shop steward in Lindsay Anderson's *Britannia Hospital*.

Tim's other conquests are a series of bizarre scenarios and unstoppable interruptions. We already know that his sexual prowess doesn't lend itself to anything deviating from the norm, but now that he's in showbiz (he reinforces the 'drummers are thick' myth by replacing Kipper's. What he lacks in drumming — and miming — skills he makes up for with blind enthusiasm) he should have expected a world of perverts and drug fiends. In real life maybe, but not here. A TV presenter's party has Sid and Tim suitably impressed, and Tim hooks up with a skinny redhead with a foreign accent, only to be led into a bedroom decked out with S&M gear and — bizarrely — snorkelling equipment. Tim thinks he's

going diving. This is near the truth, but we never get to see. There is a two-way mirror, and the rest of the party guests get to look in on the couple's antics. Just as strange is his encounter with a shapely blonde contortionist ("just a little fakir") after he gets lost — *Spinal Tap*-style — backstage at a royal performance at the London Pallusium(?). She is enthusiastic but slightly disturbing in her readiness to pounce on this stranger. Interruptions and a disastrous gig follow.[12]

Kipper's best gig is their first, at a local hall. The biggest group of fans to turn up are a bunch of old biddies. All five musicians wear leather waistcoats and no T-shirts. They launch into a bovverboy number called 'The Clapham'. The audience seem to like it. Were this lot ever a proper band? The event ends in a riot of sorts. Tim is pursued backstage by a fan who has mistaken him for Mick Jagger. A straight-haired brunette in red platforms and rainbow kneesocks, she eagerly molests him ("I knew it wasn't a cosh you kept down the front of your jeans!") with the blind determination of a seasoned groupie. In a business where musical competence equals charisma, Tim seems to have found his natural place, not that he is allowed to stick around and explore. On the losing end again — with Tim reduced to playing one-man-band to cinema queues[13] — Sid soon sets his sights on another business venture, and you don't see the pair for dust. A pity: as the chaos descends on Kipper's first gig, Tim abandons his drums and begins to prance around the stage waving the mic high above his head. With his bare torso and patchwork flares, from a distance he looks like Stooges-era Iggy Pop. From a distance.

Down, down, down we go. How much more of this can you stand? Another feature of this peculiar world is rampant short-sightedness. Big signs are everywhere (EXIT, ENTRANCE, DRIVING SCHOOL), there not so much for the characters but the audience, just so no-one gets confused. As previously mentioned, the only lasting effect the *Confessions* films might have is to embarrass certain actresses into eternity. This desperate grabbing at straws when you're at the bottom of the ladder will come back to haunt you (heh-heh). The best example can be found in *Confessions of a Driving Instructor*, when we get to see (albeit briefly) Lynda Bellingham's — the actress from the Oxo Cube adverts — tits. Parked up in a car, Tim gets his hands on her globes, one breast is even liberated from undergarments, but only for a moment. For all Bellingham's protests ("Oh, Timmy!") she still sticks her tongue eagerly into Askwith's mouth...

Bellingham is Mary Truscott, jolly-hockey-sticks daughter of Mr Truscott (Windsor Davies), owner of the Truscott Driving School, soon to have a more down-market rival, as Sid and Tim have bought the neighbouring Dumphrey School Of Motoring and re-christened it NOGLEA (those big signs again). They have also inherited the school's secretary, Avril Chalmers, a carved blonde in regulation check-pattern suede miniskirt and tight white blouse, but that's Tim's department. Mr Truscott has an assistant lackey in toff Tony Bender

12. Askwith generally doesn't have a lot of luck with the bands he's involved in — see the chapter **Party Girl Who Is Painted**.

13. Confessions Trivia No 1: Tim soon gets distracted by a foxy blonde in spike-heeled boots leaving the cinema, only to see her meet up with a boyfriend. The girl Is Bobby Sparrow, a blink-or-you'll-miss-it face in many 1970s sex and horror films. The man is Bristol-born ex-bouncer/strongman and future Darth Vader Dave Prowse.

Psychedelic Decadence

(George Layton), a snorting sycophant and would-be suitor of Mary who is the recipient of many of Truscott's pearls of wisdom ("nature abhors a vacuum, Bender"). The rivalry is set up: school vs school, Bender vs Lea, until Truscott suggests a merger (Bender: "that's a bit strong, isn't it? Couldn't we just maim them?").

But again, the plot isn't important, nor are the film-makers' attempts to develop the series as a sort of cinematic soap opera: Sid and family move out of the palatial Lea household and Tim takes up lodgings at Avril's place. No-one cares. Bring on the girls. Tim has to pass a driving test so that they can start up the school. Luckily the instructor is female, and soon dampens nicely in the presence of so much gearstick fondling. Tim passes with flying colours.

Elton John eat your heart out. *Confessions of a Pop Performer.*

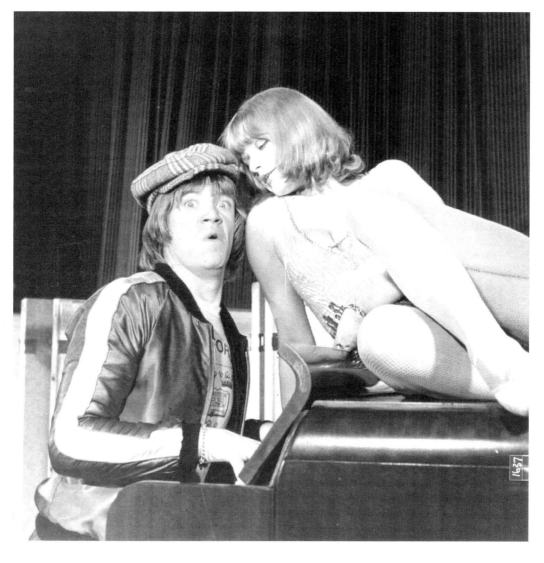

The Birds 75

Like the window cleaning business, there are a lot of customers to catch out there, all female, all bored...

In the race for crumpet, Tim comes up trumps. Mrs Hargreaves (Suzy Mandel, sex film regular and player in Mary Millington's few screen adventures) is a petite, sultry beauty in a denim dress who doesn't so much walk as prowl. Her voice appears to have been dubbed by Joan Greenwood. In the car, her dress comes off at the touch of a button, but passing rozzers force the pair to relocate to a building site and one of those handy sheds, though they fail to notice that this one is attached to chains attached to a crane: workmen come back from a break, shed goes up, workmen cheer on the naked couple. One of them makes a thrusting movement with a length of scaffold pole.

Like the previous two films, there is an actual object of desire for Tim to pursue (Linda Hayden's copper in *Window Cleaner*, Carol Hawkins' journo in *Pop Performer*) throughout the film, and here it's posh Mary Truscott. They first meet when Tim pulls one of his cak-handed stunts with a fish-filled aquarium: cue a wet blouse for Mary, fish in her bra and Tim and Sid's hands impolitely thrust into her erogenous zones. Mr Truscott and Bender then walk in on them. Mary looks posh and walks posh; she has the childish enthusiasm of a sports-playing schoolgirl who hasn't yet encountered a rather too-friendly classmate in the showers. Her gung-ho attitude no doubt extends to sex as well. They make quite a sweet couple. She invites Tim to her parents' drinks party. A bull in a china shop situation. Even with a gobful of wine ("shall we try the '69' together") he resembles a tree-swinger. Tim must like her quite a bit as he even takes part in a climatic rugby match for her. Idiot. But these targets don't deter him from notching up a few more girls, and in *Driving Instructor* he surpasses himself: not just Avril Chalmers in a pink nightie (it does the rounds, doesn't it?) — cue fast-forward nookie and collapsing beds — but also her mother, played by the omnipresent Liz Smith, pushing it a bit but still up for a laugh, dressed to kill in a black basque, stockings and suspenders. Tim can't even be left alone to read his copy of *Titbits* in peace. Smith — permanently roaming her house in skimpy underwear — and Askwith have the distinction of participating in what may be the most uncomfortable-looking sex act ever captured on film. They splash about in a full bath, Tim on top while Mrs Chalmers looks vaguely distressed, and wet, with foam attached to her chin. When Tim retires to his bed with an aching cock he is greeted by Avril in the final act of a rather successful round of sex which has also included Mrs Dent (RADA grad Sally Faulkner), a middle-aged golf widow — the pair get torrid in a sandpit — and Lady Cynthia Snodley (Chrissy Iddon) a grand country dame. She has a driving lesson, while her dogs run rampant in the car ("DOWN MONSTER!") then takes Tim back to her mansion in order to paint him.[14] Lord Snodley (Ballard Berkeley — the Major from *Fawlty Towers*) arrives home unexpected. No change there, then, except that this fucker's got a gun. Lady Cynthia is Tim's chunkiest encounter yet, an aesthete who

14. Inside, it *looks* like a mansion, but a brief glimpse of glass doors led me to believe it was actually a sideroom of a local town hall.

15. Confessions Trivia No 2: a member of the opposing team is played by Rocky Taylor, the film's stunt co-ordinator and also one of the motorcycle gang in *Psychomania* (see the chapter **Real Class!**).

16. Hayden's early promise as horror cinema's dark angel (displayed in *Blood on Satan's Claw* and *Taste the Blood of Dracula*) was quickly overshadowed by limp comedy roles. She even appears in the first episode of *Some Mothers Do 'Ave 'Em* ('The Job Interview') as a secretary. Although looking slightly nervous, Hayden has the major advantage of being clothed in a bee-stripe mini dress and shiny, shiny brown platform boots. Frank Spencer, naturally, is terrified of her.

Psychedelic Decadence

prefers to get sex out of the way so that she can concentrate on her art, but it's another lost opportunity for Tim, and the series as a whole continues its slow slide into mediocrity. Not even the Sexual Rejuvenation Pills (named 'Bang On') procured by Mr Truscott — and used to Mickey Finn Bender into a sex-mad potential rapist — can revitalise the film. There is a climatic rugby match[15] and a car chase, but Tim isn't interested in squeezing other men's 'nads, and neither is the audience, and it takes a ludicrously-placed advertising board in a scrapyard for Sid to find a way out, onto the next adventure. You know it's all downhill when one of the credits reads: 'Robin Askwith's Denim Suits by Mr Americar'...

"It's Timmy Lea, yet again". By the time *Confessions from a Holiday Camp* opens even Askwith sounds tired, fully aware that interest in his exploits is running out. A depressing tint is cast over the entire film. Tim and Sid are now entertainment officers at the Funfrall Holiday Camp. The whole thing looks like it was filmed in some sore on the Norfolk coast at the arse-end of summer, a place that Jim Jones would have rejected: the beach is a sandpit next to a lake. The last time Askwith was this deep in the country Michael Gough was trying to lobotomise him (in *Horror Hospital*). The plot concerns attempts to stage a beauty contest, but apart from that, everything has come full circle; with the appearance of Linda Hayden[16] the film is stripped down to bare acts, no teasing from her this time around, playing a French(?) camp worker, she and Tim get right down to it in the games room. In fitting with the tired atmosphere, even the birds that Tim pulls have ulterior motives for fucking him: they all want to win the beauty contest. The family Lea turn up, Sid's face looks even more bizarre — the painted-on features of an invisible man, Lance Percival camps it about, the jokes get more cringeworthy... *Holiday Camp* is a leaden farce that speeds the girls through on a conveyor belt. It's appropriate that while the lettering on the staff T-shirts reads 'FUNFRALL' it actually looks like 'FUNERAL'. Brigitte Dubra (Hayden) in a white bikini ("oh, Timmy!"), another bored wife (Penny Meredith) in a sauna; the camp announcer (Kim Hardy), a blonde school prefect type with angular features and uniform of white blouse/short skirt, over the intercom (Tim gets a round of applause); Glad (Caroline Ellis), a teenage Brummie with pink underwear, small tits and an overwhelming keenness to give head (a literally electrifying blow-job!). An hour into the film its makers realise things need livening up and send for Liz Smith (she was well into her forties by now), as the manager's sex-mad (what else!) wife. But she's still wearing the same get-up from *Driving Instructor*, still undergoing the same fake fumblings. It takes a bit of exotic colour to make Tim come over all Jim Davidson; Blackbird (Nicola Blackman) is just that, a black bird, but one of confused origin: is that accent Westcountry or Welsh? Some bright spark decided to divide the camp's guests into the four playing-card suits. Her big curves clothed in fringed denim shorts and a spade T-shirt, Blackbird glides past Tim, only to have him make the

observation: "you're a spade, aren't you?" A few minutes later he watches her big arse move away and declares "phhrrowwh! I can see what they mean now by racial tension." It's the best joke in the entire film, but Blackbird gets her own back later by giving Tim a damn good rogering; afterwards he has the look of a man whose cock has been well and truly sandpapered...

CONFESSIONS from a Holiday Camp barely allows the series to limp to an end. It must mean something when the two women you remember most from the film were not even recipients of Tim's French Stick. Glad's giggly mate Reen (Sue Upton) is a cute bundle of glasses and blonde pigtails, but she keeps her kit on. Similarly, Tim comes into contact with another beauty, but only because of his cak-handedness: accidentally removing the top of a sunbathing young mother (Janet Edis). This dark-haired woman, clothed in a red bikini and beads, lingers on in the mind until you realise that all the best women really *are* married. It took death and old age to stop the *Carry On* cast carrying on, but despite the dead-end feel of *Holiday Camp* you know that Tim and Sid will gladly move onto the next money-making scheme. There's no *Alfie*-style contemplation or life-changing decisions from Timothy Lea, it's just "oh well" and onto the next adventure. The credits roll and the nadir is reached as the theme song ('Give Me England') by The Wurzels injects the final lethal dose. The climax mirrors the far superior *Carry On Girls* (a film notable for the transformation of Valerie Leon from Bernard Bresslaw's dowdy wife into, well, *Valerie Leon*) by bringing it to an end in the only way possible: with a custard pie fight.

Coda

AS WE all know, charity shops are occasional goldmines. But there can sometimes be too much of a good thing. After finishing this chapter — thinking that Timothy Lea's literary adventures stretched to a mere six books — others began to surface. This I should have known; no doubt someone's uncle somewhere, with a pile of *Confessions* paperbacks stuck in a box next to James Herbert's 1970s output, could have told me this. So I discover *Confessions from a Stud Farm* (1978) hidden away in some side-street shop, its faded spine a fine disguise amongst the other paperbacks. The shock comes in finding that the quality control has lapsed. The cover proclaims 'Over 3,500,000 Confessions books sold in Sphere', but Tim's no longer at the helm: now the books are written by someone called Jonathan May (and copyrighted to him on the inside cover).[17] He may not be the only successor, as the back cover now lists seventeen books, ranging from the bizarre (*Astronaut, Housewife?!*?!*, the punctuation marks are part of the title) to the dull-sounding (*Shop Assistant*, c'mon!) to the sounds-like-it-may-be-barely-legal-and-involve-little-boys *Games Master*. But really there is nothing more you need to know: Jonathan May's exploits make Timothy Lea sound like Casanova, and *Stud Farm*'s typeface IS PRINTED REALLY BIG WITH SPACES, ideal for the brickies' lunch-hour. Safe in the knowledge that I had at least covered the two ends of the *Confessions* books, I was sure that the coast was clear to trawl over a few charity shops after work. But now the fuckers won't leave me alone: a few hours before I sit here writing this, *Holiday Camp* displayed its faded spine to me, and 20p is nothing, right? But I didn't buy it, thinking that to do so would upset the balance of this chapter. However, returning home my mind flips like a coin: I'll go back tomorrow, it'll still be there (who else is gonna buy it?); or, I'll buy it and wait until *Psychedelic Decadence* is completed before reading it. More disturbing is the thought that I *should* have bought it, because *someone else* might snatch it up. I fear that there are a lot of *Confessions* books out there, a situation that feels like an LP with a locked run-out groove. And someone has to pick up the stylus and shout "Enough!"

Next page: Timothy gets the horn. *Confessions of a Pop Performer.*

17. In fact a pseudonym for the prolific late British author, Laurence James.

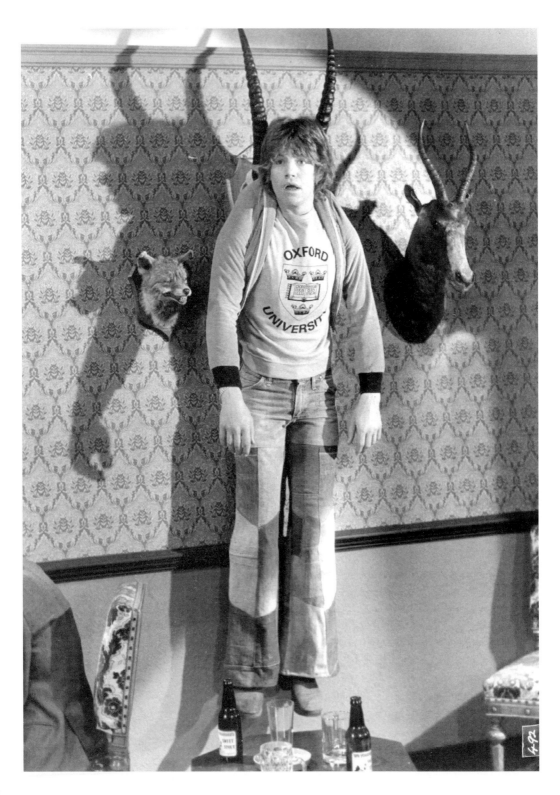

Psychedelic Decadence

Six Shillings to Happiness

Entertainment for Men

On the whole, I don't think girls should wear bras. After all, they don't do a great deal to improve a figure, and they can be deceitful. If women can wear bras, I think men should be allowed to wear padded codpieces. I personally like the gentle swinging of unbridled breasts. Breasts are soft things; they're not meant to be hard and pointed.
—letter in *Mayfair*, Vol 4, No 3

I was fascinated to hear that there was once an aeroplane called the Felixstowe. Can you tell me something about it?
—letter in *Mayfair*, Vol 5, No 11

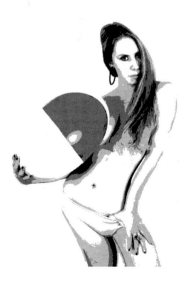

THE BEAUTIES of bad living are numerous, the drawbacks thousand-fold, and the time span in which to indulge yourself variable. Lifestyles of sex, drugs, booze and rock'n'roll cannot be maintained without something (physical or mental) snapping, big time. But be sure that fun will be had along the way. What kind of fun is up to you.

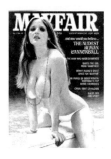

Personally, I'd go for a king-size bed, a couple of Marilyn Burns lookalikes, a good crop of mushrooms, a crate of red wine and 'I Wanna Be Your Dog' cranked up full on the stereo (with other Stooges records patiently waiting their turn). Well, we can all dream. You don't always get what you want — and that's probably what keeps many a hedonist alive. The best maps of human desire are always the ones that can be easily read. All praise and glory then to the written word, haven to anyone with an imagination: a ringside seat to other

This page & next: A selection of ads from the October 1976 *Mayfair* (Vol 11, No 10), an issue which also featured Marianne Morris in the buff, star of José Larraz' *Vampyres* (1974), several episodes of *The Benny Hill Show* and a Brutus jeans TV ad.

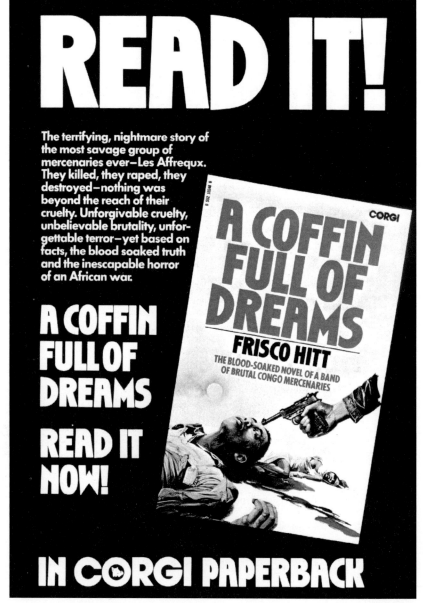

82 Psychedelic Decadence

worlds, bad living from the safety of the armchair...

What are these books, these manuals for degenerate practises? Perhaps Wilde's *The Picture of Dorian Gray*? Or JK Huysmans' *Against Nature* (the finest accompaniment to solitude there is)? Or Lautreamont's *Maldoror* (one long curse against whichever god you happen to be rejecting)? Or, if you're really, really far gone de Sade's *The One Hundred and Twenty Days of Sodom*? There are many more. And don't neglect the bad and beautiful of the twentieth-century: William Burroughs turning wild life into wilder writing, or Henry Miller freeloading and fucking his way around Paris. These subjects have two things in common: *1)* they're male, and *2)* one way or another sex (in all its diversity) appears, the bright red rag to readers.

But these hedonistic delights would not appeal to everyone, and sometimes bad living + male + single = pornographic magazines. One such bible in that crossover 1969–70 period would be the glorious *Mayfair* ('Entertainment For Men'). There were enough slivers of decadence within its pages to satiate even the most panting palate, carefully hidden amongst the usual 'male interest' ephemera. In fact, it's hard trying to resist useless dewy-eyed nostalgia when faced with the yellowing pages of this magazine; and as you stifle back the sobs you think of how goddamn *lucky* your dad/uncle/older bother was: because the *Mayfair* (as good an example as any) of the swinging era is a compendium of sordid delights, a tarnished gold-mine for lovers of British horror films, left-field writing, perverted tales and full-figured well-groomed chicks getting their kit off for London's photographers. Demand to barn-storm the parental attic now!

MAYFAIR tackles all the subjects men supposedly like with a large dose of fun and a hint of naughtiness. And not a shred of irony. Articles by William Burroughs and essays on fire-arms exist happily together (subjects not so far apart, if you think about it). To continue the connection to extreme literature the 'Mayfair Book Society' even offers up — amongst the usual pile of self-help and sex paperbacks — essentials such as *Naked Lunch*, *Tropic of Cancer*, *Last Exit to Brooklyn* and *Justine*. Elsewhere, film promotions go overboard on the bare flesh angle, supplementary additions to the few models gracing the pages; and the boys' own war/car/sailing features are there in full. I've often

Six Shillings to Happiness 83

thought such diversity was planned deliberately to keep rampant onanism in check: you're chugging away over some dish and turn the page to come face to face with an article on Panzer tanks. Suddenly, the blood drains.[1]

On the surface the magazine projects an image of the ultimate male bible, and you think of its readers as Peter Wyngarde clones: brandy-sniffing, cigar-smoking, sports car-driving dandies not averse to playfully slapping a filly's rump as she totters past. This specimen was the naughty Victorian gent transported into the twentieth-century, especially when you realise that — bereft of today's beaver spreads — obsessions had to be directed elsewhere. In *Mayfair* it was glimpsing a woman's underwear. A *lot* of the readers letters waxed on about this subject. Here's one example in full:

> I was walking in a big chain store when I observed a particularly attractive girl mount the ascending escalator. In male anticipation, I stood at the foot of the escalator to watch her journey up to the next floor. Slowly but surely more and more was revealed. As she rose I saw the loveliest bulbous bottom under a pair of light tan tights. I now mounted the escalator to follow. When I reached the top, I saw that she had made her way over to the lingerie department. There I observed that she purchased a pair of black panties. My adventure was becoming more intriguing. She then proceeded to the ladies with her purchase. She was in there a good five minutes.
>
> By now, I was waiting at the bottom of the escalator for her to come down. She started to descend, and I was amazed to observe that she was now wearing the panties she had just bought. I wonder why she had gone out originally without them?
>
> (Vol 5, No 11)

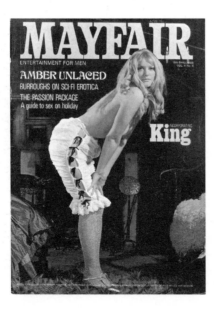

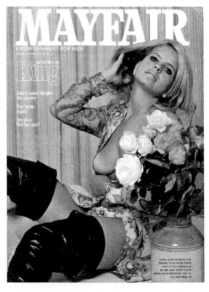

Left to Right, this page & next: *Mayfair* Vol 4 No 8, Vol 5 No 11, Vol 5 No 12, and Vol 4 No 3.

84 Psychedelic Decadence

Obsessive? If that letter wasn't safely hidden away in the pages of a magazine you'd think it was an admission from the young Peter Sutcliffe. Ultimately, the readers come on more like Eric Idle's 'nudge-nudge-wink-wink' character from *Monty Python*: pipe-smoking, ale-drinking, cravat-wearing losers. But somehow there's a strange kind of dignified calm hanging over these letters pages, a lot more interesting than the fist-pumping football chimps of current times. *Mayfair*'s readers seemed to take on the benevolent view that they knew what was best for the young ladies, especially regarding the wearing of bras/knickers/tights. Indeed, London and all its satellite towns spreading out into the green belt appeared to be populated by middle-aged men with extensive knowledge of women's undergarments and WWII battle strategies; like those philanthropic gents from another century they have no visible means of making a living and too much time on their hands. And all this was healthily encouraged, as this typical editorial response (Vol 4, No 3) to an 'anti-tights' letter proves:

> Tights have plenty of erotic delights of their own. They have introduced that taut transparent crotchpiece that appears when a girl spreads her thighs… When you roll them off, like skinning a rabbit, it is a simple matter to whizz off the pants with them.

That's right — skinning a rabbit. Images abound of Simon Raven types all over the country putting pen to

1. A more contemporary example: an anonymous friend was having a tug over a porn mag, turned the page, and — to his horror — encountered a photograph of Larry Flynt with his guts hanging out. The excitement rapidly disappeared. Or so he told me.
Fast-forward to a 1980 *Mayfair* (Vol 15, No 10): deep within the pages, hidden between the six photo-shoots, lies an article on John Merrick, the Elephant Man. Some beautiful women and a hideous creature vying for your attention. Many readers probably never approached that issue again with thoughts of an erection. What an earth were the publishers *thinking*?

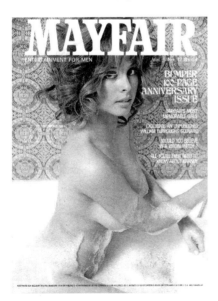

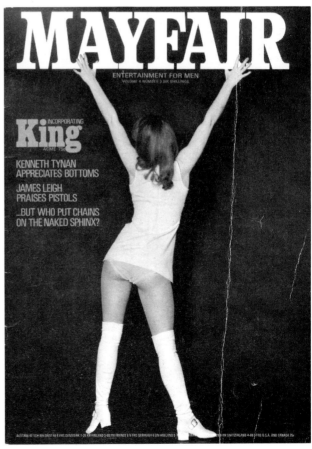

Six Shillings to Happiness

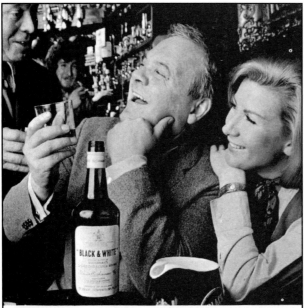

Patrick Wymark entertains.

The Earl of Strafford suffered from gout, before they put him out of his misery—on the scaffold.
That's the part I play in the new Columbia picture, "Cromwell".
When I wasn't rattling around in a coach, I was shuffling around on sticks.
It was exhausting.
After that I was appearing nightly at a Brighton theatre, playing a nun.

All dressed up in black and white habit.
Which brings me to *my* favourite form of entertainment.
An evening at my local. A few friends. And a few glasses of 'Black & White'.
Entertaining people enjoy the big flavour of 'Black & White'.

paper after witnessing a mini-skirted dolly bird accidentally flashing her undies in some pub beer garden or other. These were men bloated by too much real ale, unable to move with the quick-changing times. Glued to their leather smoking chairs, they can only watch in amazement as the hip scene mutates around them. This stationary philosophy provides occasional nuggets of off-kilter thought:

> It has often given me food for thought that the word 'sadism' was derived from the fantasies of that pitiful subject, the Marquis de Sade and that therefore the onus for cruelty has been placed on the shoulders of the male sex. I have personally found that for sheer viciousness, the female species can by far outrank us in this field especially when very young. In teenage gangs it is generally the 'Mamas' who incite the roughs to violence.
>
> (Vol 5, No 12)[2]

VICTOR gets the birds!
Acqua di Selva
cologne for men
also: After Shaves, Deodorants and Talcum Powders

Next page: *Mayfair* Menswear — Snaps taken from 'Sex and the Single Suit' (left) and the ('no longer poncy') 'Gay Is OK' articles.

This smells less of concern for such groups arising than a naughty desire to punish the delinquent girls. Perhaps it's intentional that the shadow of history's ultimate good-time bad boy should dart fleetingly through the pages of *Mayfair*. With the Marquis long dead, the editor did the next best thing and employed Burroughs. But, if de Sade were to magically appear in 1970s London (*de Sade A.D.1972*?), I'm sure his sulphurous reputation would be exploited to every end: they'd have him popping up in fags and booze adverts in no time; if the actor Patrick Wymark[3] could flog readers scotch whiskey, anyone could.[4] And these lifestyles required the right kind of clothes, so there were also fashion spreads usually featuring a hirsute male and a suitably sycophantic female model. In one such feature, 'Sex And The Single Suit' ("A suit which makes him feel complete and poised. Like a man should."), the male contingent looks disturbingly like cheesy TV magician Paul Daniels; in 'Gay Is OK' a man with an alarming (false?) moustache shares photo space with an afro'd black chick. She looks quite sexy, just happy to be there; his clothes make a good case for universal colour-blindness. The accompanying message reads: "The hard fashion lesson for all men is that patterns are no longer poncy".

Far be it for *Mayfair* to make their readers feel like a bunch of poofs. Five pages down the road waits William Burroughs, probably the most masculine homosexual the magazine's readers ever encountered. Certainly the furthest out. 'Twilight's Last Gleamings', Burroughs' wild film 'scenario' makes its first appearance here[5], as do other delights such as 'The Voracious Aliens', an essay on the extra-terrestrial take-over of humanity's inner-space ("The virus thrives on unthinking conservatism") that utilises the work of other literary outsiders, such as Colin Wilson's *The Mind Parasites*. Whereas other articles bandy about over subjects such as women's choice in colours regarding their sexual appetites, Burroughs stands alone at his lectern, ready to take the reader to places far from military hardware and colourful girls. You can almost imagine him announcing: "Gentlemen, if I can divert your attention away from this rampant heterosexuality for one moment, I believe we have more pressing issues at hand…"

Whether his words were studied or skimmed over is unknown, as some areas in *Mayfair* remain untouched by the radical hand. The culture guide, for instance. Books, films, night-life, drink, television and toiletries are all present, although the critics seem to exist on some higher plain, unaware that to a vast number of readers these are books that'll never be read, films that'll never be seen (Pete Walker's *School for Sex* gets a bit of a pasting), night-clubs that won't let you in and drink that's way too expensive. That only leaves the last two. And

2. In Vol 5, No 11, a letter appears from a Scientologist 'explaining' the 'Reactive Mind'. The letter following it is about rubberwear.

3. Strangely enough, Wymark — relevant to these pages through appearances in *Matthew Hopkins: Witchfinder General* and *Blood on Satan's Claw* — kicked the bucket the same year the ad appeared. The cause was a bit of a mystery; but here's a clue: the photo has a large bottle of whiskey in front of him.

4. Witness also the full-page advert for a 'Strip Light' ("The only girl in the world who takes her clothes OFF when you put the light ON"), which includes the telling line: "Send away now for a light for your room, for your friend (or send for several for your club)."

5. It can be found in *Exterminator!* (1974).

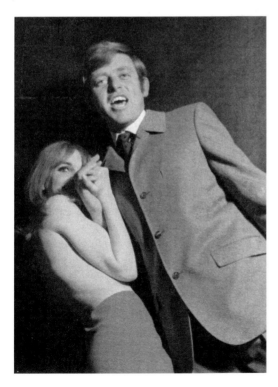

Six Shillings to Happiness

how much fun is it to sit at home, watching the TV, doused in Hai Karate?

Maybe I was born twenty years too late, but if your obsessions lead to cheap British horror films and voluptuous, heavily made-up girls with a touch of hippie in them, it's worth wading through any amount of drooling letters and aftershave reviews to find the gold dust. This really is the road to Oz, and *Mayfair*'s cinema articles are wonderful; anchored in the arena of sex, but showing much, much more as well. For instance, 'The Other Cinema' (Vol 4, No 3) — 'where to find the rare bare films of the hippie movie industry' — by Sheldon Williams (a Peter Cushing type in a bow tie) not only skits briefly over the work of underground luminaries such as Jack Smith (*Flaming Creatures*) and Harrison Marks (*Come Play With Me*) — as well as mentioning Kenneth Anger and *Pandora's Box* — but also tells you the difference between home-made, blue, girlie and striptease films and explains the various methods in which they can be viewed: through film hire, repertory cinemas,[6] clubs and societies. The (still active?) Gothique Film Society sounds like heaven, with membership at only 30 shillings. Williams is most helpful even in totting up the cost of making your own film, giving a list of cameras, projectors, film and screens for the budding dirty movie-maker. European sex films get their fair share of promotion in 'The Other Cinema' as well as elsewhere; 'What The Bishop Is Missing'[7] contains enough stills from Swedish and Italian flesh-fests to make excited audiences defect *en masse* to their local repertory cinemas, leaving every Odeon in Britain emptier than a post-shag scrotum...

Top: Sheldon Williams, 'opponent of censors', according to the biographical blurb in *Mayfair*.

6. Outside of London, a typical season at Birmingham's Cinephone included *Madchen Madchen*, *Sex Quartet*, *Pussycat*, *Virtue Runs Wild* and *Mondo Bizarre*. Manchester had to make do with *Comic Strip Hero*, *A Question of Rape*, *Mondo Cane No 2* and *The Bonnie Parker Story*.

7. Vol 4, No 8. Referring to the then Bishop of Lichfield's attack on 'the sexual motive in today's cinema'.

As the 1970s arrived — bringing with them a heavy dose of nudity everywhere so that you only had to blink and, for example, Dennis Wheatley's entire *oeuvre* was repackaged with topless girls on the covers, worshipping devils or otherwise — the pensionable horror film industry finally caught on and realised that sex sold. Or, to paraphrase a line from the film *Eating Raoul*: people paid cash for gash. It may have been the age of the mini-skirt and see-through blouse, but you still couldn't beat a bit of tender, bare flesh (and some *Mayfair* readers obviously wanted to). Any film article in the magazine meant more photos than words. And these weren't the sort of stills you'd find flicking through *Sight and Sound*. If film-makers were quick to exploit nudity in their movies, then adult mags were even quicker to show their readers exactly *where* the cast started getting their kit off. 'Satan And The Skin Game' (Vol 5,

No 11) is a three-page feature on *Blood on Satan's Claw* (refered to here by its less common title *Satan's Skin*). Words like 'virgin' and 'nude disciples' compliment the great photos, which are mostly of the big-breasted naked dancer who gets Barry Andrews all excited towards the climax (with her pubic hair seemingly airbrushed out). Appearing in a decent film for once, Linda Hayden is at her seductive best, although there's too-few shots of her in the feature. Perhaps *Mayfair* didn't think her tits were good enough for their readers. Poor, misguided fools. At least one still is taken from the scene where she strips off in an attempt to seduce priestly Anthony Ainley; the caption reads: 'Linda Hayden, her mind taken over by the devil, tries to seduce the local clergyman, but sadly for him, she fails.' The rest of the text makes noises over how certain members of the cast and crew are related to various famous folk, but it's merely blah-blah-blah to the full-colour eye-candy on show. Just like in those Wheatley novels, the cultured gent of the time knew that devil worship tended to involve sex as well. The blood-letting and sacrifice was just a cover so that those dirty little kids could get up to no good. One issue on from this spread and the perplexing question is asked: 'Gentlemen, would you believe a Virgin Witch?' It heads a similar feature for *Virgin Witch*, a film that, to all intents and purposes, appears tailor-made for *Mayfair* readers: sisters Ann and Vicki Michelle head for the big city in search of success, but instead find devil worship and lesbianism. What an earth will become of them? And what an earth did become of them? Lovers of British tat will know that Vicki

Mayfair champions Ray Austin's *Virgin Witch* (1970).

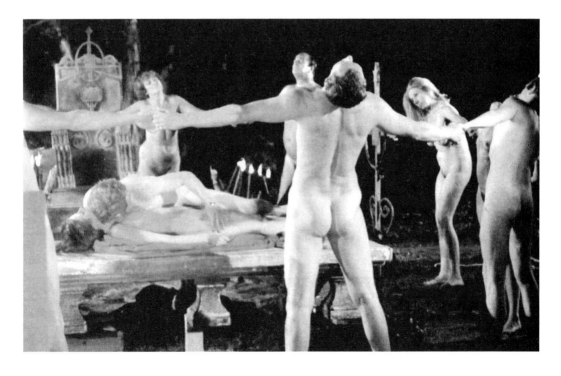

Six Shillings to Happiness

Michelle ended up tottering about as a French waitress in the sitcom 'Allo, 'Allo. But what of her sis? Ann Michelle did a great turn as the enthusiastic (and dead) biker chick in *Psychomania*, and little else, it seems. Pity. But there's no better souvenir than a glossy spread in a men's magazine, especially one with plentiful shots of rolls in the hay and naked initiation rites involving our two dark-haired innocents. Ann's breasts, oiled and alert in one photo, are described in the accompanying text as 'perky'. Such innocent days...

At the time, there weren't so many obvious connections between sex and horror. Nudity was there to pull the punters in, forcing them to sit through the 'dull bits'. *Blood on Satan's Claw* and *Virgin Witch* probably found fans amongst the men's mag readers. Any connection to the flesh was a good one. Anyone with a vial of interest in Hammer films will know that identical siblings Madelaine and Mary Collinson graduated from modelling to starring in *Twins of Evil* (1971), and were cast less for their acting skills than for their willingness to get their kit off. But *Mayfair* can claim to have had them in their pages first, a good few months before the innocent-looking eighteen-year-olds popped up in a *Playboy* centrefold. They're certainly famous enough now to Hammer fans, but back then, sharing issues with a topless Brigitte Bardot, Maddie and Mary were just a couple of underwear-clad girls, strategically placed to brighten up another fashion shoot.

And here we reach the vital point. For all the articles and features and classy writers, what about the *girls*? Isn't that what a ten-page dirge on traction engines was about, cover for the models? Not legends like Bardot or those touched by film roles, like the Collinson twins, but the real women: tits out, legs not-quite wide apart; a glimpse of pubes and definitely *no* gynaecology. Just three pages of natural poses and an interview as light as a helium balloon. Read the words later, look at the pictures now. Okay, so to today's devourers of porn mags these women at first glance hardly induce a rampant tugathon that the omnipresent, raven-haired Veronica or colossal sex-machine Linsey Dawn McKenzie probably initiate, but there seems to be something so much more *sexy* about these silicone-free '69–70 girls. I'm not going to enter the realms of the crowd-pleasing liberal and carp on about 'natural' looks etc. The more make-up the better — it's probably to do with that, or the big hair.[8] Or the bedspreads or something. Anyway, to finish this chapter, here's a choice selection of beautiful *Mayfair* women, some of whom are probably your mother/aunt/father's second wife by now...

8. Hands up if you used to watch *Fawlty Towers* and find Sybil Fawlty quite attractive. Feel better for telling someone?

9. A film *The Hammer Story* describes as 'An absolute must for lava-lamp lovers everywhere, *Moon Zero Two* is so far out it's very nearly in.'

Amber

IS AMBER a woman out of time? *Mayfair* seems to think so: 'when we first met her, we were struck with the pert, bubbling mischief in her eyes. It reminded us of the captious girls of the Restoration, the swinging 1670s...' Yes, on the cover (Vol 4, No 8) Amber looks fine in lace-up bloomers, but she's really a hip Londoner in King Charles' court. Amber's biggest asset is her hair, all tight curls and straight

Photographs this chapter Mayfair / Fisk Publishing Co

Amber

golden tresses. It's pretty *wide*. She looks quite happy on the sheepskin rug, although — if the written information is anything to go by — this photo session must have been a blip in a full day: after designing fashions and running a boutique, Amber entered the wonderful world of films, appearing as one of Warren 'Alf Garnett' Mitchell's girlfriends in Hammer's sci-fi romp *Moon Zero Two*.[9] The lucky lady.

Six Shillings to Happiness

Gabrielle ANOTHER cover girl (Vol 5, No 12) with big hair. But gabrielle is safely in the sex kitten category. Her rusty-blonde curls are the last thing to catch the attention. She has a freckled nose and eyes that demand search parties; her enormous breasts stay *just there* in the many photos where she's draped over a bed. And what could be better than a naked woman in a bath, bubbles clinging to her curves? (A naked woman in a bath that actually fits two?) Gabrielle likes modern furniture and antiques. Hence, in one photo she sits in a plastic chair; in another she leans against a wooden chest of drawers. But a possible future of travel seems undecided: '...perhaps I should work in one of those private zoos. They always seem so happy there.'

Gail

MAYFAIR liked their blondes. Gail is the forerunner of today's home county mall chicks. If there was a slab of concrete consumerism springing up in 1970 no doubt Gail would be hanging around it. Or on the beach: beyond those thigh-length black leather boots exists a tan betrayed only by bikini marks. Besides looking quite lonely on a double bed, Gail sports the prerequisite tarantula mascara and (metallic?) blue eye-shadow. The decoration doesn't end there. On the cover (Vol 5, No 11) her patterned dress is carefully unbuttoned, but the right sleeve is tight enough to make it look like a full arm tattoo. Strange.

Josephine

UNLIKE some of the other girls, Josephine has an aura about her that suggests she actually enjoys sex. That is: quite willing to get down to it ASAP. Continuing the trend, she is blonde and has eye make-up that probably weighs a ton. But apart from the others — and ignoring the blue pants — she has striking fair skin and a wonderfully rounded body. In short, Josephine is the sort of woman you could spend days exploring, and always come up with surprises. To top that she reads Dostoevsky and Henry Miller. There's something frankly *dirty* about Josephine, I don't know quite what. She looks like she attends biker rallies 'for the company'.

Monique MEET Monique: 'She likes child-size clothes; skirts that make men turn their heads at her because the cheeks of her bottom show.' Monique is a pouting French poodle with tiny tits. But we forgive her. It may be something to do with the long, straight, dark hair; or the dirty lips; or the intergalactic eyebrows. She looks like a space-age girl. The prose claims she is 'shy', but it's a very carefully trained shyness. Monique probably pretends not to notice the lustful glances she receives, although she's well aware of her assets: hers is the first rib-cage glimpsed so far; and her arse and waist are like two ripe melons nailed to a stick. *Viva la France!*

Stephanie JUST to show that *Mayfair* wasn't all sweetness and lust, here's Stephanie, who 'knows she's sexy'. There's a fair chance that if you attended a party in 1970 and found numerous bloodstains dotted over the walls, Stephanie had been there first. The more sensible guests were obviously trying to knock themselves unconscious rather than spend another minute with her. A room would empty before she could finish saying "daaarrrllliiinnnggg!" Stephanie's looks are in that twilight zone between 'attractive' and 'ugly' and… oh, I could go on. She's just irritating. Far be it from me to judge someone purely on physical appearance, but she's got horrible, sloany tits as well.

Honourable mentions...

TOKEN Arabian babe *Sophia*, shiny and encased in gold chains ('I will dance for you if you like, and then make you some Egyptian sweetmeats.'); Petite *Maggie*, a curvaceous little minx with a rock'n'roll hairstyle; encased in skin-tight yellow jeans is *Charlotte*, the perfect seventies babe, with all the attributes of the day (hair, make-up, tan, tits) present and correct; and finally, *Alexandra*, a leather-clad goddess with deadly-looking breasts. One of the few models who doesn't seem to give a toss about the camera, Alexandra is very purposeful-looking; her face suggests that she wants to fuck you to death... and beyond.

Charlotte

AND THERE are more, waiting patiently in-between those glossy, ageing pages. Discarding the more conventional aspects of men's magazines — the world of sex manuals and probing questionnaires, of racing cars and fanciful letters — imagine a sister planet where the good stuff is infinite, where bad living is aided by radical writers, sleazy horror movies, and dynamic women: a colourful boudoir of pleasure ruled by a circular bed, on which you wrestle with Alexandra and Monique; Bowie on the stereo, *The Vampire Lovers* on the TV, Burroughs in your mind and, obviously, endless booze and drugs in the corner bar. An impossible trip? The tablets of instruction, old and forgotten, are still around us, in attics and basements, wardrobes and car-boot sales, waiting to be rediscovered. And the girls? The girls within are immortal. They are the Doriana Grays of adult magazines, a small price to pay for what they possess: ageless beauty and infinitesimal patience. It's up to you to discover them. *They* have all the time in the world.

Next page: Mary and Madeleine Collinson, sharing one bikini. *Mayfair* Vol 5, No 12.

Psychedelic Decadence

Real Class!

British Bikers Develop Psychomania

> Although they were supposed to be outlawed, Jerry knew what the noise meant. The sweat of fear ran into his blind eyes as he turned to face the Angels.
> —*Angels From Hell*, Mick Norman

> There was only one basic driving force… the constant need for kicks, any kind of excitement. The Angels needed speed, danger, thrills, sex… more than they needed their booze and their drugs and their outlets for violence.
> —*Speed Freaks*, Peter Cave

WHY SHOULD skinheads have all the fun? Richard Allen cornered the market in cropped-haired thugs in crombies and "the paki's teeth shattered beneath his fist — it felt good" prose in the early 1970s, but segregating the bloodletting to one particular tribe was never going to last. Everyone wanted a piece of the action, and publishers New English Library (NEL) were more than happy to oblige, hence Allen's boys' main rivals: the bikers. Piss-soaked denims, puss-caked beards and easy chicks with big thighs encompass the British biker of the period.

Especially in the written form. The most famous of this particular group are Mick Norman's[1] 'Angels From Hell', whose history spans a quartet of books beginning with vile initiation rites in *Angels From Hell* (1972) and ending in an attempt at psychoanalysis in *Angels On My Mind* (1973). But Peter Cave,[2] author of titles such as *Mama* (1972) and *Speed Freaks* (1973), deserves some kind of equal billing. In fact, all of NEL's 'youth-orientated' output takes an honorary place in that cultural dark alley of Fiction Schoolboys Shouldn't Read (which itself incorporates the chapter of Gross Scenes Recited To Amazed Mates), along with James Herbert and Guy N Smith, bless 'em. What is there today? 'He hugged the raver next to him — it felt good.' Ugh. Collected, the NEL books are an encyclopaedia of youthful extremities. A pulp of hedonism, violence and general prejudice it may be, but at least it's a British pulp. Reading just one book satisfies that element sometimes neglected by writers of fiction: escapism.

1. 'Mick Norman' is a pseudonym of the late Laurence James; see: 'Bike Boys, Skinheads and Drunken Hacks', an excellent James interview conducted by Stewart Home, to be found in his book *Confusion Incorporated: A Collection of Lies, Hoaxes & Hidden Truths* (Codex Books, 1999).

2. Absurdly-prolific, Cave has penned at least six biker novels. His overall track record would make most authors puke up their literary lunches. Charity shop rovings have uncovered war, eco-adventure, sci-fi and TV tie-in titles. And hang-gliding.

3. The awe with which these bikers hold their American counterparts in seeps through the pages of NEL's books. *Speed Freaks*, a post-Altamont tale of media manipulation and who's-playing-who games has Angel leader Mucky Mervyn practically wetting himself when he meets an American speedway rider who actually *knows* Californian chapters ('This was too much... actual, if secondhand, contact with the Mother Angels themselves.')

I've read only a fraction of NEL's output, but that's enough to form vivid impressions of these imaginary biker universes. Norman's ambitious books exist in some kind of bleak future, where the barren countryside between cities is one long motorway for gangs of Hell's Angels, led by rising star Gerry 'Wolf' Vincent; sociological comment — in the form of news reports, interviews and press cuttings — from various 'experts' interspace the action; Norman's chapter headings echo Michael Moorcock's use of newspaper headlines in his 'Jerry Cornelius' tetralogy. Cave takes a more straightforward approach

and stays in the present, letting his gang run wild in recognisable locations. Anyone who has resided in Bournemouth will dig chapter twelve of *Mama*, where the boss-lady and her boys kick up the turf of the town centre's gardens (it's bad news for a passing seagull). Both authors' creations are the bikers of oily dreams. Lawless and a law unto themselves: all-drinking, all-shagging, all-bone breaking fuckers with bottomless petrol tanks and a grudge against authority. And on top of all this, the hat is tipped to the assumed sex of the reader, so the eponymous Mama is equipped with long golden hair, big tits and a black, one-piece leather suit:

> It looked sexy, yet aggressive... almost a contradictory visual statement. The overall effect of the leather was masculine, virile, but it drew attention to the proud swell of her breasts, the tightness of her narrow waist and the smooth, rounded shape of her hips and buttocks.

As was the fashion. Cave's suffix-strewn lines ('-ly' is thrown onto every verb whenever the action heats up) contain plenty more goodies like this, as we follow Mama — or Elaine, to use her straight name — and her merry band on an inevitable downward spiral of destruction. Like all imaginary bikers, this mob are a rag-bag of mythology and diverse extremes, always — unfortunately it seems — riding to catch up with their North American counterparts. Another area where Britain is the poor cousin.[3] You let the throttle out in this Anglo Hell's Angels paradise and two seconds later you're hitting Birmingham. Not nearly enough room to breathe, let alone decide on a clear-cut choice of influences and role-models. Picture their clubhouse:

> A huge SS flag dominated one wall, accompanied by crudely-drawn swastikas and witchcraft symbols. Several nude pin-ups cut from various magazines adorned other corners of the warehouse, and a poster depicting Che Guevara wearing a halo sat next to a colour picture of Peter Fonda in a scene from 'Easy Rider'.

I can see the link between swastikas and witchcraft, even pin-ups and Peter Fonda, but Che Guevara and the SS? Still, who's going to be fool enough to

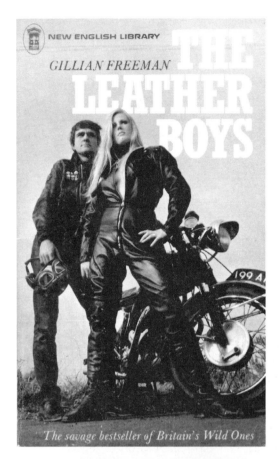
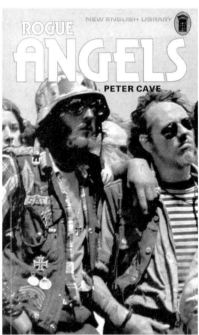

A sampling of Biker covers from the New English Library. There are *plenty* others.

100 Psychedelic Decadence

point this mismatch out to Elaine and her crew. What's far more important to them — as with Mick Norman's Angels — is the showing of 'real class'. A paperback definition (albeit a North American one) defines 'class' as:

> Achievement of status in Angel society by the performance of any violent, spectacular or shocking act.[4]

So real class to these bikers is snapping bones right out of the skin, or downing a bottle of whiskey and drilling a couple of girls, or taking it like a man during a faecally-inclined initiation ceremony. It's this real class that separates them from the thousands of sheep who exist in the council estates and concrete block shopping centres. "That was real class" or "he showed real class" become the complements that pepper these books. But with every climax the kicks lived by the Angels inevitably finish in a dead-end. Halfway through *Mama*, Elaine is planning a robbery, not to increase the strength and terror of her gang, but to flee to America and the motion picture freedom of its highways. Once they reach their apex of supremacy, Britain's bikers run out of acceleration space and look for somewhere bigger in this world to burn rubber. There are, however, other options…

MEET another gang, this time on film. They weave their Triumphs through a set of misty standing stones. Most of them wear black leather. Their helmets are crudely customised: white bones painted on, large white visors acting as goggles. These eight are The Living Dead, led by Tom Latham. The rest are his girlfriend Abby, a raven-haired hot-wire called Jane, and a surplus of blokes who are bikers by name, if nothing else: Bertram, Hatchet, Chopped Meat, Gash and Hinky.

Tom has plans. He wants to commit suicide to escape a world that has become boring. Abby is reluctant, but she doesn't know that he has the necessary resources for this transformation. Tom's mother is a spiritualist, operating from the family mansion, helped only by her ageless butler, Shadwell. Tom constantly quizzes them about death and resurrection, and why his father died in the house's mysterious locked room. Eventually, they agree to let him enter, protected by a peculiar toad amulet.

The room is a contrast of light and dark: white blinds and hollow screams, disappearing doors and freaky mirrors. Tom finds a pair of glasses on the floor. Putting them on, his reflection vanishes, replaced by a floating toad and piercing noise. Then he sees the standing stones, and watches as his mother — accompanied by himself as a baby — signs a contract with a faceless cloaked figure. Overcome, Tom collapses.

Tom has been in the place where his father died. The glasses were his. His mother explains to him that his father tried to transcend death and return as an actual member of the living dead, but he lacked the courage to make the

[4]. From the glossary of *The Sex And Savagery Of Hell's Angels* (NEL, 1972) by Jan Hudson: "The full story of America's motorcycle 'Wild Ones'."

Real Class!

leap: those who cross over must *really* believe that they are going to come back.

Armed with this information, Tom urges his gang to mark up a ton on their bikes. Abby doesn't share his reckless spirit but goes along anyway. Before they hit the duel carriageway, the gang terrorise the locals: kicking over cones, riding on pavements and generally upsetting the status quo. Trolleys, boxes and people go flying until the police turn up and give chase. The Living Dead lead them out into the countryside in a precarious race around sharp bends. Soon they have to split up, but Tom rides away from Abby and deliberately crashes off a bridge into a river, killing himself.

After meeting Tom's mother to ask permission to give him a biker's send-off, Abby learns from Shadwell that the chosen burial ground — the standing stones known as the Seven Witches — is so called because a group of witches broke a bargain they had entered into, and so were turned to stone as punishment. Shadwell and Mrs Latham realise that Tom has no intention of staying dead.

Shadwell briefly attends the funeral — a subdued affair with acoustic guitars and flower chains — to drop the toad amulet into Tom's grave. Tom himself is buried upright on his motorbike. Jane uses the occasion to declare herself the new leader of The Living Dead. The gang reluctantly agree.

Psychomania: going nowhere fast.

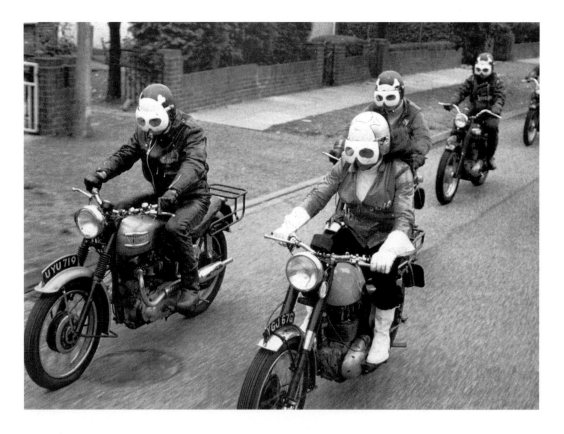

102 Psychedelic Decadence

A broken-down motorist takes a shortcut across the Seven Witches and witnesses Tom's resurrection — flying out of the grave on his bike — before dying under his wheels. Now very much immortal, Tom strangles a petrol pump attendant, telephones his mother from a pub, flirts with a local girl and, when she tries to cadge a ride off him, kills her too.

As the police, led by Chief Inspector Hesseltine, become involved, The Living Dead find themselves under suspicion of the murders and Tom's grave empty. Even when Tom makes an appearance they refuse to believe it's really him: only when he survives being stabbed in the back do they realise what he's become. Jane and Hinky jump readily at the offer to join him, driving full-speed into heavy traffic, but only Jane survives to cause havoc on the road. Tom tries to persuade Abby to join him in death, but she still has doubts.

Hesseltine arrests the gang, and assumes that a couple of morbid impostors are riding around on Tom and Jane's bikes. The pair free the remnants of The Living Dead from the police cells — killing a few coppers in the process — and urge them to join the real living dead, which they do in quick succession: Chopped Meat dives out of a tower block window, Gash carries himself and a load of weights into a canal, Bertram goes parachuting without a parachute, and Hatchet bellyflops off a motorway bridge. Abby chooses a more serene exit with pills. She dreams of meeting Tom at the Seven Witches, and riding off on the back of his bike. But the dream soon turns sour as she is left alone to watch her body be subjected to some kind of black mass autopsy by another Abby — dressed as a nurse — and a shadowy, cloaked figure holding a dagger.

Although she survives, Hesseltine leads Tom to believe that Abby died. After the gang's corpses disappear from the morgue, he still thinks that a group of grave robbers are behind it all and sets a trap with Abby playing dead on a slab. Unfortunately, Hesseltine and his constables are the ones who end up as corpses.

Now that they are all — except Abby — undead, the gang are back on the road, riding wild in a supermarket. Still suspicious, Tom dares Abby to motorcycle through a brick wall, but she blows her cover by chickening.

Tom's mother feels she has to stop her son. With Shadwell, she decides to break the contract she signed when Tom was a baby, even though it means sacrificing herself. Out at the Seven Witches, Tom and the gang give Abby a choice: kill herself and join them, or be killed and die forever.

Shadwell and Mrs Latham perform a black magic ritual involving a sword and a toad. Winds begin to blow, both in Latham Manor and at the Seven Witches. Abby takes the gun offered by Tom and shoots him, to no avail. Tom's mother has been transformed into the toad. The ritual is complete. Before Tom can kill Abby he is slowly turned to stone, along with the rest of The Living Dead.

Distraught and alone, Abby is joined by Shadwell, the cloaked figure from Tom's childhood vision.

Real Class!

Below: Down, down, deeper and down in *Psychomania*. Abby (Mary Larkin) says goodbye to Tom (Nicky Henson), while (bottom) Abby and Jane (Ann Michelle, right) disagree over funeral arrangements. Next page, top: Hatchet (Denis Gilmore) prepares to hit the road, as (below) Abby gets her first supernatural snog.

The film is *Psychomania*, a 1972 release from Benmar Productions, directed by Don Sharp, and written by Arnaud d'Usseau and Julian Halevy. As British films go, it's weird. As British *biker* films go, it's very much out there on its own. A real mind-snapper. In a fight, The Living Dead would inevitably be slaughtered by Mama's mob. And then probably pissed on for good measure. They're blow-dried bikers, riding the sort of machines that old men wheel out at county fairs. Whereas Mama feels the need for speed (the drug and physical state), The Living Dead pass the comb around after a run. All the blame can be put on their leader, Tom. Played by Nicky Henson in a white polo neck jumper, he thinks he's pretty cool, with his inexplicable death-wish and snappy lines ("it's not me that scares you. It's the *world*"), but he's really just a more streamlined version of Robin Askwith, after the laboratory got the formula right. The rest of the gang fair little better. Tom's wet girlfriend Abby (Mary Larkin) looks more like a denim-clad Bay City Roller's fan; she even has her name sewn on in yellow. The men are a mixed bag of bit-parters, distinguished by *their* painted-on names and little else: Hatchet (Denis Gilmore) is a squat ginger trotter; Chopped Meat (Miles Greenwood), The Living Dead's token hippie; Bertram and Gash (Roy Holder and Peter Whitting) are interchangeable, and just as anonymous is the short-lived Hinky (Rocky Taylor, the one actual motorbike rider in the gang). Only Jane (Ann Michelle) lends a touch of real class to the gang. With long, dark hair, red leather jacket and white boots and gloves, she seems up for anything, enthusiastically jumping at the chance to top herself in return for immortality:

TOM: You can only die once. After that, nothing and nobody can harm you.
JANE: Oh Man! What are we waiting for?!

But one character doesn't carry the rest. Sonny Barger[5] would shake his head and mutter "Man, is this the best you could do" (before decapitating

Tom and forcing Abby to pull a train, no doubt). But what The Living Dead do share with their sleazy literary counterparts is an unnerving sense of self-destruction. There is only a certain point they can reach as a gang before nothing else can be achieved, before no more minds can be blown. Mama tries to escape this by fleeing to America. Tom's plans are bigger: he wants immortality — wants to kill himself in order to return. It's a more imaginative escape route than any dreams installed by repeated viewings of *Easy Rider*.

Luckily, Tom has the right background. And the tools. In Latham Manor — an art-deco nightmare of stone/wood walls, red leather chairs, yellow cushions and astrological backdrops — lives his spiritualist mother (Beryl Reid) and her dapper butler, Shadwell (George Sanders, obviously). Shadwell reveals his cards early on when he grimaces at the sight of a cross. And the recurrence of a toad ring on his left little finger states implicitly that he's the devil himself. Sanders was always good at playing the advocate: Shadwell comes across

as an older, more world-weary Sir Henry from *The Picture of Dorian Gray* (a part the actor played), bemused by the kids, but ready to take their souls without hesitation.[6] With these two for company, what could go wrong? Tom acts flirtatious with his mother, dancing a waltz and correcting her English: 'fuzz' for 'police', 'busted' for 'arrested'. A real lovable rogue. But for all the talk of blowing minds, Tom sure has his blown in the locked room. To an eerie two-tone accompaniment. Shat out of the other side of this black magic Pandora's Box, he now has bigger plans for The Living Dead.

This man is truly a leader: there's even a heavenly choir as he speeds off the bridge to his death. With no regard for officialdom the rest of the gang bury him themselves, his head above ground, the burial mound conspicuous. This induces a wave of sentimentality that New English Library would have ruthlessly censored out of their books. The remaining seven reveal themselves

5. Real name Ralph Hubert Barger, 'Sonny' was the president/spokesman for California's Oakland chapter of the Angels. He was 'adviser' for — and had a cameo role in — the Jack Nicholson biker movie *Hell's Angels on Wheels* (1967).

6. Too close to reality. Bored with life, Sanders killed himself in the year of *Psychomania*'s release, aged sixty-six. He didn't come back.

Real Class! 105

to be just another bunch of cinematic hippies. Bright clothes rule: mini-dresses and waistcoats, flared jeans and hands on hips. By this point it'd be too much to hope that they shove Tom's corpse arse-first onto a sharpened pole, douse him in petrol and parade his blazing remains around the town centre. No, they sit quietly in small groups and make chains of flowers to throw in his grave. Chopped Meat has now embraced this attitude totally and become a cheesecloth-shirted fuck with an acoustic guitar and a song for the occasion:

They tried to clip his wings just like a fly /
so instead of standing still he chose to die

Just who is he singing about here? Certainly no-one in the film so far. The song is 'Riding Free'. Chopped Meat is miming. And he isn't playing the guitar, simply strumming it, changing chords meaninglessly to add to the illusion. In another dimension, Black Sabbath pull his intestines slowly out through his navel.

"*That lot!*" Chief Inspector Hesseltine (Robert Hardy) picks up the Living Dead's trail.

They tried to tie him down / to make him place his two feet on the ground

Three people — David Whitaker, John Worth, Harvey Andrews — composed the song. One wrote the music, one the lyrics, one sung it. Three people. The original score by John Cameron fares much better. The title song, played over The Living Dead's slow-motion manoeuvres around the Seven Witches, is groovy as hell. It comes on like the *World In Action* signature tune[7] done over by a mess of session musicians, all bloated on hash cake. Organ and guitar led, it crawls into a slow descent, with the lead guitar seemingly on the edge of contracting wah-wah fever. A fitting theme for a bunch of diabolical bikers, much more so than Chopped Meat's lame effort.

The chaos caused by Mick Norman and Peter Cave's bikers is painfully sadistic, and usually involves a helpless ethnic group.[8] Tom's gang play it safer and swarm over a shopping precinct, instigating strategically-placed hassle: hotpants-wearing young mothers pushing prams are chased, a baker carrying a tray of goods (where has he come from? Where is he going?) is sent flying, a man standing on a stepladder that leads to nowhere is tipped off-balance. Luckily his fall is broken by a pile of cardboard boxes below. The fuzz, naturally, make a quick entrance. The gang lead them out into the green belt,

On a highway to Hell. *Psychomania*.

down roads so familiar (possibly circumnavigating film studios) that you half expect the car chase from *Scream and Scream Again* to be following.

Perhaps the gang are happy to be escaping such a place. Renowned yokel actor Roy Evens is lucky enough to witness Tom's resurrection: shooting out of that odd-looking mound on his motorbike; a pub looks like the women-and-kids area of a working man's club: half a Skol and a packet of cheese and onion crisps. The warden from *Dad's Army* is behind the bar. A couple of local tarts flutter their eyelashes at Tom. The place seems to have crawled out of a Pete Walker film. Until Tom's resurrection, you imagine that the police hardly have their work cut out. Chief Inspector Hesseltine (Robert Hardy) is a straight-talking copper from some indeterminable part of Northern England, cut from the same cloth as Donald Pleasence in *Death Line* and Alfred Marks in *Scream and Scream Again*. All three are old hands at bizarre crimes. When the dead girl's friend tells him she was killed by one of The Living Dead, Hesseltine glances around intensely and hisses *"that lot!"*

But the fuzz are unable to stop The Living Dead from killing themselves. From Jane and Hinky's head-on enthusiasm (complete with comedy wheels bouncing over concrete), the rest really throw themselves into it with gusto. A bunch of Hell's Lemmings. Tom and Jane's antics seem enough to convince anyone; terrorising old ladies and truck drivers ("YOU STUPID KIDS!"), they even manage to induce petty jealousy in Abby (jealous of what her dead boyfriend and a dead girl are getting up to?), the real outsider in the group: "well, you two must be having fun!" Drowning or crashing into the ground like a sack of mouldy potatoes seems a small price to pay, although they're all pretty

7. Which was based on the title track of Canadian prog-rockers Mountain's 1971 album *Nantucket Sleighride*.

8. Though the gang in *Mama* does include Winston Oliver, a high-kickin' martial arts black dude who, once he proves he has real class, is swiftly rechristened 'Superspade'.

Real Class! 107

intact — and alive — in the morgue. Ordered to come down by a passing policeman, Chopped Meat jumps from a tower block window — an easy way out considering his former crimes; oblivious to passing cars, and clad only in Speedo shorts, Gash carries a fetching necklace of heavy metal towards a canal; Bertram exits a plane(?) without a parachute, leaving the audience to wonder if a member of the *Psychomania* crew had a sideline in aerial photography; the best and most convincing death belongs to piggy little Hinkey, bellyflopping off a motorway bridge, a smile on his face as he dies under the wheels of a van.

Faced with the NEL competition, The Living Dead may be a bunch of wimps, but they're tough as nails compared to Abby. How the hell did she get into this gang? It's a wonder she doesn't ride a pink motorcycle. She even tries to kill herself in a soft way, with pills. Drifting off to Hades, Abby's dreams have the fuzzy focus of a Vaseline lens: she wears a loose-fitting, patterned dress and waits for her man to ride up. As the film ends, Abby is the sole surviving member of The Living Dead, but you feel she'd be of little use to Shadwell. Or anyone.

In *Mama*'s final chapter, Elaine gets dragged to the cells screaming revenge; *Angels From Hell* closes with a poem and a (kind of) new beginning; *Speed Freaks* plants the stops on its Angels' greed with a spectacular, bloody conclusion. Tom and his living dead buddies — in fitting with a film where plausibility is not part of everyday life — are transformed into ugly stone. No matter how fast they ride, all these bikers cannot escape moral consequences. The dreams aimed for are kept out of reach by death. Tom's mother asks her resurrected son: "what are you going to do next?" To which he replies:

> There's lots to be done. For starters d'you know how many policemen there are? And judges? Teachers? Preachers? Do-gooders?

But all these plans are hollow. America or the afterlife, the violent way in which these imaginary bikers live cannot last forever. There's only so many minds that can be blown before the repercussions begin. Mrs Latham's question is their eternal dilemma. Through Mick Norman and Peter Cave's worlds, to the weird landscapes of *Psychomania*, the size of the tiny island they live on means that no-one is going to get away with it for long, that no plans are going to go unnoticed, that no group is going to remain autonomous forever. Cave nails it home with perception in the last lines of chapter ten of *Speed Freaks*:

> The strongest chain is only as good as its component link. The very essence of the dropout is weakness, inability to cope, let alone conquer. The essence of Angeldom was destruction... and destruction is a two-edged sword.

You said it, man. Burn, baby, burn!

Filthy Towers

Basil Fawlty and S.E.X.

WHAT'S the connection between Basil Fawlty and Aleister Crowley? It's a slight one, but still a connection. One is probably the finest comic creation ever to have emerged from Britain: the psychologically unsound hotel manager of *Fawlty Towers* who terrorised his customers and always assumed the mantle of righteousness. The other was an egotistical occult hero admired by moody males the world over.[1] Still a bit tenuous? A fictional character, Basil Fawlty was created by John Cleese and Connie Booth. Crowley was an actual person who devised his own mythology.

There's nothing too deprived about the connection; in fact, it's rather quaint. What links Basil Fawlty and Aleister Crowley is Torquay, a popular seaside resort on the south coast of Devon.

Not much, is it? But perhaps these two larger-than-life characters have something more in common, thanks to their extreme differences in one crucial area: sex. Crowley, the old tart, used to put it about a bit, mainly under the pretence of achieving some kind of mystical union; sex magic, as it was called. His famous maxim, 'Do what thou wilt shall be the whole of the Law,' covers a Hell of a lot of ground. Whatever the man's numerous shortcomings, at least he practised what he preached. As long as it involved him, obviously.[1] No hang-ups there about sex.

Basil Fawlty, on the other hand, carried enough repression to equip the whole of merry olde England. *Fawlty Towers* never descended into murky *Confessions*/Robin Askwith[2] territory (although its structure owes a lot to farce), but there was usually some indication of sexuality present: scantily-clad guests, Basil's misinterpretations, his wife's course innuendoes. Basil had two reactions when faced with the problem of s.e.x. If it involved a man in any way: scathing disgust; a woman: toadying fear. Two episodes in particular deal with his conflicts with the Big Sex Monster, fights he inevitably loses.

As played by John Cleese, Basil Fawlty ranks as one of the most complex comic characters of all time; certainly of the 1970s, where there was more than enough comedy brilliance around. You could have ensemble brilliance (*Dad's Army*), or intimate brilliance (*Porridge*). But, in the end, all the best television shows came down to one thing: fighting. The Home Guard of *Dad's Army* were fighting a war they could never be part of; Norman Stanley Fletcher, doing *Porridge*, was constantly fighting the prison system (and usually winning). Basil Fawlty was fighting for an England that had long since vanished, a time of gallantry and courtesy, where no man wore his hair long, no-one chewed gum, and good manners were all. The gleeful re-instatement of the class system, basically.[3] Here was someone still clinging on to the disintegrating remains of the British Empire — the old order — holding back the advancing armies of bra-less women and tight-trousered men. At the time of *Fawlty Towers*' first broadcast in 1975, the only other creation that could hold a candle to Basil's insanity, prejudices, and ruthlessly bigoted attitude was Leonard Rossiter's Rigsby in *Rising Damp*. But, despite a full boarding house, Rigsby was practically alone in his fight against a changing England. Basil always had his wife, Sybil (Prunella Scales), around to point out the hysterical error of his ways. As she tells him in 'The Psychiatrist': "you're either crawling all over them licking their boots, or spitting poison at them like some Benzedrine puff-adder."

Fawlty Towers ran for only two series. Six episodes each. Remarkably, for a comedy show of that decade, there is no surplus fat to add to those six classic hours: no Christmas specials or spin-off films. The hotel staff — Basil, Sybil, Polly and Manuel — did their job and then disappeared into comedic immor-

1. Especially Led Zeppelin's guitarist Jimmy Page, who went so far as to buy Bolekine House, one of Crowley's former homes, situated on the shores of Loch Ness. See *Hammer of the Gods: Led Zeppelin Unauthorised* by Stephen Davis, Pan Books, 1995.

2. Wasn't Crowley's autobiography entitled *The Confessions of Aleister Crowley*? Would Askwith play him in the film adaptation?

3. In one of the most extreme instances of this, 'A Touch Of Class' — the first episode of the first series — Basil fawns with attitude over a supposed aristocrat, Lord Melbury. Michael Gwynn — the actor playing Melbury — is the spitting image of George Orwell. In the final episode of series two, after Basil and staff have been castigated by the hotel inspector for keeping an unhygienic kitchen, chef Terry (Brian Hall) defends himself by saying: "Have you ever read George Orwell's experiences at Maxim's in Paris?" Panicking, Basil replies, "No, do you have a copy? I'll read it out in court!"

4. Fans of *Python* and residents of Torbay may well know that Goodrington beach and YMCA were used for sketches; as was the main seaside road between Paignton and Torquay, a route travelled by John Cleese — in "and now for something completely different" announcer mode — on the open top deck of a double-decker bus.

tality. The show's origins come from John Cleese's involvement with *Monty Python's Flying Circus*. The *Python* team were filming in Torbay[4] (a district made up of Brixham, Paignton and Torquay) in the early 1970s, and staying at the Gleneagles Hotel in the Babbacombe area of Torquay. The hotel's manager was, apparently, a proper little dictator, ruling the establishment with an iron hand, terrorising staff and guests. All this was duly noted by Cleese, who went on to write the show with his then-wife Connie Booth.[5] The rest is comedy history. Cleese himself suffered a nervous breakdown after completing the show, such was the intensity of Basil Fawlty. Forget Robert DeNiro in *Taxi Driver*, surely the most dedicated, demon-driven performer of the 1970s must be John Cleese?

The basic premise of *Fawlty Towers* is this: Basil is always wrong, and Sybil is always right. Whilst he scurries around fretting like a "brilliantine stick insect", she effortlessly deals with the hotel's problems without even putting down her cigarette. The fact that she *is* always right is a source of constant irritation to Basil, even though he's terrified of her. Sybil seems more at ease with the 1970s, existing in a casually created atmosphere, signified by her big hairstyle and clothes and chatty bar manner (not forgetting that laugh. Basil: "reminds me of somebody machine-gunning a seal"). Basil — in his ill-

5. An odd myth surrounding *Fawlty Towers* is that it was actually filmed in Torquay, or, at least, the exteriors were. But all the external filming took place around the home counties. For the sake of authenticity, Basil can be seen reading a copy of long-forgotten local newspaper *The Torbay News* in one episode. In the 1980s a small hotel opened in Torquay named after the show. In the interests of quality, it should be noted that its B&B neighbour was called 'EastEnders'.

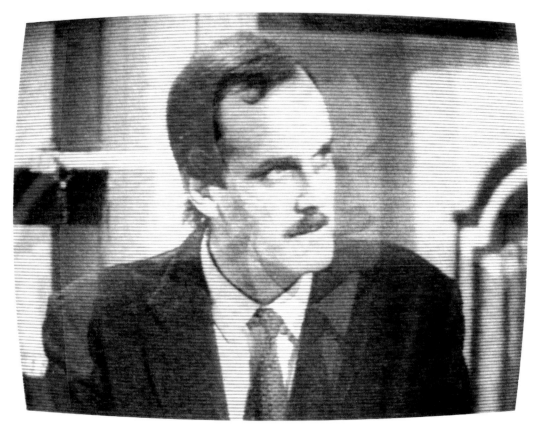

Basil (John Cleese), 'The Wedding Party.'

Filthy Towers

fitting, dull suits and antique moustache — has gone beyond being a flag-bearer for decency to enter an anxious world of his own creation, still clinging desperately on to the lost empire and its heroes. The ghosts of Rudyard Kipling and David Lloyd George dog his every move, and he possesses the unique talent of being ruthlessly snobbish whilst simultaneously fawning at the feet of those a class above him. Armed with unbreakable assumptions, he can never admit defeat or say that he is wrong (more or less the theme of every episode). When faced with modest superiority from a guest, he resorts to sarcasm. But Basil's very personal demon is the Big Sex Monster, and, in a decade where he seems to be surrounded by indecency, there is no escaping it…

THE HOTEL air in 'The Wedding Party' (series one, episode three) is thick with physical sexuality — real or imagined. This is West End farce rewritten by some dubious Austrian psychoanalyst; something that might have been intentional, given Basil's encounters with Polly Sherman's (Connie Booth) sketchpad. Her surrealist talent turns up in numerous episodes, usually in the form of a picture left about to rile her boss. In 'The Wedding Party', it claims a direct influence over him, when he tells Polly:

> I know these kind of drawings are considered decent at art school but would you please not leave them lying around on display at reception.

Then Basil proceeds to flick through the pad, until the telephone rings, and he answers it with: "Hello, Fawlty Titties…"

Throughout the episode, Basil oozes a puritan hypocrisy worthy of the Witchfinder General. When a couple, Alan and Jean (Trevor Adams and April Walker), book in, Basil takes an instant dislike to them. Why? Probably because they're young, frivolous in attitude (under his breath, Alan comments, re: Basil's dress sense, "that's a nice suit") and seem to be enjoying each other's company. They're also not married. To Basil Fawlty, marriage is an unhappy institute, so why should others have fun? From here on he treats Alan and Jean like a couple of toilet-traders who, given a double bed, will no doubt indulge in some kind of illegal activity:

> BASIL: Well, I can't give you a double room.
> ALAN: Oh look!
> BASIL: It's against the law.
> ALAN: What law?
> BASIL: The law of England. Nothing to do with me.

Also staying at the hotel is Mrs Peignoir (Yvonne Gilan), an attractive French woman, with whom Basil has been casually flirting. Guests such as herself, and Alan and Jean, flit around Basil with carefree ease as he tries to

uphold dubious standards, fighting promiscuity, loose morals, and perversion. The last is what's mainly on Basil's mind. He knows what is right, knows what the younger generation get up to. His prejudices are reinforced when Alan comes down to reception later, and Basil jumps to conclusions that probably don't even cross well-adjusted people's minds. Innocently enough, Alan inquires if there is a chemists still open in town; Basil instantly thinks: contraceptives, and becomes mortally offended when Alan asks:

I don't suppose you've got a couple?

BASIL: Now look! Just don't push your luck. I have a breaking point you know.

Sybil (Prunella Scales), 'The Wedding Party.'

When Alan continues to explain that he only wants some batteries, Basil thinks: vibrator.

You know something? You disgust me. I know what people like you get up to and I think it's *disgusting*.

People like you. Basil was probably glued to the television in previous weeks, watching a *World In Action* special on the 'permissive society', tutting to himself as he kept one eye on the screen. All Alan actually wants is to have a shave, leaving Basil once again down an alley he cannot back out of. If you

look closely, you can almost see the twitches of realisation on his face, first signs of an eruption of embarrassment.

The private life of the Fawltys speaks volumes, about Basil in particular. Witness his and Sybil's sleeping arrangements: single beds. Who made that decision? Probably Sybil. She is clad in some kind of frilly nightie that looks as if it's having a fit; hair in rollers, magazine (something called *Sexy Laughs*), chocolates. Basil, in striped pyjamas, is as uptight — and upright — as he'll ever be, trying desperately to read whilst Sybil drags out one of her bizarre telephone conversations ("Ooh! I know..."). But the paperback in his hands is hardly the highbrow fare we'd expect: Peter Benchley's *Jaws*.

Polly (Connie Booth), 'The Germans.'

And what about the staff? If all-rounder Polly is the scapegoat/problem-fixer that Basil can communicate with, then linguistically-challenged Manuel (Andrew Sachs) is simply a scapegoat. Basil displays his superiority over Manuel — in fact, over any foreign people — by using bullying and sarcasm. Late at night, through convoluted circumstances, Alan witnesses a drunken Manuel (who has been out celebrating his birthday) leaning over Basil, exclaiming: "I love you!" The next morning at breakfast, a hungover Manuel collapses on the dining room floor, and Basil instigates close contact in trying to get him up. The looks on Alan and Jean's faces suggest that they've already made up their minds what sort of 'working relationship' this pair have. In their eyes, the hotel manager takes nightly advantage of his employee's arse. Cowering Manuel *is* actually the object of a man's affections in another episode, 'Gourmet Night',

when a gay, alcoholic chef falls for his Mediterranean charm.

Basil Fawlty an aggressive homosexual? Nah. His repression lies elsewhere, just a Freudian slip away. Witness his stance when faced with a beautiful, confident woman, such as Mrs Peignoir. Lively, cultured, and occasionally drunk, she terrifies Basil. He hates to be seen with his guard down, in a position to enjoy the same sordid delights that he believes the younger generation get up to. So when Alan and Jean find him in an innocently compromising situation with Mrs P, he offers a lightening-fast explanation and the quickest exit possible. Every move the French woman makes adds another layer of unnecessary guilt to Basil's psyche — terrified that Sybil might suspect something out of nothing. At a later date, he is totally unable to handle Mrs P, even her compliments:

MRS PEIGNOIR: Are you romantic, Mr Fawlty?
BASIL: Good God no.
MRS PEIGNOIR: Well, I think you are. I think under that English exterior throbs a passion that makes Lord Byron… look like a tobacconist!

Petrified laughter hides his inability to join in with such banter. Each word suggests to Basil that she wants to sleep with him; every flirt means a commitment to have sex. Not that he would. He'd be too scared. True to the upright nature of the British Empire, Basil acts the cornered coward when faced with matters sensual.

The depravity concocted by Basil in *Fawlty Towers* is usually a twisted figment of his imagination. Alan and Jean have booked in at the hotel despite the warnings of Polly, an old friend. Jean's mother and stepfather arrive soon after. All are in Torquay for a wedding. But Basil isn't to know that, is he? The old cogs of his brain start turning when he believes them all — Polly included — to be part of "the Karma Sutra set". First he chances on Jean and her stepfather, Mr Lloyd (Conrad Phillips), hugging in greeting. Basil misreads the incident, and doesn't pause to discover the facts. His judgements are instantly connected with sex, and so he thinks he has to distract others from this immorality. When he finds Polly greeting Mr Lloyd in the same manner, he looks on the verge of having a breakdown, trying as he is to protect Mrs Lloyd (Diana King) from 'the truth'. A misinterpreted eavesdropping on Alan and Jean's room convinces him that they're *all* at it. Basil experiences some very physical discomfort at the idea, his brain jumping to the sexual conclusion, something that can never be very far from his thoughts. Even finding all those people in one room together suggests a sordid tableau. When Sybil explains everything to him, Basil refuses to accept responsibility ("you can't blame me for this!"), or apologise. Sybil must bear the brunt of his misunderstandings. If there's anything that Basil can find to hide behind — his snobbishness, his wife — then he will, rather than say, "I was wrong". Not that he

can resolve anything with his guests by now. Sticking to the episode's farcical origins, the party arrive back from their wedding late at night to find Basil in the lobby, clad only in shirt and shorts, a frying pan in his hand, and a battered Manuel lying face down beneath him...

SEX FOR Aleister Crowley was never so complicated. Despite being born at a time (1875) smack-bang in the middle of Victorian repression, he soon broke away from the nanny and made up for lost time. And once Crowley discovered a link between sex and the occult, there was no stopping him:

> ... Crowley set about performing sexual magic with a diligence, sodomising Victor Neuberg [one of his followers] in Paris in 1913 as part of a magical ceremony. He also practised sexual magic with a companion of Isadora Duncan's, Mary D'Este Sturges... He also took a troop of chorus girls to Moscow — they were called the Ragged Ragtime Girls — and had a violent affair with another 'starving leopardess' of a girl, who needed to be beaten to obtain satisfaction.[6]

And so on. You get the general idea. Towards the end of his life (he died in 1947), Crowley was a chronic heroin addict. But, before his end came, and long after he'd stopped putting it about, 'The Wickedest Man in The World' (as the public knew him) lived for a spell in Torquay, the English Riviera; home of mild weather and palm trees.[7] Crowley in a deck-chair licking a 99 cornet? How about as a guest at *Fawlty Towers*? More than enough to give Basil one of his fake heart attacks. In his sycophantic memoir of Crowley, CR Cammell (father of *Performance* co-director Donald) recalls how the Great Beast

> managed to finds some rooms at Torquay; and one morning early he came to me. With his income from America cut off by the war, and no prosperous provider within momentary reach, he was in a dilemma. Richmond was killing him; but how to get to Devon? I gave him the few pounds that were in my pocket... I was glad enough to help him, and see him safely on the road to sunshine and peace.[8]

The Devon resort must have seemed extremely tranquil to someone like Crowley. He wrote to Cammell from there in September 1940:

> "... I found myself walking six miles up hills and long flights of steps without discomfort! My own wisdom bade me stay. Then the heavenly branch of the business took a hand again, and led me to a perfect haven for the winter. Lost in the hills, a room made for study opens on to a noble garden with a prospect of illimitable beauty..." [9]

6. *The Occult* by Colin Wilson, Mayflower Books, 1976, pp.474–5. Wilson, who usually had a hard-on for Nietzschean supermen, goes on to note: 'Whatever else one can say against Crowley, he was certainly a powerful, dominant personality, and he attracted weaklings, as all strong people do.' (p.487).

7. Torquay's most famous daughter is probably crime writer Agatha Christie (1890–1976), but a couple of its more interesting sons are the explorer and translator Sir Richard Burton (1821–90), and comedy rogue Peter Cook (1937–95).

8. *Aleister Crowley: The Black Magician*, New English Library, 1969, p.105.

9. ibid.

Psychedelic Decadence

Sounds like the view from the window of one of *Fawlty Towers*' bedrooms. A landscape of studio-bound scenery. Crowley's 'haven' does fit in well with Basil's berating dialogue towards deaf Mrs Richards (Joan Sanderson), when she complains about the lack of a view in 'Communication Problems' (series two, episode one):

> Well, may I ask what you were expecting to see out of a Torquay hotel bedroom window? Sidney Opera House, perhaps? The Hanging Gardens of Babylon? Herds of wildebeest sweeping majestically—

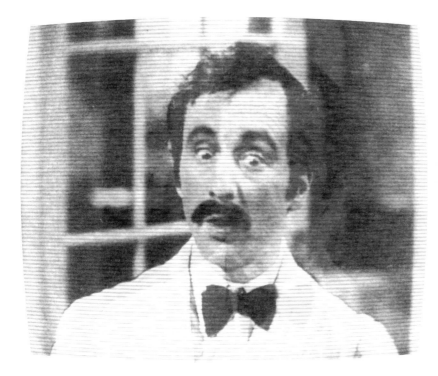

Manuel (Andrew Sachs), 'A Touch of Class.'

Sunshine and peace. Never any of that with Basil around. He creates situations that have no point of existence. Acts of crisis flit around his mind like ghosts. Behind every closed door is a filthy act waiting to be intruded upon by his pious self. The sexuality may have been very real in 'The Wedding Party', but in 'The Psychiatrist' (series two, episode two), the visions of sin are all in Basil's head.

Here, Basil is confronted by his two greatest fears: a cocky, confident young man, and a probing, sex-obsessed psychiatrist. At least, that's what they are in his eyes. Never has one man created so much chaos through so little actual evidence (or was there more behind Basil's famous Hitler impersonation?). His sexual nemesis here is Mr Johnson, played perfectly by Brit exploitation flick actor and *Psychomania* star Nicky Henson. To say Johnson is a bit of lad

Filthy Towers 117

is a slight understatement. He is Timothy Lea with an address book. He wears thigh-hugging brown leather flares. And a yellow shirt open to the waist. Hair perfectly waved and chewing gum in mouth, he remains calm when Basil is at the height of his attack. And don't forget the medallions; Sybil is seductively impressed, Basil less so. He thinks Johnson isn't so far removed from our simian cousins — "have we got enough bananas this week, dear?" — although you can see the annoyance in his eyes as Sybil laughs at Johnson's jokes. But even this doesn't weaken Basil's sledgehammer wit: "I heard you laugh, I thought perhaps he was having a tea party."

What riles Basil the most about someone like Johnson ("Piltdown Ponce," as he calls him) is the fact that he's no cowering dumb pleb, but a witty, gregarious male who women seem to find attractive. As Sybil points out, Basil's list of admirable males extends to that lost, empirical England: Earl Hague, Baden-Powell, etc. Any slur put on the British Empire's name instantly has Basil on the attack. To him, Johnson is an uneducated, posing oaf ("that type would wear a dog turd round its neck if it were made of gold"). Basil only has respect for guests of power and influence. Guest such as the Abbots. All three of them.

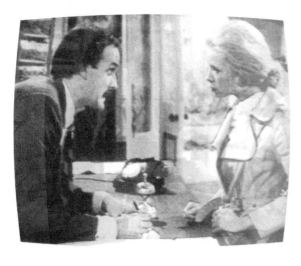

Top: "Ooh! I know..."
'The Wedding Party.'
Above: "Don't mention it to my wife..."
'A Touch of Class.'

Basil's charm leaps into action when he discovers that Mr Abbot is in fact a doctor. After a bit of confusion ("how did you become two doctors? Did you take the exam twice?"), he finds out that Mrs Abbot is a doctor, as well. His crawling attraction moves along under its own steam — trying to make some sort of connection any way it can. But things have to go wrong, something has to shatter Basil's illusions of class. When Abbot informs Basil in the dining room that he is a psychiatrist, Basil swipes his complimentary glass of port, says, "very nice too. Well, cheers", and takes a sip. The unconscious slip has happened. After that moment the doctor is the enemy and Basil his edgy prey — oblivious to Sybil's calm reassurance — already thinking that Abbot is quantifying his psyche: "I don't want some total stranger nosing around in my private parts... details!" And these were days untainted by rampant cod-psychology in magazines, self-help books, and passing strangers. As Sybil so rightly points out to the be-

mused doctors: "it's only recently that we've been seeing it on TV." Totally in fear of his repression, Basil tries to dismiss ideas such as psychoanalysis:

> You know what they say it's all about, don't you? Hmm? Sex! Everything's connected with sex. Cor! What a load of cobblers!

And so begins a prime piece of farce: Basil riding on one track, his guests on the other. As he flits from dining room to kitchen — his paranoia feelers on full alert — misheard words and the ends of conversations create a mess of confusion. The Abbots inquire of Basil how often he goes on holiday; naturally, when Basil is asked, "how often can you and your wife manage it?" he thinks they're talking about sex. And again, it takes Sybil to show him the error of his ways.

Only Basil was thinking about sex. No-one else. Guests get on with their lives. Basil thinks that Johnson has smuggled a girl into his room. The rest of the episode is devoted to his efforts to catch him red-handed. All he wants to do is wipe the smile off Johnson's face, and so becomes single-minded in his pursuit — tapping walls, looking for lipstick traces on cigarette butts, climbing up ladders to peer into the wrong window — to the annoyance of every other guest. When Raleen Miles, a vivacious, blonde, Australian woman arrives, Basil is touched in the way he usually is when faced with female good looks and/or intelligence: he crawls or makes cock-ups. He can't help it if all these people get in the way of his mission. Busty Raleen, in her tight tops, seems to have a magnetic effect on his insect hands. Whilst she undertakes a spot of yoga, Basil attempts to fix the light-bulb in her bathroom, only to reach blindly for the switch and catch a handful of breast and nipple instead. Ever omnipresent, Sybil witnesses the event — as she does him hiding in Raleen's wardrobe (when Sybil opens the door, Basil acts oblivious, pretending to check the screws), and him assaulting her with a paint-covered hand (long story). All Basil is trying to do is listen in on the room next door, to hear Johnson and his girl 'up to' something. Sybil knows different: "I read about it, Basil. The male menopause, it's called."

All Sybil's knowledge comes from the magazines she reads at reception, in between the times she's on the telephone to friends. Some article or other warned her this would happen, that Basil's hormones would freak out and he'd pursue a younger, more attractive woman. But that's the last thing on gallant Basil's mind. With a sizeable audience, the rabid Basil confronts Johnson about the fabled 'Mrs Johnson' for whom the young man has booked a room,

"A case of valuables..."
'A Touch of Class.'

Filthy Towers

only to learn that — far from being some strumpet — it is in fact his mother. Once everyone has dispersed, Basil becomes the stick insect Sybil describes him as: squatting down, arms over a retractable head, trying to escape from his hideous mistake. Only when he sees the light does realisation come crashing down — all the walls he has built up against promiscuous society are no longer there to protect him. Basil's repressed terror is naked for everyone to see. As Dr Abbot comments, in a slight aside (he is on holiday, after all): "there's enough material there for an entire conference."

IN THE last minutes of the final episode of *Fawlty Towers*, the place is teetering on the edge of being closed down because a hotel inspector saw a rat emerge from a biscuit tin. The last we see of Basil Fawlty is his lifeless body being dragged out of the dining room by ever-obedient Manuel. The pressure of twelve episodes of such an intense farce was too much for him. Better to burn out than to fade away. *Fawlty Towers* did just that. Aleister Crowley did a bit of both. His sexual energy sapped the power from his later life. His final years were not in sunny Torquay, but on the wilder shores of Hastings, living in a boarding house, lonely and frightened of the long evenings. The old man by the sea:

> The photograph of him at this period shows a thin old gentleman dressed in tweeds, smoking a pipe and looking like any retired colonel.[10]

Couldn't he have taken up residence at *Fawlty Towers*? It already had one eccentric/mad relic, in the form of drunken Major Gowen (Ballard Berkeley). Despite Basil's reservations, Crowley might have been at home in such a place. When Sybil suggests that her mother said it was "black magic" that got her and Basil together, he replies: "well, she'd know — her and that cat." Crowley's biographers validate the fact that he could see images through staring at mirrors for hours, and magic up ethereal forms from nowhere. Basil and Sybil, through John Cleese and Connie Booth, performed a similar kind of trick during 'The Psychiatrist', when Sybil drones on to Johnson about her mother's "morbid fears":

> … rats, doorknobs, birds, heights, open spaces, confined spaces… footballs, bicycles, cows. And she's always on about men following her. I don't know what she thinks they're going to do to her. Vomit on her, Basil says.

Without the audience seeing a thing, Sybil has performed a bit of comedy magic, producing a line that is one of the best, conjuring up images of strange men puking over old ladies. Turning base materials into priceless gold.

10. *The Occult*, p.489.

Vessel of Pleasure

Ruffling Emma Peel's Feathers

RIGHT from the opening titles of *The Avengers* we know who Mrs Emma Peel is: a fetishistic feminist fantasy. Her character is drawn up very nicely before each episode starts. The black-and-white forth season (1965–1966) has a series of photographic images of John Steed and Emma interacting. Emma is in her famed black leather catsuit in one shot, then a more 'feminine' evening dress in another. The best shots are when the titles wind up: back in her catsuit, Emma poses in a quick succession of static fighting moves; one depicts her stretched forward to the camera — almost bent over backwards — a gloved right hand to the fore.

121

The end titles have Emma pulling on a knee-length black leather boot with short stiletto heel.

For the fifth and sixth seasons (1967), and the advent of colour to the imagination, the titles became more glamorous: roses in pistol barrels, the heightening of the champagne aspect of Steed and Emma's lives. Before the title music intrudes, Emma — in misguided yellow tracksuit — shoots the top off Steed's champagne bottle; its contents, predictably, froth out. All this soundtracked by fast-paced bongos. Seasoned by such actions, Steed has a glint in his eyes that says "I'm in here, anytime I want". The defining moment for Emma Peel's character comes when her head and shoulders slide out from behind a red velvet chair, dinky pistol in hand. Yes, you think, the empowerment of beauty. But she has to brush a wedge of luxurious dark hair back behind her ear before finally getting the aim right.

Rigg reclining.

A perpetual object of fascination for anyone with a sex drive, Mrs Emma Peel, as played by Diana Rigg, emblazoned her mark on *The Avengers* so successfully that the other partners of John Steed (Patrick Macnee) seem like confused schoolgirls in comparison. Consistently attired in cum-enducing clothes, Emma breezed through the series with an air of inquisitive coolness, never breaking into a sweat even when caught in a scrap, her private life beyond the adventures something of an enigma. In fact, Emma lived a lifestyle unique to the 1960s: no visible means of financial support, an unlimited

amount of leisure time, and endless possibilities for adventure in an England devoid of a massed population (anyone possessing these qualities in the present day would have to answer a *lot* of questions). Considering what *The Avengers* got up to, the landscape would *have* to be deserted to allow such escapades. Because of all this, Emma's iconic status is assured. There's barely a hair out of place on this woman, who we assume maintains a distanced cool throughout her adventures, and, because of that, it becomes very entertaining to see her getting agitated, to set her up against villains that bring a repulsive wrinkle to her nose. It's like encountering the first change of character in a lover after the honeymoon courtship is over...

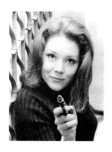

Dinky pistol in hand, Diana Rigg as Mrs Emma Peel.

Dig this arousing black get-up: knee-length, stilletoed leather boots, laced all the way up over bare flesh at the back; lacy silk strapless bodice, see-through from the stomach downwards; over-the-elbow silk gloves; a loose chain from collar to left wrist; hair piled high, eyes heavily made-up, with gems stuck on, and to top it all a three-inch spike dog-collar. Oh, and a python. The whole outfit screams TIGHT, and Emma Peel seems unsure as to how to take her new role as 'The Queen of Sin'. The episode is 'A Touch of Brimstone' (forth season), the theme is decadence, and the mindset of Mrs Peel is occasionally very irritated. Good.

Some way into the standard investigations, Steed undergoes a pretty slack initiation test to infiltrate the Hellfire Club (a replica of the English eighteenth-century drinkin' and a-eatin' and a-whorin' high-society holes) and is told:

We believe in the power of evil, Mr Steed. We believe in the... ultimate sins. Have you... ever committed an ultimate sin, Mr Steed?

To which he replies:

No. But I'm always open to suggestions.

So much for the serious business of pleasure. Unfortunately, the Club's 'ultimate sins' add up to nothing more than stuffing your face, allowing unidentifiable alcohol to splash down your tunic and manhandling wenches without touching their breasts. The leader of all this is Lord Cartney ("... handsome, and dynamic, very compelling, quite fascinating... we got on rather well," Emma tells Steed), played to the stately hilt by soon-to-be *Jason King*, Peter Wyngarde. The Hellfire Club's agenda is practical jokes on state officials escalating into an explosive take-over of the country, but this seems to be secondary to Cartney's own hedonism. Tarted up in riding boots and britches (but with a shirt open at the neck, a sure sign of the decadent), he lounges around a sparsely-furnished boudoir being fed grapes by *Monty Python*'s Carol Cleveland (Cartney: "you're insatiable, aren't you?") Cartney is not a million miles from one of Hammer's evil aristocrats, particularly John Carson's dastardly

Vessel of Pleasure

Rigg alongside Peter Wyngarde in the 'A Touch of Brimstone' episode of *The Avengers*.

squire in *The Plague of the Zombies*; he even has the same personality: suave and charming, but not afraid to make sacrifices for his evil deeds. And a smooth player of the harpsichord. Emma herself almost falls under his spell, until she enquires where a woman's place is in the Hellfire Club; when Cartney replies: "we have vessels of pleasure," he blows his chances there and then of getting any further with her.

When Emma Peel first encounters the Hellfire Club, the fun begins. The little cracks start to show. That permanently glued-shut, ironic mouth isn't so steady anymore. Introduced into a typical night by Cartney, Emma remains unimpressed by the alcohol-aided activities until she is sat down and offered a drink. A figure behind her knocks the chair a few times. The rowdiness con-

Psychedelic Decadence

tinues. Booze is spilt. Emma begins to look annoyed. Then a priceless moment: her feline eyes betray some discomfort with the situation. The debauchery on offer at the Hellfire Club may be low-risk, but it's enough to ruffle the uppercrust London feathers of someone like Emma, a million miles from one of her tedious drinks parties at some embassy or other. Perhaps the intoxicating atmosphere created by Cartney and his cronies is something that Emma has never previously encountered, quite different from deranged scientists in the rear of a sweetshop or ice-cool assassins.

Much the same happens in 'Dead Man's Treasure' (sixth season), *The Avengers'* very own *It's a Mad, Mad, Mad, Mad World*. Emma finds herself trapped in a racing car simulator that gives out electric shocks each time you go off the track. As the speed increases, so do the shocks. Needless to say, the episode's villain sadistically bangs it up full-tilt and Emma gets in a right tiz when the volts start a-tingling (you can imagine her thoughts, on the edge of panic: "this isn't *right*, it *hurts*"). Much joy is to be had observing her flusterings.

But to simply see Emma Peel as a sexy object to be toyed with isn't on, of course. She was the first example of female empowerment on television, etc. She and John Steed shared an ambiguous, playful relationship that pissed on the usual man-plus-girl assistant stuff. They never seemed to engage in spontaneous one-night-stands together, so where else did Emma get her rocks off? And who would have the ability?

For the climax of 'A Touch of Brimstone' Emma and Steed turn up at the night of All Sins (but not *all* of them, as it turns out) kitted out in eighteenth-century gear. The party is in full swing when they arrive, conforming to the strict regulations of studio-set brewery piss-ups, although Emma's eyes almost cross at the sight of some off-screen debauchery. Cartney, however, isn't impressed with Emma's dress sense and speeds her off for the 'Queen of Sin' transformation. The Hellfire Club may be planning to topple Parliament, but the moment Emma reappears — somewhat moody — in her new gear, all mouths drop (Steed looks on the verge of a coronary). "She's yours," Cartney tells the flock. "To do with what you will!" A host of hands lift her high and carry her out of the room, into an unviewable scenario, surely? In her S&M incarnation she is strangely passive, as if not being in trendy suits and skirts has made her powers disappear. A beautiful, scantily-clad woman allowing herself to fall into the hands of the depraved Hellfire Club conjures up numerous scenarios that all reach the same conclusion: a gang-bang. Cut to next scene and a bare-knuckle fight is in progress, the participants goaded on by the entire party, Cartney included. Emma sits next to him, looking bored. Has the event happened, or not at all? Like the rest of her 'normal' life, Emma's sexual encounters remain beyond the gaze of the camera, though it's hard to imagine what kind of person could satisfy her. When Cartney whips her into a showdown the last words he utters before dying are "very impressive. Now what are you like with the big boys?" She kills them, that's what she's like.

Psychedelic Decadence

A Menace in Pigtails?

Earlyscarybowie

I'm a phallus in pigtails
—'Unwashed And Somewhat Slightly Dazed'

DIPPING into any of David Bowie's performing 'stages' has the man coming on as paradoxical as his blue and green eyes. And then infuriatingly so. A loner who craved an audience, a voracious bisexual who felt no love, an extravagant rock star who only attained financial security a decade after his ascent; the changes in his career have been charted more times than are necessary, with a new title to match each phase. Perhaps one of the most striking aspects of Bowie's career is the continuous writing-off of his recorded output pre-*The Man Who Sold The World* (1970).

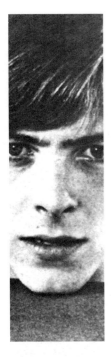

In this evolving period between 1966 and 1969, only two songs tend to linger in the public imagination: 'The Laughing Gnome' and 'Space Oddity'. The former has, for some bizarre reason, been relegated to the section reserved for Embarrassing Novelty Hits;[1] the latter has reached that 'Bohemian Rhapsody'-like nadir of classic status on local radio stations. But hidden amongst these two jukebox fillers are some starkly disturbing songs that hint at a mindset out of place in the coffee-bar London that Bowie sings of in the likes of 'Maid Of Bond Street' and 'The London Boys'; these songs are unrealised anthems for teenagers like those inhabiting *Dracula A.D.1972*: a bunch of crazy, irritating dudes ('Join The Gang' has the line: "Johnny plays the sitar/ he's an existentialist", which makes a solitary life seem enticing). Before the fear of inheriting his family's erratic strain of schizophrenia found its way into later albums (although 'Janine' — from *Space Oddity* (1969)[2] — does contain blatant references to a split personality), Bowie's dark side emerged in a small group of tunes that veered from the light-hearted to the very nasty.

After spending most of his late-teens in a variety of forgettable R&B groups — releasing a few average pop singles in the process — the David Bowie of the late sixties faced a slight crisis of direction. Taking any work that lent towards the 'artistic' (including, desperately, mime[3]), leaping between male and female lovers, and continually frustrated by a non-starter of a singing career, Bowie appeared to rely on others to give him the necessary pushes, resulting in an era that reeks of too many Svengalis (with mixtures of personal and professional interests in the Bromley lad) in the pot. It's strange that this period resulted in any decent material at all. The intense focus that Bowie subsequently utilised in his seventies LPs was definitely lacking, with all his energies seemingly stored up for the acres of available free love. Not that the boy wasn't up to it. As Christopher Sandford notes in his enjoyable biography, *Bowie: Loving The Alien*:[4]

> ... Ken Pitt[5] would remember his client's habit of 'loping around the flat, naked, his long, weighty penis swaying from side to side like a pendulum of a grandfather clock'.

So everyone had an eye on some part of him. Soon after, Bowie met his future wife, Angela Barnett, and the pair decamped to an Edwardian villa flat at 42 Southend Road, Beckenham, better known as Haddon Hall. As fine a sprawling enclave of Bohemia as you could imagine a fledgling rock star to live in. And so another chapter of rock and roll mythomania, with all its accompanying absurdities, was born. However, Bowie's life is not the subject here, moreso the songs that disappeared as his star ascended, for the most part written off by biographers as juvenilia. They number only a few, but are of extreme significance.

1. Odd, as it's a fine example of Bowie's little-regarded skill as a writer for children.

2. Actually, like his debut LP, it was eponymously titled. But for the purposes of this chapter we'll stick with the name given to it's 1972 re-issue.

3. A photo-section in George Tremlett's 1974 cut-and-paste book *The David Bowie Story* (Futura) offers four shots of David 'doing mime'. The caption beneath: 'the only photographs ever taken of David doing mime. He is standing on the coffee table in Ken Pitt's flat' dredges up uncontrollable thoughts of destruction.

4. Warner Books, 1997.

5. Bowie's manager, 1967–1970.

6. Christopher Sandford notes: 'When Bowie's publisher sent Anthony Newley a copy of the record, he smashed it.'

Psychedelic Decadence

For a singer aspiring to a strange kind of hipness, Bowie's first album, *David Bowie* (1967), owes a grand debt to such granny-sucking crooners as Tommy Steele and Mr Extravagant Gesture himself, Anthony Newley.[6] More a collection of nursery stories than an album reflecting contemporary life, *David Bowie* casts the singer as part-storyteller, part-variety entertainer; although you'd be hard pressed to find the right kind of pier for Bowie to perform on: stick-thin, with varying degrees of haircuts, he must have seemed a bizarre, skeletal-featured figure in stylistically-obsessed London. The contradictions become apparent when you dive into the album, a mixture of songs utilising acoustic, pop and ballad structures, with occasional weirdness. 'She's Got Medals' and 'Uncle Arthur' are typical examples. Decidedly upbeat, the former tells of a lesbian who joins the army ("passed the medical / don't ask me how it's done"), is presumed dead in the war, and returns to London to settle down to a more feminine way of life; all told in Bowie's half-sung delivery. Chirpy is the word that springs to mind. 'Uncle Arthur' is another small-scale life examined, as the middle-aged man of the title abandons a maternally cosy life to marry, only to find — like Norman Bates — that mother knows best. Happy ending. These songs are atypical in that they project Bowie as the world-weary raconteur, an entertainer with a thousand tales, and still only twenty-years-old. When uncle Arthur closes his shop and rides his bike home to mother, you can see Bowie lurking at a nearby corner, his limbs jerking as he sings of this unassuming man's life. Other songs on the album display the effects of being a post-war kid, growing up in an England rebuilding itself (he was born in 1947). The strangely comforting 'Rubber Band', concerning army love won and lost makes way for 'Little Bombardier', and the balance tips slightly.

London (boys) calling.

Although not yet invented, the term Post-Traumatic Stress Disorder could accurately describe 'Little Bombardier', a deceptive waltz that tells a simple

yet ambiguous story. Alone, unskilled and broke after an unnamed war, little Frankie spends his time drinking and at the cinema, until one day he is noticed by two children there. From then on, the three are inseparable, until Frankie receives a visit from the local police, and is warned off any further 'friendship' with the kids. Heartbroken, he leaves the town for good. Bowie relays all this with a crack in his voice, suggesting that all Frankie wants is a little friendship. But the rest of us know better: Frankie is cut from the same cloth as those for whom friendship is interchangeable with complicity, where innocent fun is a scoutmaster and a couple of his charges playing 'worms' in a

Above: Promotional photograph by Brian Ward.

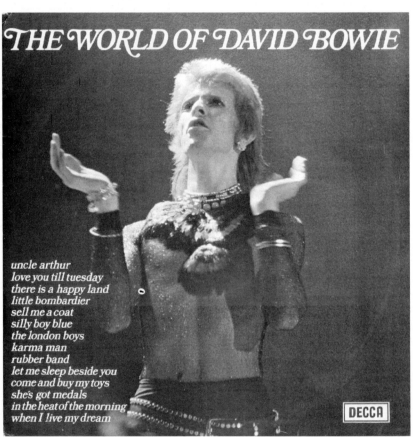

tent. For all his protestations to the rozzers, it's easy to see where the trails of sweets are leading to; easy for *us*, in the present day, that is, where the attention of a stranger cast on a child can mean the slippery slope to having your nuts cut off in the prison showers. 'Little Bombardier' is tragic in its innocence, but also in the fact that there is no way it can be read as that today. It's easy to forget that there was a time when many (myself included) saw child molesters as comic or just plain non-existent: being kidnapped by a man in a

Psychedelic Decadence

blue parka meant nothing more than a blindfold and instant mash for dinner, while the parents tried to raise the ransom money.[7] We ran laughing from paedoes in the local swimming pools, pointing them out to friends as they waited outside schools, as well-hidden as a hard-on amongst a plate of sausage rolls. The dirty old man was the comical bogeyman of small town life. We never get to find out whether little Frankie's friendship was genuine, or if the police's intervention was an act of coitus interruptus, but in the end Bowie's voice and the melancholy tune convince us. With reservations.

If we can interpret our own version of what is essentially a song about the destruction of friendship, 'Please Mr Gravedigger' is pretty fucking straightforward: Anthony Newley discovers Edgar Allan Poe and is suddenly inspired. Too obvious a reference? Another way is to place the song in the tradition of scenery-devouring British actor Tod Slaughter, a man for whom the phrases "subtle interpretation" and "justified violence" were completely alien. Macabre, probably. Grand Guignol, definitely. A gothic reference is unavoidable. It is also a song without music, just sound effects. A year or so earlier, Ian Brady and Myra Hindley were creating their own tape-loops from Hell. Utilising the same subject, 'Please Mr Gravedigger' is strangely entertaining. A church bell rings beyond the hiss of pouring rain; sniffing with a cold, Bowie speaks the lyrics with no care for a tune:

> There's a little churchyard just along the way /
> used to be Lambeth's finest array
> Of tombstones / epitaphs / wreaths / flowers all that jazz
> Till the war came along and someone dropped a bomb on the lot

More post-war concerns? No. Bowie has something else on his mind. He's watching the gravedigger "dig little holes for the dead and the maimed", and predicting his future actions: the little old man is going to steal a locket containing a dead girl's hair, leaving her mother to still believe that it is within her daughter's coffin. Bowie sympathises ("and Ma wouldn't understand / so I won't tell"), but it's a homicidal kind of sympathy. The sneezing singer is the girl's killer, churning up the endearing image of witnessing Bowie in a graveyard, in the distance, through sheets of rain, talking to himself. The psycho revisiting the burial ground to gloat:

> Marianne was only ten and full of life and o-so gay
> And I was the wicked man who took her life away… very selfish

Polite to the last, this obsessive figure gives out signals of mad love for Marianne: he knows that the gravedigger won't tell anyone his secret, but just to make sure he's "started digging holes my friend / and this one here's for you". No one's going to come between the special relationship he has with the

7. Like images of Susan George gang-banging, I have vague memories of a dearth of child-kidnapping dramas being broadcast on television in the 1970s.

A Menace in Pigtails?

little girl. 'Please Mr Gravedigger' is the other side of the coin to the Little Bombardier's plight. It's upfront, first-person insanity. And Bowie is the badge-wearing mad fucker...

THIS SORT of insidious madness surfaces again in 'Love You Till Tuesday' and, especially, 'Unwashed And Somewhat Slightly Dazed.' Obsessions such as these aren't welcome in the London that Bowie inhabits, and he joins the line that also includes Johnny Alucard and Mike Roscoe as hipsters who (however strange) look the part but have darker intentions. Sometimes the methods to his madness have to be found between the lines, as the danger signs are not as blatant as they are in 'Please Mr Gravedigger'. Bowie nearly took part in a more upfront attack on his peer group, playing the killer in *The Haunted House of Horror* (1969), a film which, as Kim Newman notes in his book *Nightmare Movies*, started life as *The Dark*

> ... a project which writer/director Michael Armstrong saw as a 'cynical attack on the Swinging Sixties', in which a group of trendy teens lark about in a haunted house and get hacked to pieces...

Cool. But Bowie didn't do the film, and it got hacked up before reaching the screen, taking Frankie Avalon along for the ride. *The Haunted House of Horror* is not important, but the fact that Bowie got close to playing a killer is. Imagine this stick figure lurking in the dark shadows (but, please, no miming), fumbling with a chick's clothes one minute, then turning psycho the next. No need for guessing games with this casting: Bowie's presence amongst the kids would be enough to signal his outsider status, enough for the audience to wonder "who is that strange young man?"[8]

Such imagined roles would have been the only obvious concession that Bowie gives to Gothic (i.e., a horror that is upfront) ideals. The deception works on a grander scale when the tune is upbeat, and in the case of 'Love You Till Tuesday', relentlessly so. Although cut from the same musical cloth as 'The Laughing Gnome' — the backing sounds like that song in reverse — 'Love You Till Tuesday' returns to the dark ambiguity that is the rule for Bowie, not the exception. It's fixation time for him again, serenading some unknown individual below their window, an emaciated Romeo. But here the clock is ticking on his affection, which'll run out on the day of the title. The base level of the song can be translated as an acknowledgement to free love: I'll take you for the time being, but then I'll move on to the next; it wraps Bowie's alleged 'coldness' in a pop song blanket, with the shallowness of his world exposed. Skew the vision a little and 'Love You Till Tuesday' becomes the predatory foreplay of a killer, like if Bowie really had starred in *The Haunted House of Horror*. And then times it by ten. After the killer's shot his bolt ("I shall always love you / until my love runs dry"), there's no further use for the

8. As with the Michael Reeves/Vincent Price exchange (see the chapter **Death is not the End**), the source of this information comes from Newman's *Nightmare Movies*, but I have no idea of its origins. Bowie's near-miss at playing a psycho is also mentioned in Andy Boot's *Fragments of Fear: An Illustrated History of British Horror Films*, David Pririe's *A Heritage of Horror* and *The BFI Companion to Horror*.

object of his obsession. Or — more in the style of Mr Slaughter — as soon as he gets bored, he'll just do in his beloved and then move on to the next:

> Oh-o / beautiful baby / my burning desire / started on Sunday
> Give me your heart and I'll love you till Tuesday

Who's that hiding in the apple tree, clinging to a branch? Don't be afraid, it's only David, hoping for a little romance. This intrusion into an intended's life reaches its limit in 'Unwashed And Somewhat Slightly Dazed', but with 'Love You Till Tuesday' his motives are intentionally hidden, and for good reason: if he blurted out what he *really* wanted to do to you, you'd run a mile. But be thankful that, for your final days at least, he'd give you his complete, unflinching attention.

The question of what this rather sexually threatening young man would get up to (beyond simple murder) if he won the affections of his subject is a tricky one. As already mentioned — and known — Bowie's world before his 'break' in the 1970s was already rife with across-the-board promiscuity. In common with every other rock star, if it had an orifice, he'd do it. Christopher Sandford calls 'Let Me Sleep Beside You':

> ... an effort to cash in on the [then] current vogue for songs about horizontal activity...

But if that was the case, shouldn't it have been called 'Let Me Sleep On Top Of You'? Although kicking off with a spastic Jethro Tull-style guitar riff, the song proceeds onto ground that isn't as well mapped as the area Sandford mentions. Again, it seems to have been shoved in the same box as 'The Laughing Gnome' and forgotten about. Strange.

> Baby baby / brush the dust of youth from off your shoulders
> Because the years of threading daisies lie behind you now

This isn't Bowie and some like-minded chick getting it on, this is charm utilised as a means towards an end: plucking that sweet cherry ("I will give you dreams / and I'll tell you things you'd like to hear"). The predator of 'Love You Till Tuesday' still had that hint of madness in his voice. The singer of 'Let Me Sleep Beside You' is effortless in his persuasion. Eventually he'll win over his subject, coaxing her into bed with soft words, but it isn't going to be the joyous experience she expected ("I will show you games where the winner never wins") as Bowie's hysteria rises, and there's suddenly no turning back:

> You could not imagine that it could happen this way / could you?

A Menace in Pigtails?

When the string section kicks in, it's the aural equivalent of shutting a door, leaving us to worry about what Bowie is subjecting the poor creature to. But all these songs are merely starters for the psychotic feast that is 'Unwashed And Somewhat Slightly Dazed' (from *Space Oddity*). The song transforms Bowie again into a mess of contradictions: he grabs his generation, wrestles it to the ground and gives it a severe rogering. It's hard to do justice to this song on paper without printing the entire lyrics. The nutcases of 'Please Mr Gravedigger' and 'Love You Till Tuesday' are insignificant wimps compared to Bowie in 'Unwashed'.

Like 'Tuesday', it is another serenade, but without that song's upbeat mask. The ambiguity in Bowie's madness is at its most severe here, and for a time found its way into this listener's (mis-)interpretation of a few words. Until finding the printed lyrics, the eleventh line of 'Unwashed' — which coincides with the entrance of a full band — seemed unclear, but to me was the defining statement of Bowie in this period. I assumed he sang "I'm a menace in pigtails", or at the very least "I'm a Venus in pigtails"; both versions conjured up pitch black images for the song, in which some disturbed individual terrorises a rich young girl, seemingly safe in her father's house. 'A menace in pigtails' was just right: Bowie as weird-looking loon, the girl as his next challenge:

> Spy / spy / pretty girl /
> I see you see me through your window
> Don't turn your nose up /
> Well you can if you need to / you
> won't be the first or last

Psychedelic Decadence

That last line is the kicker: Bowie as rejected suitor with a thick skin, bad thoughts, and plenty of time on his hands. A menace, alright. But in the reality of the lyric sheet, the words are slightly different: "I'm a phallus in pigtails". Just as good, I suppose. No doubt there were many who thought he was, but 'menace' sounds better. The actual line simply paints Bowie as the sexual predator he was, and not an unearthly nuisance with big plans for Daddy's girl ("and I know what a louse like me in his house could do for you"). Like the other songs discussed here, 'Unwashed' is deceptive in its musical structure: an acoustic guitar beginning that sounds everything like an alternative 'Space Oddity' gives way to a looping riff over the chorus, and when the words run out the music starts to intensify, harmonica and keyboards adding strength to its twisted backbone. Same with Bowie's voice: the first four or so lines (see above) are sung "ground control to Major Tom"-style. That's where the pleasantries end. Bowie isn't content to describe himself as a phallus in pigtails. Just to make clear to the girl that this is a pursuit, not a seduction, he continues:

> And there's blood on my nose / and my tissue is rotting
> Where the rats chew my bones
> And my eye sockets empty / see nothing but pain
> I keep having this brainstorm / about twelve times a day

Behold, the first serial killer pop song! From what we know, his victim occupies a big house, with a lot of places for Bowie to hide, to stalk, to toy. 'Unwashed And Somewhat Slightly Dazed' sounds as if it was written with his unrealised role in *The Haunted House of Horror* in mind, but is a thousand times more disturbing than any conventional horror film. There's a Hell of a lot *here* we don't see, such as what the fuck he does to the poor girl:

Next page: Teenage blood! *Horror Hospital*.

> Now you run from your window / to the porcelain bowl
> And you're sick from your ears / to the red parquet floor

This is a madman at the height of his powers, beguiling victims with those blue and green eyes, a hypnotist's stick. A menace in pigtails. The next decade saw Bowie scale the heights of creation, traversing a glut of musical styles in quick succession, earning him his own peculiar paradoxical niche. And with all this, albums such as *David Bowie* and *Space Oddity* were neatly relegated as feet-finding experiments which, as already mentioned, is a pity, because behind the prominent novelties lie the far more enduring songs of a very strange young man, simultaneously part of and distanced from the happenings around him: "And my head's full of murders / where only killers scream… "

A Menace in Pigtails? 135

Psychedelic Decadence

Party Girl Who is Painted

Horror Film Gigs (A Continuing Saga?)

> As for these young people… they come and go like flies these days. Dirty ones at that.
> —Dr Storm in *Horror Hospital*

FOR THOSE who have not visited the place, North America exists solely within the confines of the television and cinema screen. Such a country is vast enough to cater for any number of fantastical lives, creating myths of a very real past. The stretch of water between the USA and Europe separates us from its numerous harsh realities; we'd like to think that distance plus perception equals enlightenment. Example: thirty years after the event, with the knowledge of a few books, plus articles, interviews, photographs and hearsay, I can compose a short fiction involving Charles Manson, and screw his personality up even more grotesquely.

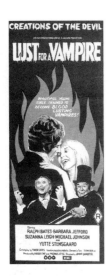

1. She is named in the end credits as 'Party Girl Who Is Painted'.
2. Cross the Atlantic for the best example of an actor-playing-musician. *Psych-Out* (1968), a San Francisco-based hippie quickie features — amongst a capital soundtrack (including The Seeds' monumental 'Two Fingers Pointing On You') — the young, hip, yet strangely square-looking Jack Nicholson wielding lead guitar in a club band. The music is 'Purple Haze' chopped up so the lawyers couldn't pounce. Big Bad Jack plays with all the style of a tennis-racquet-and-mirror-schoolboy, but without the flamboyance. He looks desperate to convince us he's cool, as if at any moment someone in the audience will scream "NARK!"
3. Co-star and former DJ Mike Raven: "That horrified me more than anything in the entire film!" (p.142 of *The Hammer Story* by Marcus Hearn and Alan Barnes, Titan, 1997).

This is done without ever having any connection — personal or otherwise — with anyone even faintly connected with those terrible events of 1969. The extreme distance fuels the fires of the myth, just like Howard Hughes or JFK, and becomes highly personalised within the individual mind: so that the mention of Manson's name stirs up a troop of long-hairs — decked out in denim and army surplus, goggles and face-masks — dune-buggying across the Californian desert under the command of a manipulative jail-bird. It'll take something bigger and stronger to erase such an image. This is an event built by knowledge of a land known only through the projected screen. A very personal film. And like all movies it needs a good soundtrack. Fittingly, my Manson family antics are accompanied by The Stooges' 'We Will Fall', from the same year. Over ten minutes of deadbeat mantra, doomed guitar, and Iggy's gut vocals, Charlie and co storm in from the desert to wreak havoc through Beverly Hills.

Just another example of Americanisation? Not really. The distance makes things palatable. What would be the Brit equivalent from a similar time? Ian Brady and Myra Hindley; Mary Bell; Donald Nielson? Nasty roll-call, but what about the music? Nothing comes instantly to mind. The Beatles and The Rolling Stones had already been abducted by Manson and the Hell's Angels respectively (Pink Floyd, perhaps?). The mind searches in vain for fitting accompaniment for our own killers, and comes up clutching at straws: Steeleye Span for Brady and Hindley? Mary Hopkins for Mary Bell? Eno-style electronic twiddlings for Nielson? Possibilities, but it makes you wonder if we can really rock out in a marriage of guitars and murder. Too British by half?

The most direct link between music and horror comes with that peculiar — and as far as I know, limited — practice of wedging a 'pop' band inconceivably into the reels of a horror film, for added teen appeal. By a stroke of great luck, most of these gigs occur during the period covered by this book. The ones I know about, that is...

THE PRACTICE of inserting hip scenes into horror films flared briefly and then burnt out, leaving a group of paisley-shirted post-teens vulnerable to sniggers in years to come. At some point during the mid-sixties, someone realised that monsters and castles and Victorians weren't doing anything for the kids, they needed something to identify with before the killing strokes came. This gave rise to the cinematic Party Scene, and nothing much else. After all, you have to remember that The Man was controlling the purse strings: hence a hip young director such as Michael Armstrong could conceive an enticing project called *The Dark*, throwing in David Bowie and the slaughter of trendy things, only to have it end up as *The Haunted House of Horror* with Frankie Avalon. Bad news. (See previous chapter.) A typical example of this cinematic cowardice comes at the beginning of *Curse of the Crimson Altar* (1968), a Technicolor fuck-up that packs in horror pillars HP Lovecraft, Christopher Lee, Barbara Steele and Boris Karloff. Brought to you by Tigon, the nurturers

of Michael Reeves. The hero, searching for his missing brother, arrives at a country mansion and walks straight into an orgy. Well, a sort of orgy: young people dance on tables, drinking champagne; the record player spins out a psychedelic soundtrack; there is kissing and groping; a near-naked girl is being body painted — though, true to the Roger Corman school of exploitation, she keeps her bra on.[1] It certainly gives the gatecrashing scene in *Dracula A.D.1972* a run for its money, but the decadence begins and ends there. The partygoers mysteriously disappear. The plot induces a headache. Most bizarrely of all, Lee's niece — also at the orgy — soon forgets her initial free-love greeting of the hero (kissing a stranger! With tongues!) and reverts to the chaise upper-class daddy's girl she no doubt was before the booze went to her head. Confident that they have lured the right kind of punters in, the film-makers jettison the hip scenes and carry on with the traditional horror business...

So much for wigging out. The maximum that producers allowed — like parents regulating a birthday party — seems to be having a live act somewhere in the film. An actual band is best, not just a bunch of actors strumming guitars,[2] or a specially-composed song thrust in for no particular reason, as with 'Riding Free' by Harvey Andrews (sounding like a charity-case Terry Reid) in *Psychomania*, or 'Strange Love' by Tracy in *Lust for a Vampire* (Cannot. Describe. Awfulness[3]). Then it's best to be certain that the music is actually likeable, and not just some easy-listening coffee-bar jazz that was only hip

On the right track to hipsville. *Beat Girl*

Party Girl Who is Painted 139

ten years previous (as with 1960 Brit teen flick *Beat Girl*'s soundtrack), as can be found in the 1964 anthology *Dr Terror's House of Horrors*. Grinning, trumpet-playing Roy Castle steals a sacred voodoo tune for his own jazz combo (real musicians apparently, from Tubby Hayes' group[4]), despite warnings from Kenny Lynch, of all people. When they strike up the number — which ain't exactly Sun Ra — some bad ju-ju comes down: winds blow, havoc is wreaked, crowds flee and Lynch disappears sharpish, shouting over his shoulder "See, I told you this would happen!"

Such trad bands were typical for a long time in British cinema. Jobbing musicians hired for the inevitable club scene. The waters become murky when rock music rears its ugly head, and you begin to asks questions of authenticity, such as: are Mystic a real band? Were they *ever* a real band? They turn up in *Horror Hospital* (1973), stuck in some dive with a song called 'Mark Of Death'. A few minutes after their appearance, *Horror Hospital* gives us one of the most brazenly straightforward slices of plot advancement your ears will ever hear. It certainly rivals a scene early on in *Incense for the Damned* (1970), where the main characters stand around in a room and talk about what has happened and what they are going to do next.

Pissed-off at the arse-end of a fight, songwriter Jason Jones (Robin Askwith) mentions to three friends that he wants to get out of the music business. This sets the ball rolling:

> GIRL: You're quite right, Jason. You should get away.
> MAN: Yes Jason, go away to the country for a few days [sniggers] you could do with the rest.
> GIRL: Hey, look at this.
> [*She hands Jason a full-page advert proclaiming 'Hairy Holidays: fun and sun for the under thirties'. A drawing of a bearded hippie accompanies it.*]
> JASON: A holiday. Yeah, that's a good idea. Think I will. Sun and fun for the under thirties. Well that's me. Just. Hairy Holidays. Yeah, I fancy something a little hairy. Might be some nice birds down there.

Go west, young man (or to Dorset, at least). From then on Jason fights hard to not turn into Timothy Lea dropped into a strange horror film. The friends at the gig are not named. The girl seems to be a film student handy on the day. The man speaks in a portentous tone out of place with his beard and glasses. Strangely, he is not in the group shots, only close-up. The film is similarly coy with Mystic. They seem to be a three-piece (guitar, bass, drums) of long-haired proportions, but the camera only shoots us a few close-ups of the bassist, and one on the guitarist/singer, a junior Lemmy who tops the three lines of the lyric "something ain't right" with a gruff "something is WRONG!" But this is the only evidence that he *is* the singer. It's a dingy basement. There is too much dry ice. The light show is two white spots. The zombie audience

[4]. This and many other gems of musical trivia can be found in Andy Boot's *Fragments of Fear* (Creation, 1996).

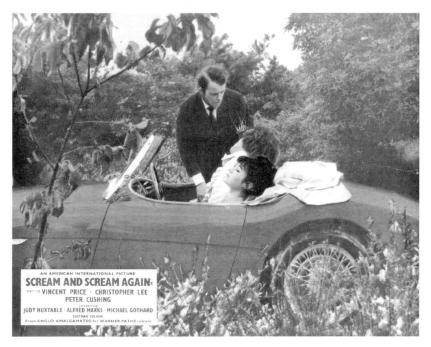

"Wake up, Brian! You're on in five minutes…" Julian Holloway, Michael Gothard, Judi Bloom. *Scream and Scream Again*.

nod along to the sub-Sabbath song ("my blood runs stone cold / and I'm looking at the golden eyes of evil"), trying to maintain some kind of cool. All the focus appears to be on a blonde-wigged, red-dressed trannie lying down at the front of the stage. Jason doesn't like him, calling him "a lemon meringue pie on heat", but he's more like *Rocky Horror* detritus crossed with Angie Bowie crossed with that bass player from Mud (the one with the big perm and Christmas decoration earrings). What is he doing there? At first you think he's the singer, then when Jason kicks off you realise he ain't, and wonder if you saw the guitarist's lips moving. Or perhaps it's the drummer, totally veiled in dry ice? There's not enough time to find out because after a few minutes Mystic's brief fame is up and Jason is ready to leave the music business. In the end the most memorable thing about the band are their names: James IV Boris, Allan (The River) Hudson and Simon Lust. But who is who?

Unfortunately, Stoneground — an obscure ten-piece band from San Francisco — are very real. Perhaps they're the most realistic thing in *Dracula A.D.1972*. They're certainly the most frightening. No sweaty clubs for this lot. Stoneground do swish gigs at upper-class penguin-and-puffy-dress parties. Who the fuck was their manager? He must have made Peter Grant look like Charles Hawtrey. But where the freaks go, others will follow like stoned sheep. Gatecrashers have burst in on this gig, leading to some tension between the starched host and his mother:

MOTHER: Charles, I asked you to invite one or two of your friends, but really…

CHARLES: These are *not* my friends. I've never seen any of them before in my life. All I did was to invite the Stoneground.

Yes, the Stoneground. Charles must be a little thick. Why invite such a band to this kind of party? It's like playing Chopin at the Isle of Wight festival. Did he really think the guests would enjoy them? Perhaps the intention was to kick back, loosen up and spray champagne everywhere. Someone at Hammer must have suggested that the young people like this sort of music. At least with the film's kids in the place things are more colourful (not that colourful:

Peter Cushing freaks out in his own inimitable fashion. *Scream and Scream Again*.

there's only one exposed navel to be seen), but they seem as self-conscious as the squares. Christopher Neame slinks about, Stephanie Beecham looks misplaced, Caroline Munro is far too enthusiastic for this sort of thing, and there's some cunt in a penitent's get-up who — considering his religious appearance — is just asking for a lengthy spell of *auto-da-fé*. Sometimes it's hard to tell who's a gatecrasher and who's a member of the band: Stoneground — who only had a couple of albums to their name — are bottom-billers at best,[5] anonymous musicians and big-dress female backing singers. They seem oblivious to what's going on in the rest of the room. First song 'You Better Come Through' is a piano-led number that The Black Crowes could have covered twenty years later; 'Alligator Man' fares little better, sung as it is by band leader Sal Valentino, a swarthy-looking individual with a ponytail who has the appear-

5. '[Don] Houghton had scripted a party appearance for Rod Stewart's group The Faces, and a contract was prepared in September 1971.' (*The Hammer Story*, p.156). Close shave, Rod.

142 Psychedelic Decadence

ance of someone who'd rather rob you than sing a song. The music comes as almost a welcome release to Beecham and co's antics. Smug and pointless, they are the biggest bunch of pricks ever to have existed on film, and contribute to six (extremely long) minutes of cringe-inducing cinema. The toes curl in anticipation of it ending. It's like watching your grandparents kiss. Several chapters ago (in **A Couple of Bad Trips**) I was quite fond of this scene, but now I sympathise with one of the party's guests: distressed by such behaviour, she sobs openly…

The nearest I could find to a 'name' band comes in *Scream and Scream Again*. The plot is far too fractured to care about here, but needless to say Yutte Stensgaard's pretty mouth opens to scream and the next thing we're in a night-club, where The Amen Corner are playing. Quite a catch, as they would have had hits with 'Bend Me Shape Me' and 'High In The Sky' by the time the film was released. Deep in the Green Belt lies The Busted Pot disco, and if you pay attention you can see a poster advertising the band. This place is kool kat Keith's (Michael Gothard) — a vampiric humanoid (long story) — chosen stomping ground, and it's confused enough for him to pick off victims easily. Everyone is dancing to a different drum, to a personal disco inside their own heads, not in time with the music. One in ten people watching *Scream and Scream Again* must recognise a parent. A mess of voices is audible above the music. And what sort of music is it? Certainly not the band's song entitled 'Scream And Scream Again' — a nice enough vocal number that's about as relevant to the film as the sensationalist title. The main music in the movie is an anonymous instrumental. It doesn't break ranks with The Amen Corner's R&B-lite set, ambling along pleasantly, when you can hear it above the chatter. There is the vague hint of someone singing, but you realise that no-one is when you see the singer — dressed in a dark suit — doing nothing more than clicking his fingers, occasionally clapping his hands. He appears to be on invisible strings, making the odd subtle jerking motion, as if someone has walked over his grave. Only his forearms move, like the elbows have been nailed to his sides. Something is out of sync here, but then the whole scene seems to be. He nods along to that internal disco, occasionally mouthing a few words. When the band turn up again, the only thing that has changed is the music, again another (similar) instrumental. For a seven-piece, they're quite shy, mostly remaining in the shadows of the stage. Apart from the strange singer, there

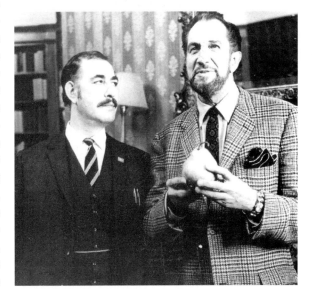

Vincent Price (right) contemplates a thrilling future in pop music videos. Alfred Marks looks on. *Scream and Scream Again*.

is a glimpse of guitar, of a drummer, and two saxophonists: doing nothing as the song progresses. Faces cannot be matched between the cover of a compilation album and those on stage; the band are credited as 'Themselves', but you soon begin to doubt it. Has someone replaced them with humanoids? It would fit in with the film's theme. Not the most high-profile gig in the world. But no wonder the camera is erratic with Michael Gothard prowling the dancefloor. Far more of a rock star than all of these Welsh boys combined,[6] he acts like a laconic renegade member of The Rolling Stones, a mysterious extra jettisoned when they realised he was too cool for them…

"Scream and scream again" with Amen Corner.

And here it reaches a full stop. There may well be other bands in other films, playing pretend gigs to hoards of extras, but this sort of obsessional detail is usually missing from even the most comprehensive reference book. Perhaps these people were never meant to be discovered, perhaps there are no more of these unique scenes. Though I'd like there to be. This defeat may only be short-lived as there are four or five other films which — when reviews are merged — hint at containing other glimpses of rock bands. And that's good enough for the hunt to begin. An encore, anyone?

6. Staying in the rock department, check out Gothard's appearance as a beatnik exorcist (complete with Lennon glasses) in *The Devils* (1971).

Psychedelic Decadence

Cracked Actor

Mike Raven's Bad Timing

DON'T PITY Mike Raven, he was once like you. It's not his fault that in the handful of horror films he turned up in he *looks* great, but can't act for shit. Actually the word 'act' is a bit strong. He does something, but I'm not sure what it is, nor, it seems, do most of the cast he shares space with. Raven's acting career began and ended in the early 1970s, and at first glance looks like the fifteen minutes thence obscurity route that befell many a bloodstained participant back then; but in hindsight it seems he was quite happy to drift from job to job…

Born Austin Fairman in 1924, Raven appears to have chosen numerous routes as well as his horror career: soldier, author (of what I don't know), teen actor in 1940's black-and-white flicks, pirate radio disc jockey (Caroline and Luxembourg) and legit Radio One record-spinner. At some point during the 1960s Raven probably said to himself (in a booming voice) "and now I shall become a horror film star!" and then made moves to do just that, emerging from the soundproof studio looking like a merge of Peter Cushing and Christopher Lee; actually, looking a hell of a lot like Lee: the pointed beard, the slicked-back greying hair, but without that air of "I am an actor, you know" that Lee sometimes had when you realised he was just making motions towards the next paycheque.

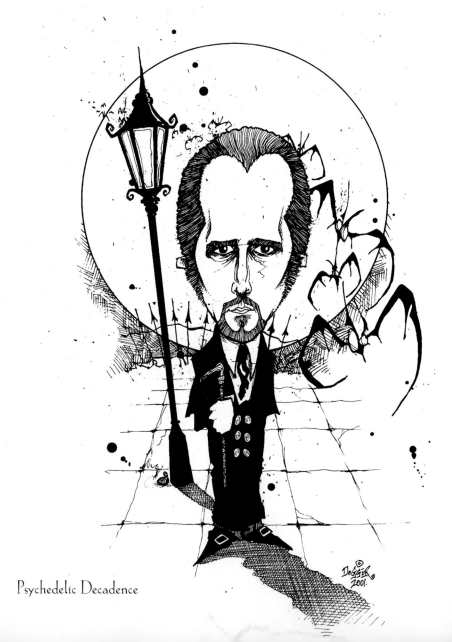

Psychedelic Decadence

And looks certainly helped. In his first film, Hammer's *Lust for a Vampire* (1970), Raven doesn't have to do much except throw out evil glares. As some Count or other he hangs around a derelict castle (church?) and broods, probably still continued to brood when the action went off elsewhere. Many sources report Raven as being dubbed, but I can't for the life of me remember him even talking. Perhaps this was a good thing; his next appearance was in Amicus' *I, Monster* (1970), a Jekyll and Hyde spin with Lee and Cushing mucking about. Once again, Raven's got it easy, sitting around in a gentleman's club drinking and reading the newspapers. He *seems* to be part of a group, mates with the two leads, but it's only when he opens his gob that you realise that the man was either pally with the casting agent or had such a silver tongue he could insinuate himself in anywhere.

Mike Raven gets his hands dirty — *Crucible of Terror* press release.

When Raven speaks the other actors appear to ignore him, or seem to dismiss him with looks of "yes, *alright* Mike. We heard you". He's the mumbling fool in the corner that people glance at and pretend they haven't seen. He's the embarrassing mate that you hope doesn't say a word. Strange, really, because he's the most memorable thing in the whole damn film.

But perhaps Raven's presence wasn't right for the big boys of horror. He should have gone underground, to the conveyor-belt Italian industry or the New York art set. Christ, Andy Warhol would have *loved* him: I can just see Raven prancing about in *Blood for Dracula*. In another life, maybe. As it is, there is much to savour in *Crucible of Terror* (1971): drunken Ronald 'comedy Nazi' Lacey, a bevy of foxy chicks, James 'wen di boot comes in' Bolam looking confused, but most of all Raven's Victor Clare, a black-clad mad sculptor and overlord of his Cornwall home. If you've ever entertained fantasies of an isolated coastal dwelling, an inexhaustible supply of booze and numerous chances of sexual liaisons, this film is for you. Raven is obsessed with youth, particularly in preserving it in nasty ways. Whilst his own haggard wife rambles about their dark Cornish cottage, Raven plays host to his drunken son (Lacey), the gallery owner who

Cracked Actor

buys his work (Bolam), and their respective girlies. As is befitting an artist's bohemian space, some people have little on their minds except nookie: one of the girlfriends, sunbathing on a pretty bleak beach with Marcia, the artist's current muse, doesn't allow her to do much more than rub suntan lotion in, getting frosty when the suggestion is made to sunbathe nude. This is to be expected. The girl — Millie, Bolam's chick — is your cut-out horror nicety. Marcia, on the other hand, is a dark-maned coil of sensuality, using her brief appearances to try and inject some free love into the proceedings. Similarly, Raven lurks around the place in black shirt, big belt and black trousers, reading from a script that is a few seconds behind the others. But don't hold this against him, his presence alone is worth sitting through *Crucible of Terror*. We can forgive his bad timing because he looks demonic simply by doing nothing, although sometimes his acting does create moments of strangeness: when his advances are rejected by Lacey's girlfriend, he booms "NO?! In God's name what's the matter now?!" and strikes a pose that suggests he's about to play an invisible Theremin. Mr Slaughter would be proud.

I'd be lying if I said I'd seen *Disciple of Death* (1972), Raven's last excursion into horror films. Not sure I want to see it. A horror comedy mix set in eighteenth-century Cornwall, Raven plays a resurrected demon on the lookout for a new bride; the one publicity still doing the rounds shows him not so demonic black. All reviews found give this low-budget piece the thumbs down, but *Disciple of Death* seems to be the logical conclusion to Raven's film career. As he was co-producer and co-writer (under the pseudonym Chuston Fairman. Subtle), it's the ultimate act of vanity publishing, although time spent with the two most successful producers of British horror seems to have had little influence on Raven. Fitting, considering his bad timing. The most he appears to have got out of such a short career is a love of Cornwall, where he lived until his death in 1997.

But *Crucible of Terror* is more than enough. A simmering pot of decadence in (fittingly) England's lowest county. It's a party that no-one is invited to; where to stand still is to be covered in dust; where booze, sexy chicks and art can only be escaped by walking along a precarious coastline — although you know that sooner or later you have to return to that cottage, where Mike Raven waits, an image of evil reading from his own script (smuggled in past the producers), a short-term actor already breaking the skin of his different drum.

"Aieeeee!"

Memories of 2000AD

"IT IS BEYOND OUR HUMAN UNDERSTANDING!"

NINETEEN-SEVENTY-SEVEN. A mixed blessing. Punk rock kicked the musical clock back to year zero, but also had the adverse affect of confining a whole load of bands to the bin marked 'Boring Old Farts': so anything existing before that wasn't the New York Dolls, Stooges or MC5 was roundly ridiculed and spat at. A pity, as rock and roll is pretty much circular and self-sufficient, and everyone has more in common than they'd like to admit. Wasn't Jimmy Page 'nodding off' to The Damned's first album around this time?

Not that I can vividly remember any of this. My brother was well into the Sex Pistols, but the only memories I have are of Day-Glo badges in *Smash Hits* and the feeling that everything John Lydon sang was really, really rude. Although I enthusiastically jumped around to *Never Mind The Bollocks* — and later *The Great Rock'n'Roll Swindle* — it was more in the spirit of duty to my older sibling than anything else. My formative years in reading and music consisted of wading through a Hell of a lot of detritus to get to the good stuff (something that never happened on the movie side[1]). Much too young to really appreciate songs beyond excitement level, my real musical influences were a number of years away.

However, revelations *were* happening in the reading department at around the same time. Up until '77, my diet of books consisted of the usual suspects: *Doctor Suess*, Ladybird Greek fables, *Asterix* etc. The first attempt at reading a 'proper' book was still a few years off,[2] but in-between the two a comic was published that in many ways was like punk rock for kids: colourful, violent, modern; it took slices of the past and moulded it into something completely new, setting standards for future generations. Okay, maybe I'm leaning too much on the hyperbole, but for a seven-year-old, *2000AD* must have seemed like the visual equivalent of those first chords of 'Anarchy In The UK'.

And it's pretty safe to say that *2000AD* was an early influence on my imaginative life. Issue — or 'Prog', for programme — one was published by IPC magazines on February 26, 1977. Bar fifties' throwbacks like the *Beano*, IPC had the mainstream British comic market saturated with every conceivable genre title: sport, adventure, girls stories, war and numerous kiddie-cartoon numbers like *Whizzer and Chips* ("that's all for this week, chums!"). We were young, and didn't know any better. The child population of Britain, myself included, probably kept IPC's employees in Soho lunches for a long, long time. But now, apart from the subject of this chapter, only titles such as *Battle* and *Action* remain in the mind: the former because of the epic and excitingly graphic World War One story 'Charley's War', the latter because of its wholesale and copyright-baiting steals of Hollywood film plots with, considering the readers' ages, some pretty gratuitous violence. *2000AD* took their ideas one step further, adding a

fantastical taste to the Boys' Own adventures. I'd like to think that, in a simple example of chaos theory, all that pocket money spent buying IPC titles and, indirectly, ending up in wage packets and so paying for some mammoth intoxicant session, fuelled someone's mind into conceiving the idea for *2000 AD*. For a number of years it reigned supreme in my life, and I devoured each weekly Prog, disturbed and delighted in equal measure.

Of course, that's what I'd *like* to think, and that's when selective memory kicks in, that handy eraser of faults. As this is the only autobiographical chapter in this book, and so the nearest I can get in my own life to the timespan of the other subjects (a series of years previous that are just out of reach), it'd be easy to write a hot appreciation of *2000 AD*, tinged with my own hardcore attitude towards it: reading every word, understanding every story, leaving childhood with a large dose of Cool; not the reality of skipping some stories, being unable to understand some stuff, and spending more time trying to copy the artists' work. Despite the fact of being a regular reader I now only possess an armful of back issues, which makes for too many gaps to fill in my childhood. Best not to bother with a comprehensive appreciation. Leave that to the historians. The one thing that I am very, very certain of is that whenever I think of *2000 AD* I think of death. Violent death. A *lot* of violent, nasty deaths. There

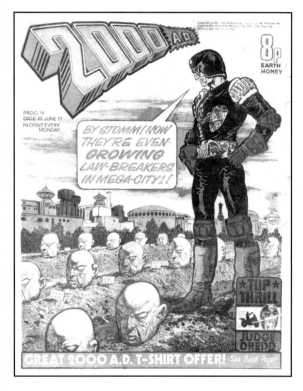

always seemed to be some character or other dying horribly, usually with drool spluttering from their screaming mouths. Nineteen-seventy-seven certainly had its sleeves rolled up, ready for a fight. Previous to this all childhood thoughts of death were anchored in the war arenas of *Battle* and *Action*: men died in an instant from single bullet wounds, and acceptance of this was echoed through childhood games with toy guns and melting your Action Man. It was exciting, it was what kids did. *2000 AD* changed everything; it screamed out loud with agonising pain, and the last words cried by many seemed to be "NO!", or more commonly "AIEEEEE!" This was real nightmare material. But don't think for a minute that it was all trauma. There was some genuinely weird stuff in those pages, some of it as hard to unscramble at the time as Johnny Rotten spitting out 'Bodies'…

1. The seeds of which were planted when I was taken to see a new film called *Jaws*. Twice. Thanks, Dad.

2. A *Doctor Who* novelisation.

"Aieeee!" 151

'Invasion', Prog 6

VIOLENCE is golden, and *2000 AD* memories are aided enormously by revisiting those browning pages. There was no need for a gimmick to sell the comic: it didn't really need anything other than its stories to make it different from the competition, but obviously IPC thought otherwise, and so the whole thing was published under the pretence of being edited by an alien being, a giant green humanoid called Tharg with a reflective disc stuck to his forehead. Tharg bought us the stories, Tharg told us of life on his home planet, Tharg was the all-powerful being. Tharg was roundly ignored by me, his poncy statements just getting in the way of the important stuff. Prog 1 contained five stories: 'Invasion!', 'Flesh', 'Dan Dare', 'Harlem Heroes' and 'M.A.C.H.1' (plus a free Space Spinner!); the comic's most famous creation, 'Judge Dredd', didn't make the scene until Prog 2. Looking over those early issues again, it's amazing to see the variety of these original six stories; there was something for every little mind, with influences from everywhere: 1950s sci-fi, westerns, American films and TV shows, traditional war stories. Most of them adhered to the visual styles that were commonplace at the time, with nondescript artwork straight from those pocket war books, but even early on a few displayed talent to burn. In the end pretty much any competent artist can sketch out violent death.

But, it wasn't all greatness. For every Sex Pistols there is a Vapors. 'Harlem Heroes' is the basketball namesakes blasted into the twenty-second-century and given a *Rollerball* rip-off to play in — this time a sort of airborne basketball/American football mix; our heroes were matched against aggressive teams from all over the world, as well as dangers outside the ring. If you liked sport, you'd love it. I didn't and I didn't. I wanted guns…

3. Although in Prog 19 Bill Savage does take the controls of a road-layer and flatten a group of Volgan soldiers into a melting tar road.

4. A position later inherited by the pointless resurrection (with shit stories and — the ultimate comic crime — photo-strips) of *The Eagle*.

152 Psychedelic Decadence

'INVASION!' came closest to *Action*-style, with Britain 1999 under control of the sadistic Volgans, and only a group of hard Londoners, led by leather-jacketed Bill Savage, putting up resistance. For Volgans read: Russians/Nazis. This was the decade where the enemy of the western world was very clear, after all (and only a few years away from 'Protect and Survive' paranoia). Like a pearly king with a shotgun, Savage fought the Volgs undaunted, full of cockney spirit and unending confidence. He was a bit of a cunt, to be honest: sadism mistaken for revenge. As the Volgans were nasty from conception, their methods of disposing of resistance — firing squads, torture — seemed much more justified.[3] 'Invasion!', like 'M.A.C.H.1' ('THE MOST POWERFUL MAN EVER INVENTED!'), belonged back in the boys own *Battle/Action* category.[4]

> *1999! YEAR OF THE VOLGAN INVASION OF BRITAIN. NOW VOLGAN TROOPS PATROL EVERY COUNTRY LANE, EVERY CITY STREET... AND ANY ACT OF DEFIANCE IS ANSWERED BY -- THE FIRING SQUAD!*
>
> —'Invasion', Prog 6

'M.A.C.H.1' stood for Man Activated by Compupuncture Hyperpower, an Anglo rip-off of *The Six Million Dollar Man*: kicking his way through a story each week for the benefit of his government masters, crushing Eastern European heads like balloons. He made up his fair quota of violent deaths; bad guys died by explosion, burning, broken necks, crushing and, most memorably of all, falling into the propellers of an airship. The heroes of 'M.A.C.H.1' and 'Inva-

> *"IMPOSSIBLE! THE NAZI SKELETONS HAVE COME ALIVE!"*
>
> —'M.A.C.H.1', Prog 6

"Aieeeee!"

'M.A.C.H.1', Prog 32

sion!' had a passion for the job, if nothing else. Their appearances in *2000AD* were probably designed to tempt over the Boys' Own readers. It must have worked: these polo-necked hard men were deceptive enough to lure the reader into darker, freakier territories.

But not that dark, obviously. This was still a mainstream kids' magazine, after all. *2000AD*'s 'darker, freakier' stories still adhered to self-contained narratives and simple storytelling. At the time my childhood reading habits were pretty much limited to more traditional avenues, then along came *2000AD*. A bit like hearing 'New Rose' after 'You Make Me Feel Like Dancing'.

> WITH THE DISCOVERY OF TIME TRAVEL, FUTUREMAN CAN GO BACK IN TIME TO THE AGE OF THE GREAT DINOSAURS! HE BUILDS TOWNS THERE, COVERED IN PLASTIC DOMES -- TO KEEP THE DINOSAURS OUT, BECAUSE WHEN THEY GET IN -- THEY'RE... LESS THAN FRIENDLY!
>
> —'Flesh', Prog 6

'Flesh', Prog 6

'FLESH' was brilliant. It predates the *Jurassic Park* malarkey by almost fifteen years. A merging of dinosaur carnage and good guy/bad guy western values, it came on like Sam Peckinpah directing one of Hammer's stone age romps. Naturally instigated by a time-travelling Big Corporation, the dinos are harvested for meat for the future populace, or gawked at as tourist attractions. There's (semi-) good guy Earl Reagan and bad guy Claw Carver, a mad bastard with a dino claw for a left hand.[5] But the real danger in 'Flesh' was Old One Eye, a drooling 120-year-old hag tyrannosaur. A lot of humans got chomped up in Old One Eye's jaws, including — most satisfactorily — brat kids.

5. In Peckinpah's film they'd be played by William Holden and Klaus Kinski.

6. Old One Eye's bloodline continued in the first epic 'Judge Dredd' story 'The Cursed Earth' (Progs 61–85) with the appearance of her son, Satanus.

Psychedelic Decadence

Cool. 'Flesh' is an apt title, there was a Hell of a lot of it being ripped, clawed, eaten — human and dinosaur. A particularly nasty storyline had the dinosaurs — after they'd been fed rotten meat — go on the rampage. While they lay siege to the city, something horrid was creeping up from below

'Flesh', Prog 6

> "The spiders must have been down there for years... feeding on the BLOOD OVERFLOW pipes."
> —Prog 13

Yeah — giant blood-sucking spiders on the prowl for sleeping human victims; or, as one future meal so memorably put it:

> "Spiders... furry and horrible! crawling all over the blankets!"

When some poor sod wasn't falling into the jaws of a T-Rex there was always another life-form ready to take its place, ready to show these pretty pathetic specimens of humanity that you shouldn't mess with nature. It was yeeuch factor ten with guns and electric whips. True to the man vs nature themes around at the time (instigated by *Jaws*), 'Flesh' leaned heavily on the nemesis-like battle between Reagan and Old One Eye, but thankfully a Hell of a lot of money-grabbing, cruel humans died in-between. A lively comic strip for kids meant nasty deaths every page, and 'Flesh' more than satisfied that need with its high body count. Even after her monumental death, Old One Eye's fossilised skeleton managed to chomp down on some pompous museum professor.[6] Tasty.

'Flesh', Prog 9

"Aieeeee!"

'Dan Dare', Prog 32

> *"RELATIVITY'S TEARING THE SHIP APART AND TIME'S GOING CRAZY!"*
>
> —'Dan Dare', Prog 13

2000AD was primarily associated with sci-fi visions of the future, and the publishers no doubt saw the need to include an instantly recognisable character to empathise this, hence 'Dan Dare'. Written and drawn by Frank Hampson, Dare was the lead story in the 1950s comic *The Eagle*, and was initially the colour centre-spread (and later the front page) in *2000AD*. But his creator, the Reverend Marcus Morris,[7] would be clawing at the earth if he knew what had become of his chocks-away airforce pilot of the future: someone took the stick out of Dare's jacket and let him battle it out with numerous aliens (and the Mekon — still), many of them looking like giant vaginas.[8] Although the drawing duties for this character's second run (from Prog 28) were taken over by the cleaner lines of Dave Gibbons, the first

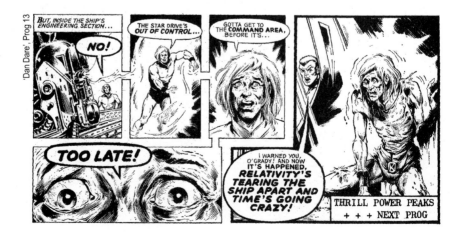

156 Psychedelic Decadence

2000AD stories were drawn by the very far-out artist Belardinelli. This made a lot of difference: his art was strange, organic, a mushroom trip realised; one of Dare's first adventures was battling the Biogs, an alien race that consume humans for fuel. Orifices are everywhere; the Biogs' servants wield living axes; Belardinelli's art seems to forever be on the verge of melting. Strange aliens, strange Dare. He looks like Aladdin Sane-era David Bowie: swept back red hair, sideburns (but still with the coat hook eyebrows) and 1950s realisations of intergalactic costumes. There is a touch of seventies glam about him, somewhere between Roxy Music and Bowie. Okay, so it's not exactly transforming him into a transsexual paedophile with a lasergun or some other revisionist fantasy, but it's a sight better than the original Dan Dare; you get the feeling *he* wouldn't last five minutes compared to this future legend. Although when Dave Gibbons took over the art got back to basics — with Dare sporting a more conventional flight jacket — the stories still remained a bit freaky, especially the one that had the genius move of merging the Roman Empire with vampires:

"GO FOR THEIR HEARTS!"

'Dan Dare', Prog 6

7. Full of 1950s morals, the Rev Morris had designed the *Eagle* as a force against the flood of American horror comics invading British shores. Heh-heh-heh.

8. Dare was also the main selling point of the 1982 *Eagle*, although this time it was not the original character but his great, great grandson. The two were more or less identical, and the stories were a pretty mixed bag.

"Aieeeee!"

Plenty of room for multiple "AIEEEEE!"s there. Vampiric empirical aliens. Try working your way out of that one, Danny Boy.

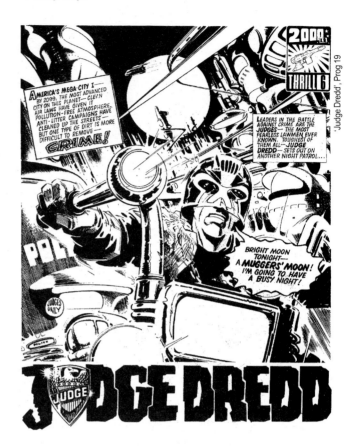

'Judge Dredd', Prog 19

> "ONLY ONE WAY --
> EXPLOSIVE BULLET
> AT THE DOME!"
>
> —'Judge Dredd', Prog 9

9. Though it would be some time before Dredd himself hit the big screen with, it should be noted, all the impact of a plucked turkey thrown into a sandpit.

IN THOSE days of '77 'Dan Dare' may well have been pushed forward as *2000AD*'s lead story, but another, less morally constrained character was about to overtake him: 'Judge Dredd' was the number one law enforcer in Mega City One, futuristic metropolis in a nuclear wasteland USA. His appeal was straightforward. Each story had him tracking down criminals and punishing them, not a million miles from other seventies' hard men — Eastwood, Bronson[9] — he even had the same stony features. Plus the added bonus of fetishtic weapons and black leather outfits. But strangely, it's not Dredd I remember so much as the great bad guys he was pitted against; he seemed to have a lot of run-ins with homicidal robots throughout the early Progs, and some marvellous characters tried to fuck him over later: the in-

158 Psychedelic Decadence

sane Chief Judge Cal (who, like the Roman rulers before him made eccentric use of his power by instating a goldfish as his deputy); the futuristic redneck family The Angel Gang (very nasty) and the evil as fuck Judge Death, a cadaverous bogeyman from a parallel dimension where living is a crime (and he came to lively Mega City One. What do you think happened next?) In the end Dredd was just a cipher for these more charismatic criminals, and, as the strip developed, he became more and more of a killing machine and physically larger: a good example of this is to compare Mike McMahon's original drawings with the same artist's work in the eighties. Dredd goes from a slim-hipped Peter Fonda type to a chunky Nick Nolte motherfucker. Thankfully, blips of humanity came later in the forms of female judges like black-haired Hershey and psychic Anderson. At least they looked better in the uniforms.

Not exactly a barrel of laughs, Dredd was an excellent straight-man against some of the weirder shit going down in Mega City One

"Aieeeee!"

"Brainblooms grow like flowers but can imitate any known sound — a result of bio-organic *GRAFTING* of plant and human…"

Prog 18, for instance, has Dredd pitted against an old lady who grows Brainblooms on her roof garden. Unfortunately, their singing hypnotises the Judge and nearly turns him into road-paste. The law wins in the end, though. And continued to win despite being up against some right hard dudes.

> *"ENGLAND DURING THE WITCH-HUNTS?"*
> —'Tharg's Future-Shocks'

AFTER about twenty-or-so Progs, new stories started to come in, and I remember most vividly 'Tharg's Future Shocks', self-contained, futuristic *Tales of the Unexpected*-style strips with nasty stings in the tails. The *2000 AD* franchise continued with Annuals and Sci-fi Specials (summer specials to you and me) which had in them mostly badly-drawn stories and factual articles, although the 1978 annual seemed to relish a LOT of nasty deaths; it also con-

'Harlem Heroes', Prog 19

160 Psychedelic Decadence

tained a particularly freaky 'Judge Dredd' mind control story.

2000 AD continued — and continues — beyond my fading interest. It weathered merges with lesser sci-fi titles such as *StarLord* (potential porn film title!) and *Tornado*, although this did have the benefit of being able to flinch some of their better stories (particularly 'Ro-Busters' and 'Strontium Dog'). It also gave the comic world some great writers and artists: Belardinelli, Carlos Ezquerra's spaghetti-western style, Brian Bolland's muscular Dredd (always a riot when coupled with John Wagner's mad scripts). The mid-1980s, just before I stopped reading, produced the two best stories in the comic: Pat Mills'

'Tharg's Future Shocks', Prog 32

and Kevin O'Neill's 'Nemesis The Warlock', a gothic amalgamation of sword-and-sorcery, witch hunts and scary aliens, brought to brilliant life by O'Neill's spiky black-and-white artwork; and (the omnipresent) Alan Moore and Alan Davis' anarchic 'DR & Quinch', two delinquent aliens with major weaponry and too much time on their hands. Soon after, James Herbert, Stephen King and alcohol intervened, and the comics, like so many other things, disappeared into a parental attic.

And now, with memory refreshed, I can say this story or that artist influenced me, but deep down I know something a lot simpler opened my eyes. Every time IPC introduced a comic there was always a glut of free gifts. Prog 2 of *2000 AD* contained a sheet of 'Biotronic Man' stickers, each one a coloured mass of wires and suchlike: you stuck them on your arms and it looked like the skin had been peeled off to reveal the bionic man beneath. Bizarre. Amazed and fascinated, at the time this was akin to being granted a wish to become invisible, or having X-ray specs, or some other childhood departure point from school. I started drawing a lot of similar things, full of dreams of one day working for my favourite comic. Back then, the only reality that truly intervened was the fact that the stickers hurt like fuck when you tried to peel them off.

Critical Vision Books
Published in 2001 by Headpress

Copyright © Martin Jones

Set in Palermo SF

This book is sold subject to the condition that it shall not, by way of trade or otherwise, by lent, re-sold, hired out or otherwise circulated without the publisher's prior consent in any form of binding or cover other than that in which it is published and without a similar condition including this condition being imposed on the subsequent purchaser.

Martin Jones

THE GENERATIONS of BRITAIN

Critical Vision

THE GENERATIONS of BRITAIN
An Imaginary Orgy

*These are the generations of Britain.**

Mike Roscoe fucked Amy Sumner. And David Sumner fucked Charles Grayson. And Charles Grayson fucked Sarah Frameson. And Sarah Frameson fucked Sam Bryant. And Sam Bryant fucked Alec Powell. And Alec Powell fucked Joe Sickles. And Joe Sickles fucked Michaela Cazaret. And Michaela Cazaret fucked George Sorell. And George Sorell fucked Marcus Monserratt. And Marcus Monserratt fucked Ann Sorell. And Ann Sorell fucked Marcus Bezant. And Marcus Bezant fucked Anna Pritchard. And Anna Pritchard fucked Elise Bezant. And Elise Bezant fucked Paul Bezant. And Paul Bezant fucked Carol Radford. And Carol Radford fucked Jill Radford. And Jill Radford fucked Gerta Hauser. And Gerta Hauser fucked Anna Mueller. And Anna Mueller fucked Lee Radford. And Lee Radford fucked Ralph Gower. And Ralph Gower fucked Sacha Seremona. And Sacha Seremona fucked Jim Radford. And Jim Radford fucked Cathy Vespers. And Cathy Vespers fucked Harry Lomart. And Harry Lomart fucked Jane Clare. And Jane Clare fucked Gustav Weil. And Gustav Weil fucked Maria Gelhorn. And Maria Gelhorn fucked Rod Strangeways. And Rod Strangeways fucked Frieda Gelhorn. And Frieda Gelhorn fucked Ingrid Hoffer. And Ingrid Hoffer fucked Hieronymous Grost. And Hieronymous Grost fucked Julian Ainsley. And Julian Ainsley fucked David Thing. And David Thing fucked Clive Cunningham. And Clive Cunningham fucked Anna Cunningham. And Anna Cunningham fucked Anton Hoffer. And Anton Hoffer fucked Kathy Weil. And Kathy Weil fucked Marianne MacDonald. And Marianne MacDonald fucked John Pritchard. And John Pritchard fucked Eli Frome. And Eli Frome fucked Paul Greville. And Paul Greville fucked Tommy Sanders. And Tommy Sanders fucked Dora Mueller. And Dora Mueller fucked Benny Gray. And Benny Gray fucked Philip Stanton. And Philip Stanton fucked Tom Lynn. And Tom Lynn fucked Hans Weimar. And Hans Weimar fucked Johnny Maltese. And Johnny Maltese fucked Fred Sharprock. And Fred Sharprock fucked Rosalind Barton. And Rosalind Barton fucked Sara Durward. And Sara Durward fucked Peter Edmonton. And Peter Edmonton fucked Jack Phipps. And Jack Phipps fucked Pamela Gates. And Pamela Gates fucked Anton Kersh. And Anton Kersh fucked Harry Mulligan. And Harry Mulligan fucked Iris Vokins. And Iris Vokins fucked Charles Freeman. And Charles Freeman fucked Stephen Brant. And Stephen Brant fucked Paul Durward. And Paul Durward fucked Sybil Waite. And Sybil Waite fucked Gerald Amberley. And

THE GENERATIONS of BRITAIN

Gerald Amberley fucked Abby Darke. And Abby Darke fucked Alex Campbell. And Alex Campbell fucked Patricia Wison. And Patricia Wison fucked James Manfred. And James Manfred fucked Alice Marshall. And Alice Marshall fucked Del Shaw. And Del Shaw fucked Victoria Brown. And Victoria Brown fucked Tom Straker. And Tom Straker fucked Bob Gillette. And Bob Gillette fucked David Broome. And David Broome fucked Brian Murray. And Brian Murray fucked Peggy Heller. And Peggy Heller fucked Michael Carmichael. And Michael Carmichael fucked Molly Carmichael. And Molly Carmichael fucked Robert Heller. And Robert Heller fucked Virgie Fane. And Virgie Fane fucked Bill Fane. And Bill Fane fucked Gwen Mayfield. And Gwen Mayfield fucked Pat Lomart. And Pat Lomart fucked Stephanie Bax. And Stephanie Bax fucked Alan Bax. And Alan Bax fucked Sara Lowes. And Sara Lowes fucked John Sterne. And John Sterne fucked Richard Marshall. And Richard Marshall fucked Brenda Blaney. And Brenda Blaney fucked Richard Blaney. And Richard Blaney fucked Robert Rusk. And Robert Rusk fucked Babs Milligan. And Babs Milligan fucked Hetty Porter. And Hetty Porter fucked Felix Forsythe. And Felix Forsythe fucked Christina Cunningham. And Christina Cunningham fucked Johnny Porter. And Johnny Porter fucked Anna Robinson. And Anna Robinson fucked George Dabernon. And George Dabernon fucked Hugh Dabernon. And Hugh Dabernon fucked Christopher Bingham. And Christopher Bingham fucked Anna Harb. And Anna Harb fucked Sir Mark Ashley. And Sir Mark Ashley fucked Joan Foster. And Joan Foster fucked Mary Valley. And Mary Valley fucked Helen Van Treylan. And Helen Van Treylan fucked Naureen Stokes. And Naureen Stokes fucked Paul Anderson. And Paul Anderson fucked Angel Caine. And Angel Caine fucked Linda Hindstatt. And Linda Hinstatt fucked Paul Martin. And Paul Martin fucked Simon Hindstatt. And Simon Hindstatt fucked Eva Caine. And Eva Caine fucked Wilbur Gray. And Wilbur Gray fucked Ellie Ballantyne. And Ellie Ballantyne fucked Alan Marlow. And Alan Marlow fucked Frank Richards. And Frank Richards fucked Joan Blake. And Joan Blake fucked Angela Mlake. And Angela Mlake fucked Joyce Ballantyne. And Joyce Ballantyne fucked Joanna Sutherland. And Joanna Sutherland fucked Stephen Ballantyne. And Stephen Ballantyne fucked William Hargood. And William Hargood fucked Martha Hargood. And Martha Hargood fucked Charlie Wilder. And Charlie Wilder fucked Harry Blythe. And Harry Blythe fucked Alice Hargood. And Alice Hargood fucked Estelle Monsarrat. And Estelle Monsarrat fucked Samuel Paxton. And Samuel Paxton fucked Cyrus West. And Cyrus West fucked Cicily Young. And Cicily Young fucked Allison Crosby. And Allison Crosby fucked Paul Paxton. And Paul Paxton fucked Lucy Paxton. And Lucy Paxton fucked Betty Rexton. And Betty Rexton fucked Jonathan Secker. And Jonathan Secker fucked Paul Jones. And Paul Jones fucked Lord Courtley. And Lord Courtley fucked Angel Blake. And Angel Blake fucked Emma Peel. And Emma Peel fucked Paul Henderson. And Paul Henderson fucked Annabelle West. And Annabelle West fucked John Reid. And John Reid fucked Susan Sillsby. And Susan Sillsby fucked Robert Caine. And Robert Caine fucked Philip Grayson. And Philip Grayson fucked Charles Hillyer. And Charles Hillyer fucked Giles Barton. And Giles Barton fucked Janet Playfair. And

THE GENERATIONS of BRITAIN

Janet Playfair fucked Richard Lestrange. And Richard Lestrange fucked Susan Pelley. And Susan Pelley fucked Sarah Framesen. And Sarah Framesen fucked Tania. And Tania fucked Vulnavia. And Vulnavia fucked Anton Phibes. And Anton Phibes fucked Margaret Spencer. And Margaret Spencer fucked George Spiggott. And George Spiggott fucked Julian Fuchs. And Julian Fuchs fucked Helen Dickerson. And Helen Dickerson fucked Margaret Fuchs. And Margaret Fuchs fucked Victor Clare. And Victor Clare fucked John Davies. And John Davies fucked Joanna Brent. And Joanna Brent fucked Vanda Sorell. And Vanda Sorell fucked Isabella Sorell. And Isabella Sorell fucked Birdy Wemys. And Birdy Wemys fucked Sandy Rexton. And Sandy Rexton fucked Kenny Wemys. And Kenny Wemys fucked Brigitte Lynch. And Brigitte Lynch fucked Paddy Lynch. And Paddy Lynch fucked Jennifer Linden. And Jennifer Linden fucked Jessica Van Helsing. And Jessica Van Helsing fucked Johnny Alucard. And Johnny Alucard fucked Imre Toth. And Imre Toth fucked Elisabeth Bathory. And Elisabeth Bathory fucked Isobel Banham. And Isobel Banham fucked Carl Ebhardt. And Carl Ebhardt fucked Mark Vespers. And Mark Vespers fucked Rosie Noggett. And Rosie Noggett fucked Elizabeth Radlett. And Elizabeth Radlett fucked Timothy Lea. And Timothy Lea fucked Alberto Smarmi. And Alberto Smarmi fucked Tiffany Jones. And Tiffany Jones fucked Sidney Noggett. And Sidney Noggett fucked Alexander Saxton. And Alexander Saxton fucked Tony Seymour. And Tony Seymour fucked Anna Karekin. And Anna Karekin fucked Harry Wheeler. And Harry Wheeler fucked Bob Kirby. And Bob Kirby fucked Steve Reding. And Steve Reding fucked Richard Fountain. And Richard Fountain fucked Joe Mitchum. And Joe Mitchum fucked Drimble Wedge. And Drimble Wedge fucked Chas. And Chas fucked Pherber. And Pherber fucked Lucy. And Lucy fucked Joey Maddocks. And Joey Maddocks fucked Turner. And Turner fucked Harry Flowers.

And Jason Jones fucked Tom Latham. And Tom Latham fucked Xavier Meldrum. And Xavier Meldrum fucked Barton Sorell. And Barton Sorell fucked Peter McAllister. And Peter McAllister fucked Jenny Welch. And Jenny Welch fucked Mark Dessart. And Mark Dessart fucked Vanessa Welch. And Vanessa Welch fucked Bernard Cutler. And Bernard Cutler fucked Valerie Davey. And Valerie Davey fucked Lucy Carlesi. And Lucy Carlesi fucked James Hildern. And James Hildern fucked Ann-Marie De Vernay. And Ann-Marie De Vernay fucked Emmanuel Hildern. And Emmanuel Hildern fucked Gino Carlesi. And Gino Carlesi fucked Hugo Cunningham. And Hugo Cunningham fucked Irina Petrovski. And Irina Petrovski fucked Edmund Yates. And Edmund Yates fucked Mandy Gregory. And Mandy Gregory fucked Dorothy Yates. And Dorothy Yates fucked Tommy Morris. And Tommy Morris fucked Jackie Yates. And Jackie Yates fucked Jill Fletcher. And Jill Fletcher fucked Edward Lionheart. And Edward Lionheart fucked Barry Nichols. And Barry Nichols fucked Michael Pritchard. And Michael Pritchard fucked Alexander Yorke. And Alexander Yorke fucked Alan Falconer. And Alan Falconer fucked Geoffrey Branscombe. And Geoffrey Branscombe fucked Stanley Moon. And Stanley Moon fucked Katie Lofting. And Katie Lofting

THE GENERATIONS of BRITAIN

fucked Olivia Rudge. And Olivia Rudge fucked Leonard Hawthorne. And Leonard Hawthorne fucked Stephen Yorke. And Stephen Yorke fucked Catherine Yorke. And Catherine Yorke fucked John Carter. And John Carter fucked Elizabeth Yorke. And Elizabeth Yorke fucked Giles Wingate. And Giles Wingate fucked Horace Clapp. And Horace Clapp fucked John Verney. And John Verney fucked Michael Rayner. And Michael Rayner fucked Beth Villiers. And Beth Villiers fucked Sally Reagan. And Sally Reagan fucked Anna Fountain. And Anna Fountain fucked Henry Beddows. And Henry Beddows fucked George de Grass. And George de Grass fucked Sue Randall. And Sue Randall fucked Judy Arkwright. And Judy Arkwright fucked Catherine Beddows. And Catherine Beddows fucked Eveline de Grass. And Eveline de Grass fucked Nick Cooper. And Nick Cooper fucked Linda Everett. And Linda Everett fucked Webster Jones. And Webster Jones fucked Gail Cooper. And Gail Cooper fucked Maxy Naus. And Maxy Naus fucked Giles Cunningham. And Giles Cunningham fucked Jill Brown. And Jill Brown fucked Ruby Climax. And Ruby Climax fucked Tony Bender. And Tony Bender fucked Brenda Climax. And Brenda Climax fucked Mary Truscott. And Mary Truscott fucked Avril Chalmers. And Avril Chalmers fucked Julia Lofting. And Julia Lofting fucked George Rexton. And George Rexton fucked Janet Ainsley. And Janet Ainsley fucked Freddie Horne. And Freddy Horne fucked Magnus Lofting. And Magnus Lofting fucked David Swift. And David Swift fucked Miles Fanthorpe. And Miles Fanthorpe fucked Marty Gold. And Marty Gold fucked Rose Flood. And Rose Flood fucked Greta Braden. And Greta Braden fucked Claudia Branscombe. And Claudia Branscombe fucked Edina Hamilton. And Edina Hamilton fucked David Sorel. And David Sorel fucked Bruce Barrington. And Bruce Barrington fucked Lamphrey Gussett. And Lamphrey Gussett fucked Helen Mallory. And Helen Mallory fucked Laurie Gordon. And Laurie Gordon fucked Milo Kaye. And Milo Kaye fucked Tom Gifford. And Tom Gifford fucked Edward Langdon. And Edward Langdon fucked Valentine De'ath. And Valentine De'ath fucked Helen Bradford. And Helen Bradford fucked Jon Pigeon. And Jon Pigeon fucked Keith Fury. And Keith Fury fucked Edwin Anthony. And Edwin Anthony fucked Dr Emmanuel Whitbread. And Dr Emmanuel Whitbread fucked Stavos Mammonian. And Stavos Mammonian fucked Moira Warrington. And Moira Warrington fucked Jimmy Joyce. And Jimmy Joyce fucked James Vaile. And James Vaile fucked Rita La Rousse. And Rita La Rousse fucked Birdy Williams. And Birdy Williams fucked Charles Marlowe. And Charles Marlowe fucked Edward Blake. And Edward Blake fucked Dorothy Chiltern-Barlow. And Dorothy Chiltern-Barlow fucked Mike Roscoe.

* With apologies to JG Ballard and chapter 13 of *The Atrocity Exhibition*.

Index

'n' denotes footnote
bold denotes illustration

2000AD 150–161

Action 150, 151, 153
Adams, Trevor 112
Against Nature 24
Aldiss, Brian 47, 54n
Aleister Crowley: The Black Magician 116n
Alfie 78
Amen Corner, The 143, **144**
Amis, Martin 46n
Anderson, Clive 28
Andrews, Harvey 106, 139
Angels From Hell 97, 98, 108
Angels On My Mind 98
Another Time, Another Place 25
Armstrong, Michael 132, 138
Askwith, Robin 62–80, **67**, 74n 104, 110, 140
Atrocity Exhibition, The 46, 48, 49, 50
Avalon, Frankie 132, 138
Avengers, The 121–125, **124**

Baby Love **18**, 70n
Bad Company (band) 73
Ballard, JG 25, 45–56, **51**
Barger, Ralph Hubert. *See* Barger, Sonny
Barger, Sonny 104, 105n
Barnes, Alan 138n
Barnett, Angela 128. *See also* Bowie, Angela
Battle 150, 151, 153
Beacham, Stephanie **35**, 36, 142, 143
Beano, The 150
Beardsley, Aubrey 10
Beat Girl **139**, 140
Beatles, The (band) 138
Bedazzled **28**, 29, 30
Belardinelli 157, 161
Bell, Mary 138
Bellingham, Lynda 74
Benchley, Peter 114
Berkeley, Ballard 76, 120
Beyond The Fringe 27
BFI Companion to Horror, The 132n
Black Crowes, The (band) 142
Black Sabbath (band) 106, 141
Blackman, Nicola 77
Blockheads, The (band) 72
Blood for Dracula 147
Blood on Satan's Claw 17, 76n
Bloom, Judi **141**
Bolam, James 147, 148
Bolland, Brian 161
Bond, James IV 141
Boot, Andy 132n, 140n
Booth, Anthony 62, 64, **67**

Booth, Connie 109, 111, 112, **114**, 120
Borges, Jorge Luis 40, 41n, 43
Bowie, Angela 141
Bowie, David 20, 43n, **126**, 127–136, **128**, **129**, **130**, **135**, 138, 157
Bowie: Loving The Alien 128
Brady, Ian 131, 138
Brazil 47
Bresslaw, Bernard 78
Breton, Michèle **40**, 41
Britannia Hospital 66, **73**
Britton, David 52n
Bronson, Charles 158
Burroughs, William 45, 46, 48, 63
Burton, Sir Richard 116n
Butterworth, Michael 54n

Cameron, John 106
Cammell, CR 116
Cammell, Donald 40, 41n, 43n, 116
Carry On (*see also* Carry On film titles) 63, 78
Carry On Abroad 62
Carry On Emmanuelle 62
Carry On Girls 78
Carry On Henry 63
Carry On Screaming 62, **62**
Castle, Roy 140
Cave, Peter 97, 98, 98n, 106, 108
Cézanne, Paul 30
Christie, Agatha 116n
Clash, The (band) 72
Cleese, John 109, 110, 111, **111**, 120
Cleveland, Carol 123
Clockwork Orange, A 34
Cocteau, Jean 48, 49n
Collins, Joan 73
Collinson, Madeleine 90, **96**
Collinson, Mary 90, **96**
Complete Book of Science Fiction and Fantasy Lists 54
Concrete Island 52, 53, 55
Condition of Muzak, The 53, 54
Confessions from a Holiday Camp 64, 77, 78, 79
Confessions from a Stud Farm 79
Confessions of a Driving Instructor 64, **68**, 74, 76, 77
Confessions of a Film Extra 61, 64, 66n, 68n
Confessions of a Games Master 79
Confessions of a Pop Performer 64, **67**, **70**, 71, **72**, **75**, 76, **80**
Confessions of a Shop Assistant 79
Confessions of a Window Cleaner 64, 66, 67, 69, **69**, 70, 76
Confessions of an Astronaut, Housewife?!?!* 79
Confessions of Aleister Crowley, The 110n

172 Psychedelic Decadence

Confusion Incorporated 98n
Conrad, Joseph 47
Cook, Peter 26, 27–32, **28**, **30**, 116n
Corman, Roger 139
Countess Dracula 58, 59, **60**
Country Life 73
Crash 46, 48, 50, 52, 53, 55
Crowley, Aleister 109, 110, 116, 120
Crucible of Terror 68n, 147, 148
Crystal World, The 46, 48, 52, 56
Cure for Cancer, A 53
Curse of the Crimson Altar 138
Cushing, Peter 17, 37, 38, 60, **142**, 146, 147

da Vinci, Leonardo 30
Dad's Army 107, 110
Dalí, Salvador 47, 48
Dallesandro, Joe 35
Damned, The (band) 149
Dark, The 132, 138
David Bowie 129, 135
David Bowie Story, The 128n
Davidson, Jim 77
Davies, Russell 63n
Davies, Windsor 74
Davis, Alan 161
Davis, Stephen 110n
Day of Forever, The 50
Death Becomes Her 16
Death Line 107
De Niro, Robert 111
Devils, The 144n
Disaster Area, The 47
Disciple of Death 148
Doctor Who 151n
Doing Rude Things 63, 70n
Donald Cammell: The Ultimate Performance 43n
Dr Feelgood (band) 72
Dr Terror's House of Horrors 140
Dracula A.D.1972 i, 34–39, **35**, **36**, 44, 128, 139, 141
Drowned World, The 47
Duncan, Isadora 116
d'Usseau, Arnaud 104

Eagle, The 152n, 156, 157n
Eastwood, Clint 158
Easy Rider 105
Edis, Janet 78
Ellis, Caroline 77
Ellis, William 36
Empire of the Sun 46
English Assassin, The 53
Eno, Brian 20, 21n, 22, **23**, 25, 138
Ernst, Max 47
Evens, Roy 107
Exorcist, The 16
Exterminator! 48
Ezquerra, Carlos 161

Faces, The (band) 142n
Fairman, Austin. *See* Raven, Mike
Faulkner, Sally 76
Faust 29
Fawlty Towers 76, 109–120, **111**, **113**, **114**, **117**, **118**, **119**

Fear 46n
Feldman, Marty 29
Ferry, Bryan 20–26, **23**
Fielding, Fenella 62
Final Programme, The 52n, 53
Fonda, Peter 99, 159
For Your Pleasure 21, 22, 25
Fox, James 40, **40**
Fragments of Fear 132n, 140n

Gasgoine, Jill 72
George, David Lloyd 112
George, Susan 13, **14**, 15, 71, 131n
Get Carter 40
Gibbons, Dave 156, 157
Gilan, Yvonne 112
Gilliam, Terry 47
Gilmore, Denis 104, **104**
Glitter, Gary 72
Gothard, Michael **141**, 143, 144
Gough, Michael 77
Grandes Baigneuses, Les 30
Grant, Peter 141
Great Rock'n'Roll Swindle, The 150
Green, Nigel 59
Greenwood, Joan 76
Greenwood, Miles 104
Guevara, Che 99
Guns and Ammo 54
Gwynn, Michael 110n

Halevy, Julian 104
Hall, Brian (n) 25n, 110n
Hammer studios 11, 35, 37, 38, 39, 60, 142, 147, 154
Hammer of the Gods: Led Zeppelin Unauthorised 110n
Hammer Story, The 138n, 142n
Hampson, Frank 156
Hancock, Tony 63n
Happy Days 8n
Hardy, Robert **106**, 107
Harris, Ernest 16n
Hassan I Sabbah 43
Haunted House of Horror, The 132, 135, 138
Hawkins, Carol 76
Hawtrey, Charles 62, 63, 141
Hayden, Linda **18**, 67, 70, 76, 77
Hayes, Tubby 140
Hearn, Marcus 138n
Hell's Angels on Wheels 105n
Henson, Nicky 104, 117
Herbert, James 79, 98, 161
Heritage of Horror, A 132n
High-Rise 25, 53, 54, 55
Hindley, Myra 131, 138
Hoffman, Dustin 15, **15**
Holden, William 154n
Holder, Roy 104
Holloway, Julian **141**
Home, Stewart 98
Hopkins, Mary 138
Horror Hospital 77, **136**, 137, 140
Houghton, Don 142n
House That Dripped Blood, The **58**
Hudson, Allan 141
Hudson, Jan 101n

Index 173

Hughes, Howard 138
Hunt, Marsha **35**
Huysmans, JK 24

I Like Birds 61
I, Monster 147
Iddon, Chrissy 76
I'm Not Feeling Myself Tonight 61
Incense for the Damned 65, **66**, 140
It's a Mad, Mad, Mad, Mad World 125

Jacques, Hattie 62
Jagger, Mick 40, **40**, 41, 44, 74
Jakubowski, Maxim 54n
James, Laurence 79n, 98n
James, Sid 62, 63n
Jaws 15, 114, 151n, 155
Jones, Peter **71**
Junk Mail 50n
Jurassic Park 154

Karloff, Boris 8, **9**, 11, 12, 16, 138
Kennedy, John F 138
Kenneth Williams Diaries, The 62
Kenneth Williams Letters, The 63n
Key, Janet **35**
Kindness of Women, The 45, 46, 56
King, Diana 115
King, Stephen 161
Kinski, Klaus 154n
Kipling, Rudyard 112
Klinger, Michael 70
Koresh, David 72

Lacey, Catherine **9**, 11
Lacey, Ronald 147
Larkin, Mary 104, **104**
Last Exit to Brooklyn 15
Last Poets, The (band) 42
Lautréamont, comte de 10
Layton, George 75
Lea, Timothy. *See also Wood, Christopher*
 61, 64, 66, 79
Led Zeppelin (band) 110n
Lee, Christopher 17, **35**, 38, 138, 139, 146, 147
Leon, Valerie 78
Longhurst, Sue 67
Lovecraft, HP 47, 138
Lust for a Vampire **138**, 139, 147
Lust, Simon 141
Lydon, John 150
Lynch, Kenny 140

Macdonald, Kevin 43n
Mackay, Andrew 21n, **23**
Macnee, Patrick 122
Mad Max 15
Magritte, René 47
Mama 98, 99, 101, 107n, 108
Man Who Sold The World, The 127
Mandel, Suzy 76
Manson, Charles 10, 31, 38, 137, 138
Manzanera, Phil 21n, **23**
Marks, Alfred 107, **143**
Masque of the Red Death 21
Matheson, Judy 68n, 69

Matthew Hopkins: Witchfinder General 8n, **8**, 10, **11**, 16
May, Jonathan 79
Mayfair 81–96
Maynard, Bill 71
MC5 (band) 149
McGillivray, David 63n
Mein Kampf 48
Meredith, Penny 77
Michelle, Ann 104
Miller, Philip 36
Milligan, Spike 73
Millington, Mary 76
Mills, Pat 161
Monroe, Matt 63n
Monty Python's Flying Circus 111, 123
Moorcock, Michael 47, 49n, 53, 54, 98
Moore, Alan 161
Moore, Dudley 28n, **28**, 29
Morris, Reverend Marcus 156, 157n
Mountain (band) 107
Mud (band) 141
Munday, Olivia 68
Munro, Caroline **35**, 36, **36**
Mystic (band) 140, 141

Nader, Ralph 48
Nantucket Sleighride 107
Neame, Christopher 36, **36**, 142
Never Mind The Bollocks 150
New Worlds 48, 49n
New York Dolls (band) 149
Newley, Anthony 128n, 129, 131
Newman, Kim 16n, 132
Nicholson, Jack 105n, 138n
Nielson, Donald 138
Nightmare Movies 16n, 132
Nolte, Nick 159
Norman, Mick. *See also James, Laurence*
 97, 98, 101, 106
Not Only… But Also 27, 29, 31

Oblong Box, The 16n
Observer, The 54
Occult, The 116n
Ogilvy, Ian **8**, **9**, 10, **11**, **13**, 16, 17, **17**
Oliver Twist 65
O'Neill, Kevin 161
Orphée 48
Overloaded Man, The 47, 50

Page, Jimmy 110, 149
Palin, Michael 16n
Pallenberg, Anita 41
Peckinpah, Sam 15, 154
Percival, Lance 77
Performance 31, **33**, 34, 39–44, **40**, **41**, **42**, 116
Persistence of Memory, The 48
Phillips, Conrad 115
Picture of Dorian Gray, The 105
Pink Floyd (band) 138
Pitt, Ingrid 58–60, **58**, **60**
Pitt, Ken 128
Plague of the Zombies, The 124
Playboy 60
Pleasence, Donald 107

Poe, Edgar Allan 21, 47, 48, 131
Pop, Iggy. *See* Stooges, The
Porridge 110
Powell, Robert 37
Price, Vincent **11**, 16, 17, 132n, **143**
Pringle, David 46n
Pririe, David 132n
Prowse, Dave 74n
Psych-Out 138n
Psychomania 76n, **102**, 104, **104**, 105n, **107**, 108, 117, 139

Queen (band) 73

Raven, Mike 138n, 145–148, **147**
Razor 16n
Reeves, Michael 8–18, **17**, 132n, 139
Reid, Beryl 105
Reid, Terry 139
Rigg, Diana 121–126, **122**, **123**, **124**
Ripping Yarns 16
Rising Damp 110
Rocky Horror Picture Show, The 141
Rodley, Chris 43n
Roeg, Nicholas 40
Rollerball 152
Rolling Stones, The (band) 138, 144
Rossiter, Leonard **73**, 110
Rotten, Johnny. *See* Lydon, John; *also* Sex Pistols
Roundtree, Richard 69
Roxy Music (band) 20–26, 73, 157
Roxy Music 21, 22
Rubens, Peter Paul 30
Russell, Ken 64

Sachs, Andrew 114, **117**
Saint, The 16n
Sanders, George 105
Sanderson, Joan 117
Sandford, Christopher 128, 133
Scales, Prunella 110, **113**
Scream and Scream Again 17, 38, 107, **141**, **142**, 143, **143**
Seeds, The (band) 138n
Selby Jr, Hubert 15
Self, Will 50n
Sex And Savagery Of Hell's Angels, The 101n
Sex Pistols (band) 150, 152
SFX 46n
Sharp, Don 104
She-Beast, The 8n, **13**
Sheer Heart Attack 73
Shock Xpress 16n
Siegel, Don 11
Six Million Dollar Man, The 153
Slaughter, Tod 131, 133, 148
Smash Hits 150
Smith, Guy N 98
Smith, Liz 76, 77
Smith, Madeleine 60
Some Mothers Do 'Ave 'Em 76n
Sorcerers, The 7, **9**, 11, 15, 16, 37
Space Oddity 128, 134, 135
Sparrow, Bobby 74n
Speed Freaks 97, 98, 108
Star Wars 15

StarLord 161
Steele, Barbara 138
Steele, Tommy 129
Steeleye Span (band) 138
Stensgaard, Yutte 143
Stewart, Rod 25, 142n
Stoneground (band) 142
Stooges, The (band) 138, 149
Straw Dogs **14**, 15
Stribling, Melissa 69

Tales of the Unexpected 160
Targets 8
Taste the Blood of Dracula 76n
Taxi Driver 111
Taylor, Elizabeth 50
Taylor, Rocky 76n, 104
Thompson, Phil 21n
Thomsett, Sally 15
Three's A Crowd (band) 71
Tintorera 15
Titbits 76
Todd, Bob **71**
Tornado 161
Tremlett, George 128n

Unlimited Dream Company, The 46n
Upton, Sue 78
User's Guide to the Millennium, A 49n

Valentino, Sal 142
Vampire Lovers, The 58, **59**, 60
Vampyros Lesbos 57
Vapors, The (band) 152
Venus Hunters, The 46n
Vermilion Sands 49n
Violation of the Bitch, The 13
Visiting Mrs Nabokov and Other Excursions 46

Wagner, John 161
Walker, April 112
Walker, Pete 107
Ward, Vernon 30
Warhol, Andy 147
Wells, HG 16n, 47
Wheatley, Dennis 35
When the Sleeper Wakes 16n
Whitaker, David 106
Whitting, Peter 104
Whizzer and Chips 150
Wicking, Chris 16n
Williams, Kenneth 29, 62, 63, 69
Wilmer, Douglas 60
Wilson, Colin 116n
Wind from Nowhere, The 47
Windsor, Barbara 63
Winner, Michael 8
Witchfinder General. *See* Matthew Hopkins: Witchfinder General
Wolfe, Tom 45
Wood, Christopher. *See also* Lea, Timothy 64, 65, 66
World In Action 106, 113
Worth, John 106
Wurzels, The (band) 78
Wyeth, Katya 68
Wyngarde, Peter 123, **124**

NEW BOOKS FROM HEADPRESS CRITICAL VISION

SEE NO EVIL
BANNED FILMS AND VIDEO CONTROVERSY
by David Kerekes & David Slater

From the authors of KILLING FOR CULTURE... A startling overview of Britain's 'video nasty' culture, SEE NO EVIL is the complete story of 'banned' films on video, the black market, and murder cases supposedly influenced by films. Features interviews and exhaustive commentary. 416 pages, containing many rare never-before-seen illustrations.

"SEE NO EVIL's breadth of research and scope is awe-inspiring. FIVE STARS." – *SFX*

"Excellent." – *Empire*

"Brilliant. FIVE STARS." – *Film Review*

FLESHPOT
CINEMA'S SEXUAL MYTH MAKERS & TABOO BREAKERS
Ed. Jack Stevenson

Pornography and erotica from around the world since the dawn of cinema... Includes an history of both straight and gay cinema, sex education features, 70s British hardcore, and much more. Contributing writers include KENNETH ANGER and GEORGE KUCHAR. Packed with hundreds of illustrations, many published for the first time. ADULTS ONLY.

"Jack Stevenson is a brilliant filth scholar ... and knows more about obscure, dirty movies than anyone alive." – *John Waters*

NASTY TALES
SEX, DRUGS, ROCK'N'ROLL AND VIOLENCE IN THE BRITISH UNDERGROUND
by David Huxley

Although never on the scale of their American counterparts, there was a comics Underground in Britain with much the same anti-establishment stance. Covering subject matter that was at once anarchic and sexually unrestrained, these comics invariably caught the wary eye of the law... From their origins in the 1960s through to the emergence of *Viz* in the 1980s, NASTY TALES is the first book to trace the turbulent history of these comics and the cultural instability from which they emerged.

SEE NO EVIL
£15.95 plus £1.60 p&p

FLESHPOT
£14.95 plus £1.60 p&p

NASTY TALES
£13.95 plus £1.60 p&p

or, BUY ANY TWO BOOKS for **£28 inclusive** of p&p

Cheques & POs payable to 'Headpress'. Please allow up to 30 days for delivery.

email: info.headpress@telinco.co.uk

**Headpress
40 Rossall Avenue
Radcliffe
Manchester
M26 1JD, UK**

Send an SAE/IRC for our latest catalogue